DUBLIN

TECHNOLOGICAL
UNIVERSITY DUBLIN

Donated to

**Visual Art Degree
Sherkin Island**

motherwell

jack flam

motherwell

PHAIDON

Phaidon Press Limited
Summertown Pavilion
Middle Way
Oxford OX2 7LG

First published 1991

© 1991 Ediciones Polígrafa, SA,
Barcelona, Spain
Text © 1991 Jack Flam

A CIP catalogue record for this book is available from the British Library

ISBN 0 7148 2720 7

Printed and bound in Spain by
La Polígrafa, SA, Barcelona
Dep. legal: B. 23.473 - 1991

CONTENTS

Photograph of Robert Motherwell, 1988. Photograph by Renate P. Motherwell.

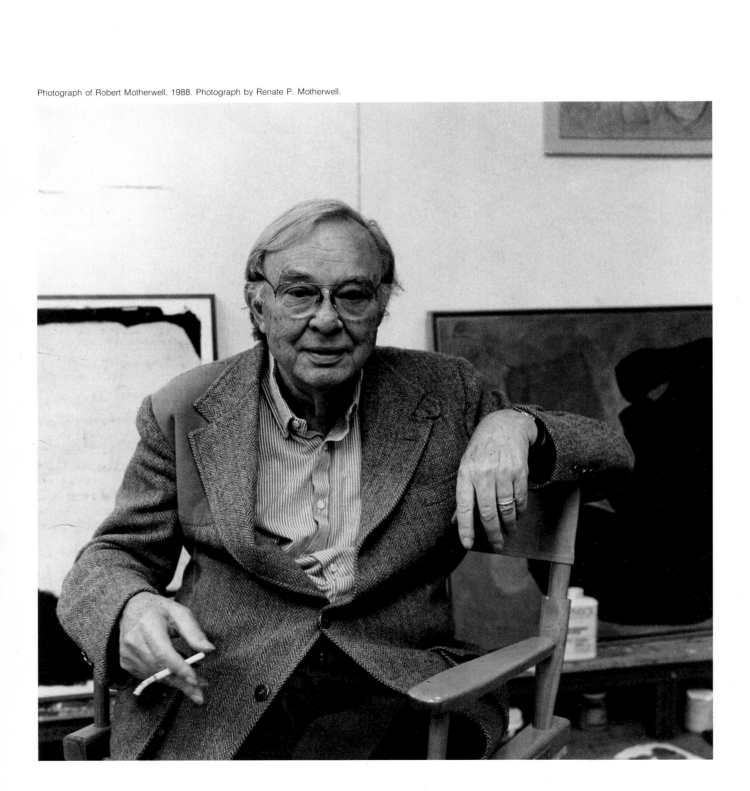

1.

Robert Motherwell has created one of the strongest bodies of work in contemporary painting. His oeuvre is also one of the most varied in the art of his generation, encompassing as it does a wide range of expression and formal structure, and significant work in collage, drawing, and printmaking, as well as painting. In it we find a broad lexicon of abstract imagery and an exploration of the expressive possibilities of signmaking that has rarely been equaled in recent art.

Motherwell has also been one of the leading spokesmen for modernism in America, and in this role, as in his painting, he emerges as both a quintessentially American figure and a distinctly international one. His own writings constitute what is probably the most eloquent description and defense that we have of postwar American modernism, and as the founding editor of the Documents of Modern Art series he was responsible for making available in English some of the most important theoretical texts of early European modernism.[1] To a degree that is quite rare in America, he has played a significant and dynamic role as a cultural figure as well as an artist.

Rich and varied as Motherwell's other activities have been, however, it is as an artist that he has made his main contribution — in terms both of the high quality of his work and of his sustained embodiment of the highest ideals of modernism in America. Though he developed and matured during a period that has been littered with brief and broken careers, and has remained active during a period when the very notion of high art has been called into question, Motherwell has continued to produce ambitious, high quality work for half a century. An inspiration to young artists thirty years ago, he still remains an influential presence to younger artists today.

Motherwell's art, like that of the other major artists associated with Abstract Expressionism, is rooted in the philosophical idealism, mythopoeia, and secular spirituality of high modernism. It is an art in which strong feeling is directed and focused by a powerful intellect, without apology for either the strength of the feeling or for the focus of the intellect. The creation of imagery that fuses instinct and intellect has been one of his major goals and one of his most impressive accomplishments.

Because Motherwell's art is paradigmatic of a certain kind of abstract image-making, it also raises a number of questions about the nature of abstract painting in general. The combination of feeling and thought that is so evident in his work inevitably directs our attention to the question of how "content" is communicated by images that have no recognizable subjects.

In the following pages, we shall consider Motherwell's art in two somewhat different but complementary contexts: as a discrete body of work that employs an original and very personal pictorial language, and as a body of work that responded to a specific historical situation and a set of broadly shared historical assumptions about pictorial form. We shall also consider certain biographical and historical factors along with purely formal ones, regarding the work alternately as being made by a specific person at a specific time and as having a life of its own, as if independent of the man who made it.

Since we are dealing with the work of an artist who has had so much to say about art, and particularly about his own art, it seems desirable to quote the artist himself at some length. Motherwell's own writings, statements, and interviews add another, particularly authoritative voice to the polyphonic sort of interpretation that his work seems to demand. I have therefore interspersed my own text with sections comprised entirely of statements by the artist. These, as the reader will see, expand and enrich — and sometimes contradict — my own thoughts about his work.

*

In confronting a body of work like Motherwell's, one runs headlong into the problems that arise from the fact that the language of discourse is linear and specific, and that in using it we find ourselves hard pressed to talk about more than one thing at a time. Pictures, on the other hand, are tabular; and since abstract pictures eschew not only overt subjects but also the world of objects, they force us to consider the basic constructive elements of pictorial form, which can have meaning in several often seemingly contradictory ways at once. Although a strong painting or drawing transcends its own mere physicality and always means more than the sum of its parts, an important aspect

of its meaning resides quite literally in its physical presence and is inseparable from the particular appearance of even its smallest parts.

Thus, at the same time that one is led to speculation about symbols and absolutes — and at times the sheer force of Motherwell's imagery seems to demand it — one has to remember not to lose sight of the simple physical presence of Motherwell's work. From the smallest drawings to the largest paintings, his pictures act upon us first and foremost in purely formal terms, even though complex overtones radiate out from the relatively simple and self-contained forms with surprising intensity, and the forms ultimately evoke multiple layers of associative meaning. This is particularly apparent in the various interpretations that have been given to Motherwell's *Spanish Elegies*. The forms are said to be like architecture, or megaliths, or phalluses and wombs, or bull's testicles, or metaphors for sexual intercourse. Each of these interpretations is based on associations inherent in the shapes of the forms, but each, taken singly, focuses attention too intensely on only one aspect or implication of the forms, at the expense of the whole.

A strong painting or drawing is an essay in a silent medium, and its very essence is often expressed in the ambiguity of its silences. When looking at one of Motherwell's *Spanish Elegies*, for example, the viewer may feel its particular urgency and mood, acknowledge its architecture, sense the overtones of death and love and physical anguish — but at the same time he remains constantly aware that these feelings are all conveyed by the medium of mute black and white paint which has been applied to canvas in a certain way. The harsh music of the oblongs and ovals, the interactions between areas, shapes, and edges, the denseness or fluidity of the forms, are all imbedded in the black and white paint that the painter's confrontation with his medium has left, like quivering skin, on the surface of the canvas. Ultimately, this signal of the surface is the matrix for all the other signals, the physical context that absorbs them and gives them back to us again in transfigured form, their ideas irradiating, but also inseparable from the movement of the brush that put them there.

In Motherwell's work this sense of the physical act is always of great importance, and it cannot be detached from the meaning of the image itself. The hand moves, feeling is transmitted. In the now quick, now light, now violent, now probing movement of the brush or pen or pencil, a gesture makes feeling intelligible. Some of Motherwell's images, such as his calligraphic brush drawings, isolate a single gesture. Others incorporate thousands of gestures: small, large, broad, linear — always integral to both the structure of the forms they constitute and the feeling that they transmit.

Historically, Motherwell has made an important contribution to the development of the language of abstract painting. He has explored a remarkably broad range of pictorial possibilities, with a remarkable degree of eloquence. Yet his technical means have been surprisingly direct and simple: the hand moves, a mark is made. The act that one senses behind all of his forms is the act of painting itself. Or perhaps one might call it the act of drawing since, in Motherwell's work, the acts of painting and drawing are so often simultaneous. "The extension of division," as Motherwell has called it, the placement of the mark, the dividing of the surface. (This is also the underlying gesture of collage, though in the collage medium the gesture itself is usually masked, and what we actually see in the finished picture is the result of the placement without a strong sense of the process

behind it.) Because of this continuity in the underlying process of their making, Motherwell's largest paintings often have the spontaneity of his drawings, and his smallest drawings can have some of the richness of the largest paintings. In either case, meaning is inseparable from our awareness of the act of making.

2.

A few years ago, I was standing next to one of my huge black and white pictures [In Black and White No. 2] *in a museum gallery, and a middle-aged man approached me and asked what the picture was about, what it "meant." Because we happened to be standing in front of the actual painting, I was able to look at it directly, instead of using an after-image inside my head. I realized that that picture had been painted over several times and radically changed, in shape, balances, and weights. At one time it was too black, at one time the rhythm of it was too regular, at one time there was not enough variation in the geometry of the shapes. I realized there were about ten thousand brush strokes in it, and that each brush stroke is a decision. It is not only a decision of aesthetics — will this look more beautiful? — but a decision that concerns one's inner I: is it getting too heavy, or too light? It has to do with one's sense of sensuality: the surface is getting too coarse, or is not fluid enough. I has to do with one's sense of life: is it airy enough, or is it leaden? It has to do with one's own inner sense of weights: I happen to be a heavy, clumsy, awkward man, and if something gets too airy, even though I might admire it very much, it doesn't feel like myself, my I.*

In the end I realize that whatever "meaning" that picture has is just the accumulated "meaning" of ten thousand brush strokes, each one being decided as it was painted. In that sense, to ask "what does this painting mean?" is essentially unanswerable, except as the accumulation of hundreds of decisions with the brush. On a single day, or during a few hours, I might be in a very particular state, and make something much lighter, much heavier, much smaller, much bigger than I normally would. But when you steadily work at something over a period of time, your whole being must emerge.

In a sense, all of my pictures are slices cut out of a continuum whose duration is my whole life, and hopefully will continue until the day I die.[2]

3.

The formal repertory of Robert Motherwell's art is unusually diverse and wide-ranging. Unlike most of the other major abstract artists of his generation, Motherwell has not developed in a steady, straight-line progression toward a single, characteristic image. Instead, he has constantly been involved with the invention of new motifs and pictorial modes, and with the reworking of old ones. In fact, it is not unusual for Motherwell to work in two or three different modes at once, as if trying to register every nuance of his sensibility, in order to work, as he has said, "as rapidly as one's mind envisions."[3] As a result, Motherwell's imagery ranges from the organic to the geometric, and from the spontaneous to the highly calculated, as is evident in comparing a work such as *Automatism No. 2A* (1965) with one like *Elegy to the Spanish Republic No. 34* (1953–54). He

is constantly inventing, reworking and reinventing. Rather than delimiting, he seems bent on expressing the complex and often contradictory nature of his own personality, of artistic expression in general, indeed of existence itself.

Motherwell has created this broad range of imagery with a working process that ranges from the spontaneous creation of Zen-like calligraphs to elaborately worked and densely painted fugal compositions. His vocabulary of forms includes both biomorphic shapes and austere, rectilinear geometry, and he often combines these extremes with telling effect. He also works with a broad gamut of feeling, which runs from the lyrical to the violent to the austerely serene. Moreover, he often explores the opposing limits of this broad range of imagery and feeling within a relatively short period of time — as can be seen in paintings such as *Figure Four on an Elegy* (1960), *Black on White* (1961), and *Summertime in Italy* (1962).

The process of drawing plays an especially important role in Motherwell's art. Unlike traditional draughtsmen, Motherwell almost never draws directly from nature; but in a deeper sense he does in fact draw from ''life.'' Not from the outward appearances of life, the constantly changing surface of reality that passes continuously before our eyes, but from his understanding and intuition of the inner workings of things — the life of the mind and of the feelings, those aspects of existence that we know though we have never seen them, and that we somehow recognize when their image is set before us.

Within the broader context of his picture-making as a whole, all of which comes from these inner sources, Motherwell draws for two basic reasons: to generate new imagery or work out pictorial problems, and for what he himself calls ''the sheer pleasure of it.'' To the first category belong what Motherwell calls ''doodles'' — drawings that may be seen as an equivalent of the traditional painter's work from the model, in that they are studies meant to generate fresh ideas and explore new realms of possibility, both pictorially and psychologically. The mode of these drawings is usually that of ''psychic automatism,'' in which the artist allows his hand free play in order to call forth images and feelings that exist below the level of his consciousness. ''What is essential is not that there need not be consciousness, but that there be 'no moral or esthetic *a priori*' prejudices . . . for obvious reasons for anyone who wants to dive into the depths of being.''[4] These spontaneous ''automatic'' drawings are part of the ongoing enterprise that Motherwell has referred to as ''my deepest painting problem, the bitterest struggle I have ever undertaken: to reject everything I do not feel and believe.''[5]

The drawings done ''for pleasure,'' on the other hand, tend to be of two sorts: the calligraphic brush drawings, which often have the resonant precision of Japanese *haiku,* and which are related to Motherwell's interest in Zen and passion for Oriental art; and the drawings done after his own paintings, in which he explores the further implications and possibilities of his own imagery. Here, as Motherwell has remarked, ''the strain of dealing with the unknown, the absolute, is gone. When I need joy, I find it only making free variations on what I have already discovered, what I know to be mine. We modern artists have no generally accepted subject matter, no inherited iconography An existing subject for me — even though I had to invent it to begin with — gives me moments of joy.''[6]

A third kind of drawing, which represents a relatively small portion of Motherwell's production, involves figurative imagery taken from remembered experience — images such as *Pregnant Woman Holding a Child* of 1953, or *The Wild Duck* of 1974,

which by the artist's own account ''was painted just after a glimpse of a wild duck that spends several weeks each summer in the bay directly in front of my studio . . . a quite naturalistic (for me) duck lifting itself from a blue sea''[7] Like Motherwell's collages, this sort of drawing usually has an overtly autobiographical content that is absent from most of his other work.

In all three modes, the hallmarks of Motherwell's drawings are spontaneity and restlessness. This is evident in their execution and also in the constant invention of new motifs and the reworking of old ones that is characteristic of Motherwell's work as a whole.

Motherwell's oeuvre is united not so much by consistency of image as by consistency of touch and color. A heterogeneous range of imagery is made ''his'' by a characteristic physical touch and a carefully delimited, highly personal range of hues; especially ochers, blues, and reds. And underlying these characteristic hues, which seem to have been chosen with the rigor of a man inventing his own musical scale, is the dialogue of the ultimate bass line, the unifying polarity of black and white — or rather of blacks and whites, for few painters have invested these two supposed non-colors with as much coloristic nuance as has Motherwell.

Black and white have been Robert Motherwell's main colors for over forty years now, the chromatic bedrock of his image-making. This underlying dialectic of black and white — graphic, stark, and reductive — has allowed Motherwell to achieve an art of absolutes without having to limit the play of his inventive mind to a single (absolute) image, and to create a purely abstract art without having to reject the notion of subject matter. It has permitted him to choose, over a long period of time, many of his own constraints and freedoms, in a way that might have been closed to him had he opted, around 1950, for a schematic rather than a chromatic framework for his art.

The dialogue of black and white forms the basis not only of Motherwell's pictorial structure, but also of the implied subject matter that he, unlike most abstract artists, has continuously been willing to accept. ''Black is death, anxiety; white is life, éclat,'' Motherwell has said of his *Spanish Elegies*.[8]

An astonishing remark, it would seem, from a man who is not only one of the leading abstractionists of our era, but also one of our most important theorists. Yet the statement is arresting in its forthrightness and in the willingness it shows to confront the fact that abstract pictures and the component elements of abstract pictures are richer in their evocations and emotional implications than any single orthodoxy might want to allow. ''It would be very difficult to formulate a position in which there were no external relations,'' Motherwell wrote in 1951. ''I cannot imagine any structure being defined as though it only has internal meaning.''[9]

And since, in order to avoid narrative or anecdote, shapes must be kept more or less purely abstract while colors can be allowed a certain range of external associations without imposing narrative, much of the explicit symbolism of Motherwell's imagery has been stated chromatically. ''Mainly I use each color as simply symbolic: ocher for the earth, green for the grass, blue for the sea and sky. I guess black and white, which I use most often, tend to be the protagonists.''[10] Not black and white separately, but in combination — the polarity of black and white, the dialogue of absolutes, which, like Motherwell's other colors, functions primarily as an autonomous formal element, but is also unavoidably rooted to our experience of the real world.

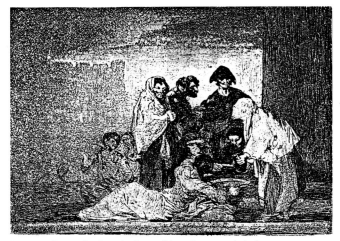

Francisco Goya, "Gracias a la almorta," from *Desastres de la Guerra*.

the passage of time; but time in the abstract, as it exists beyond events or hours or years. Perhaps it is the tension between these two levels of awareness, between the small measures of time as experienced and the larger rhythm of time as conceived of in the abstract, that accounts for the tragic feeling of loss and regret that emanates from so many of Motherwell's works. "My mind works *sub specie aeternitatis*," Motherwell has remarked. "I'm the exact opposite of an Impressionist. I seek the eternal, which is like a rock, but I want my work to be sensual, too — a cross between Mondrian and scribbles."[11]

Perhaps the underlying metaphor of much of Motherwell's black and white imagery lies somewhere in this direction, and has something to do with time lived and felt, moment by moment, tragically set against a consciousness that in the larger scheme of things these wonderfully vivid moments may count for little or nothing — and in any case always lead back to Nothing.

4.

What we call the real world is itself composed of more realms than we can keep track of: sensations, feelings, ideas, memories. Black and white, for example, may evoke the abstract idea of death and life, but they also recall Mallarmé's white paper awaiting the excruciating appearance of a word; or the matter-of-factness of any printed words or music; or the extremes of darkness and light; or other kinds of art, from Japanese brush painting to Goya's etchings and Picasso's *Guernica*. As Motherwell uses them, black and white even evoke the specific stark flat light of certain southern lands: the whitewashed walls and brilliant shadows of Mexican, Greek, or Spanish villages, punctuated by the black garb of priests and perpetually mourning women. And at the same time, there also frequently appear in his pictures — sometimes at the edge, and sometimes at the center of our attention — the colors of sky, blood, and sand, or of bright pink scarves, vivid emblems of the fleeting moments of which eternity itself is composed. Together, these other colors and black and white, all colors and none, evoke

As the paintings were being chosen for this show,[12] I came to realize how different the spatial conceptions are in my paintings — something that I was not conscious of before. I have been conscious of the Oriental concept of a painting representing a void, and that anything that happens on a painting plane is happening against an ultimate, metaphysical void. Some of my pictures are conceived that way, such as In Beige with Charcoal, *or* A View No. 1. *Another group of pictures, I consciously conceived of as walls, such as the Janss picture* [Jour la maison, nuit la rue], *or some of the* Elegies, *or the ones literally called* Wall Paintings. *Others are conceived of traditionally in terms of figures and background, such as* The Persian No. 1, *or* The Homely Protestant *or* Fishes with Red Stripes. *But these categories are not mutually exclusive. For example, the* Plato's Cave *paintings were originally conceived of (as the* Opens *in general are) as walls. Because of the* Caves' *liquidity and their darkness, they became literally "caves"; and that was unexpected and unintentional on my part. The sense of a "voyage"*

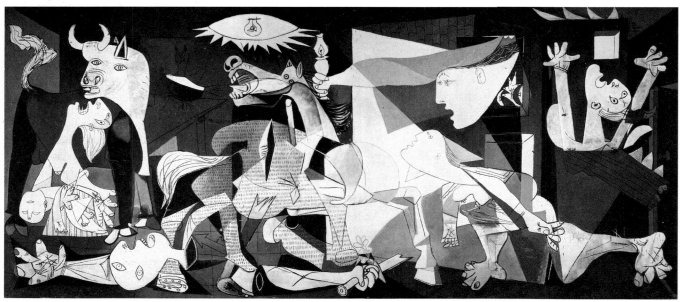

Pablo Picasso, *Guernica*, 1937.

is crucial to the process of such works. Fishes with Red Stripe involves the void as well as figuration; it also involves both spontaneity and correction in equal measure. In a way, it is closest to what I have been after all my painting life.

My paintings also cluster in terms of colors. Many are built on black and white; some on black and white and yellow ocher; some on sky blues; some on scarlet. I am not a "colorist" in the sense that Bonnard or Matisse or the Impressionists are, orchestrating many colors; but nevertheless (although it seems a contradiction) I think that specific hue is more important to me than to most artists, even those who orchestrate colors. Not only in art but in everyday life, I recognize color before shape.

I use hues somewhat the way small children do. They use bright colors very naturally; they rarely muddy them or work tonally. Practically all professional painters work essentially tonally, not primarily with color. This is especially true of painters who "model" forms. In Henri Rousseau's sense of the term, I am deliberately an "Egyptian" painter.[13] I use flat, linear, local hue. One of the deepest influences of my early days as a painter was a three-volume set of rotogravure photos of the antiquities in the Louvre, especially the Ancient Near Eastern and Egyptian basreliefs, even more than old paintings, probably because of the incisiveness and clarity of lines and shapes in low relief.

My images are determined by a combination of vectors. A subjects emerges out of an interaction between my self, my I, and my medium. It is determined by what dominant hues I am using, by the format, by whether the spatial concept is of a void, or a wall, or a figure (or, very rarely, of a landscape). While that puts a large lot in, in another way it also leaves an awful lot out. My paintings are not an "abstract version of nature," nor is most Abstract Expressionist painting. My work has a strong sense of light, but it is not atmospheric light; it is generated instead by planar color and value. And in real life, I would rather spend time looking at nature that has been modified by man — at parks or town squares with walls, say — than at raw nature or wilderness. The Open series was generated in part by these feelings. In Mexico, in the old days, they built the four walls of a house solid, without windows or doors, and later cut the windows and doors beautifully proportioned, out of the solid adobe wall. There is something in me that responds to that, to the stark beauty of dividing a flat solid plane.

The different images in my paintings are the result of these and various other preoccupations. I work with these more or less a priori conceptions, plus gestures, then my own imagery is just what comes out. I name it all afterwards. Naming is a primitive, inadequate but deeply rooted way of identifying the ineffably complex nature of reality.

*

When I say that I recognize myself in my pictures, I mean that in the sense of the phrase "shock of recognition," and with no a priori idea of how to bring it off. It is not like walking up to a mirror where you look and see yourself. As you fiddle around with the malleable, plastic stuff of paint, you begin to shape a sense of your own inner semblance — what Baudelaire refers to as "mon frère, mon semblable." Baudelaire's poetry is a kind of miracle — that a subject matter so radical, in trying to represent one's inner archetypes rather than social conventions, can be expressed with such clarity, in classical, faultless rhyme. As

Picasso said somewhere, drawing is a form of rhyming. If you use gestures, you instinctively make forms rhyme, either against a void or against a wall. That, in a way, is what I have been doing all my life. Sometimes though I work off and on for years on a picture, it never becomes "mon semblable" and ultimately I have to abandon it.

When I look at a great number of my pictures . . . I can see ones where I really let go, in an almost physical sense — where I got down on my hands and knees, where I got my face and my hair and my clothes covered with paint, where I got involved like a desperate animal in a cave, or whatever. There are others that were painted with my street clothes on, so to speak. I can tell by looking which ones I wrestled with, like Jacob and the Angel, and which ones I painted almost with the detachment of Velázquez.

5.

The circumstances in which art is created — that is, the events of an artist's life — frequently occupy a problematic position in relation to the art itself. Although biographical information cannot answer all, or even most, of the questions that a strong body of work raises, it can nonetheless shed a kind of light on certain aspects of an artist's work which nothing else quite can.

What precisely the external events of an artist's life can tell us about his art is uncertain, though. When we look at the early works of Claude Monet, for example, with their peaceful, sun-drenched landscapes and scenes of domestic tranquility, we never suspect the tumultuous events of the artist's life at the time he was painting them: his struggles and travails, his uncertain health and the uncertainty of his material circumstances. In an instance like this, it is difficult to know how we can interpret the relationships between the life and the work. Should we see the work as an escape from the horrors of everyday life? Should we see the work as evidence of a deep inner strength that triumphs over the tumultuousness of everyday life? Or should the question be phrased in a different, more subtle way, recognizing that an artist's art is something that runs parallel to his life, only occasionally intersecting it in readily apparent ways?

The circumstances of Robert Motherwell's early life, for example, could have been those of many other men of his time and background. But since something so special emerged from them, it is worth giving them some attention.

Motherwell was born in Aberdeen, in the state of Washington, on January 24, 1915, the first child of Robert Burns Motherwell II and Margaret Hogan Motherwell. A sister, Mary-Stuart, was born in August 1916. At the time of Motherwell's birth, his father was a bank cashier; he would later become a prominent San Francisco banker. Motherwell was reared largely on the Pacific Coast and until 1940 spent most of his school years in California. In later years he frequently attributed his predilection toward certain colors, such as sky blue and ocher, to his California upbringing; and there is indeed a spaciousness and openness in his work that seems to reflect his having been brought up on the West Coast.

At the end of the first World War, the Motherwell family moved to southern California. From his earliest years, Motherwell had been interested in drawing. He later remembered having been encouraged to express himself graphically by a kindergarten teacher (because he was tone-deaf), and also vividly recollected the same teacher drawing abstract impressions of the weather

on the blackboard.[14] In 1926 he was awarded a scholarship to the Otis Art Institute in Los Angeles. Because of his age, however, he was not allowed to work from the live model, and so he painted from imagination, mostly — according to his own later memories — pictures of knights in armor, shields, battle flags, and medieval heraldry. Around this time he also won a prize for "color harmony" in a kite contest sponsored by the Los Angeles County school system. He later would remember this kite as being in effect his first "collage."

In 1927, the Motherwell family moved permanently to San Francisco where, a couple of years later, Motherwell developed acute asthma. As a result, he was sent away from the damp climate of San Francisco to the Moran Preparatory School in Atascadero, in central California, where he graduated as class valedictorian in 1932. Motherwell's asthma seems also to have had a fairly direct effect on his later work. The theme of struggle against suffocation and imprisonment is a recurrent one in his painting, from *The Little Spanish Prison* on, and Motherwell has also remarked that his early experience with asthma may well have affected his later working habits. During his early youth, the attacks usually occurred in the early morning hours, between about 2 A.M. and 3 A.M., and he subsequently developed the habit of trying to go to sleep as late as possible, in order to try and avoid them. To this day, he paints primarily at night, as if quite literally to keep himself alive. Furthermore, his habit of painting at night has reinforced his tendency to turn in on himself, rather than to the external world, for his imagery.[15]

That fall, Motherwell entered Stanford University. He also briefly studied painting at the California School of Fine Arts in San Francisco that year, and later remembered being deeply impressed by the Matisses in the collection of Michael and Sarah Stein in nearby Palo Alto. At Stanford he studied philosophy and modern French literature, two of the cornerstones of his later artistic development, and wrote his undergraduate thesis on Eugene O'Neill's relation to psychoanalytic theory, which would become another of his lifelong interests.

It was also at Stanford that Motherwell began to read the writings of the American Empiricist (or Pragmatist) philospher John Dewey, whose *Art as Experience* Motherwell has referred to as "one of my early Bibles."[16] Dewey's emphasis on learning through doing, and on art as a response to lived experience, provided Motherwell with a firm point of departure for his own developing thoughts about art. In particular, Dewey's insistence that the expressive energy of works of art comes from formal interactions rather than from representational subject matter provided Motherwell with a theoretical basis for communicating emotion through abstract forms and colors. "I owe Dewey part of my sense of process," Motherwell has said. "He demonstrated philosophically that abstract rhythms, immediately felt, could be an expression of the inner self."[17]

During the summer of 1935, Motherwell took his first trip to Europe, with his father and sister. This grand-tour style trip included most of the western European countries as well as England and Scotland, where they visited the town of Motherwell, near Glasgow. During this trip Motherwell remembers having been most deeply impressed by the hill towns of Italy.

In 1937, the year that he graduated from Stanford, Motherwell heard André Malraux speak about the Spanish Civil War at a large rally in San Francisco. Motherwell's involvement with the idea of the Spanish Civil War, and the way in which this later acted upon his imagination, would have lasting reverberations for him. "The *Spanish Elegies* are not 'political,' " he later wrote,

"but my private insistence that a terrible death happened that should not be forgot."[18]

Later that year, Motherwell came east and entered graduate school at Harvard University, in the Department of Philosophy. At Harvard he studied aesthetics under Professors Arthur O. Lovejoy and D. W. Prall, and attended lectures by Alfred North Whitehead. Prall's book *Aesthetic Analysis* was especially influential, in its emphasis on abstract formal elements over recognizable subject matter and in its insistence on the unity of form and content. Whitehead reinforced Motherwell's sense of the inadequacy of deductive analysis as a tool by which reality could be understood. Whitehead also provided Motherwell with a philosophical model for the process of abstraction as a process of selection and concentration. In particular, Motherwell seems to have been struck by what he has described as Whitehead's notion that "mathematics is thinking about certain patterns in concrete reality and ignoring others, and is consequently a form of abstraction — thought in this sense, he insists, is a form of emphasis. And so with art. All art is abstract in that it presents certain things and omits others from the fullness of man's experience Modern art is more abstract than any preceding art, because it rejects more around it than any other art."[19]

But at the same time that Motherwell was deeply involved with American pragmatic philosophy his main interest was not in developing a philosophy of art but in creating art. It is revealing, for example, that for the subject of his thesis he chose to work with the journals of Eugène Delacroix, thus dealing directly with the writings of a specific artist rather than becoming mired in aesthetic speculations about art in general. His contemporaneous interest in French Symbolist poetry can be seen in a similar context, as providing a tangible instance of meaningful modernist poetical practice rather than mere theory about the aesthetics of modern poetic expression.

His passion for modern French poetry was also another avenue of escape from the bourgeois, specifically American milieu in which he had been raised. In 1974, for example, looking back at his early involvement with Symbolist poetry, Motherwell told an interviewer, "Forty years ago I was trying to find out about a certain kind of modernist vision and it so happens that, among other people, some symbolist poets came closest to expressing it. I was looking for what would help me understand modernist art. In the 1930s it was almost impossible to find out in English, in America, modern art's deepest concerns, theoretically and culturally."[20]

In order to work on his thesis, Motherwell went to France at the end of the 1938 school year. That summer he spent at the University of Grenoble, studying the French Symbolists and reading extensively in French Romanticism. In the fall he took a studio in Paris, which he kept until July of 1939, neglecting his thesis research in order to paint. He studied briefly at the Académie Julian that year, and also worked on a translation of Signac's *D'Eugène Delacroix au Néo-Impressionnisme,* one of the earliest and most concrete texts we have by an artist on modernist painting. Toward the end of the summer, Motherwell went to England in order to sail on the *Queen Mary,* and spent several weeks with student friends at Christ's Church College, Oxford. He returned to the West Coast at the end of August and stayed at the family beach house near Aberdeen, Washington.

In September 1939, Motherwell took a substitute position teaching art at the University of Oregon, at Eugene. The following fall he came to New York, where he entered the department of Art History and Archaeology at Columbia University. There he

studied briefly under Meyer Schapiro, who taught medieval and modern art and was actively supportive of abstract painting. Schapiro introduced him to some of the European Surrealist artists living in exile and encouraged him to devote himself to painting rather than scholarship.

During the winter of 1940–41, Motherwell worked with Kurt Seligmann, through whom he met a number of the European Surrealists, notably Max Ernst and Matta Echuarran. That June, Motherwell traveled with Matta and his wife to Mexico, on what was to be one of the crucial voyages of his life. At the start of the Mexican sojourn, he fell in love with Maria Emilia Ferreira y Moyers, a young actress whom he met on the boat to Mexico and whom he would marry a few months later. It was at this time that Motherwell first began to do "automatic" drawings, and painted his first mature pictures, among them *The Little Spanish Prison, Mexican Night*, and *Spanish Picture with Window*. It was also at this time that he decided with certainty to make painting his primary vocation.

It is important to note that Motherwell's final commitment to painting was made under the dual signs of Eros and Thanatos — of his love for Maria, and of the powerful presence of death that he sensed everywhere in Mexico. "And death!" Motherwell recollected in a 1964 interview. "The continual presence of sudden death in Mexico. . . . The presence everywhere of death iconography: coffins, black glass-enclosed horse drawn hearses, sigao skulls, figures of death, priests in glass cases, lurid popular wood-cuts, . . . and many other things, women in black, cyprus [sic] trees in their cemeteries, burning candles, black-edged death notices and death announcements . . . all of this contrasted with bright sunlight, white garbed peasants, blue skies, orange trees and everything you associate with life — all this seized my imagination. For years afterwards, spattered blood appeared in my pictures — red paint."[21]

The final months of his Mexican sojourn were spent in Mexico City working near the influential Surrealist artist Wolfgang Paalen. Through Motherwell's relationship with Matta and Paalen, he became deeply interested in Surrealist theories, particularly automatism. That December, having permanently abandoned university studies in favor of painting, Motherwell returned with Maria to New York City, where he would remain for most of the next three decades.

Motherwell's intellectual and academic background distinguished him from the other Abstract Expressionists, who had come out of a more traditional art school training. In particular, Motherwell's interest in philosophy, in Symbolist literature, and in psychoanalysis would serve as the intellectual matrix from which a good deal of his later thinking would develop and be sustained.

6.

I was always concerned with the culture of Modernism as much as with my personal fate — to the degree that that is possible. When I was still in my twenties, I realized that the enduring art and writing and music that had been produced in our time was that which almost always could be grouped together under the umbrella of Modernism. Another clear thing was that although Modernism was difficult for most people to accept or comprehend, it was our own historical creation. It was begun in large part as a critical act, as an act of rebellion against the corny academic art so beloved by the bourgeoisie; and not only by the bourgeoisie, as it turns out, but also by the working class, comprising anecdotes, sentimentality, religion, and so forth. An art of what in the nineteenth century would have been called "moral uplift." What all this anecdotal art had in common was a lack of vitality and an essential falseness. It did not reflect reality as we know it; but rather an outmoded, and somewhat sentimentalized model of reality. The Modernist critical act, accomplished by the most serious artists and writers of our own century, involved not only getting rid of the worn-out baggage of officially acceptable art, but also, conversely and more positively, a new investigation into what constitutes art as art; and therefore of what constitutes reality as we know it.

One of the tasks that modern art set itself was to find a language that would be closer to the structure of the human mind — a language that could adequately express the complex physical and metaphysical realities that modern science and philosophy had made us aware of; that could more adequately reflect the nature of our understanding of how things really are. Cézanne, for example, discovered not an art that was "solid like the art of the museums," but something quite the opposite. In a way, he unknowingly discovered that the solidity of the museum itself — literally — was a false concept and that things are not solid. In doing so, he came closer to the nature of things, according to modern physics.

When I started out, all but a few were against abstract painting. The art world, as it was then, hated it. But the university world was very interested in what we were doing. Since I knew how to talk about it (I had originally been trained in philosophy) I was given, by default, the office of spokesman for the Abstract Expressionists, especially in the university world. A lot of my writings were originally speeches — there was an audience, and a direct feedback — either the people in the audience visibly agreed or didn't agree — something you don't get with painting. If you have a show, a dozen or so people may be moved to tell you how they felt about it, but on the whole, exhibiting paintings is a very indirect way of "exposing" yourself. Music and drama are played in front of an audience, an intelligent book is widely reviewed by literate people, and people talk about it. But with painting, there is relatively little direct feedback. I meet people who look at me with a certain amount of awe, but they rarely say anything about my painting. With writing there is a lot more feedback, a much more literate audience.

I was going to write my Ph.D. thesis on Delacroix's Journals. Delacroix was constantly preoccupied with theoretical questions, with the nature of art, the moderns versus the ancients, and so forth. He was very sustaining to me when I started out. I was interested in ideas — in talking about them and in writing about them. Poets, for example, have traditionally been involved in writing criticism. In the same way that, say, T. S. Eliot wrote criticism as well as poetry, there is no reason, if one regards one's paintings as "poems," that a university-educated painter cannot write criticism as well, and become involved with theoretical issues. I never met an outstanding artist not interested in ideas, as well as in sensuality.[22]

7.

In June of 1941, when the twenty-six year old Robert Motherwell left for Mexico, he brought with him a small Whatman sketchbook, in which, during the latter part of July, he executed eleven drawings with brush and pen. This sketchbook contains

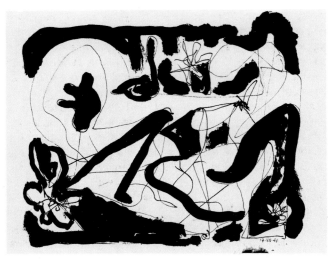

Robert Motherwell, "The Mexican Sketchbook," page 1, 1941. India Ink on Whatman drawing paper, 9 × 11½ in. (22.9 × 29.2 cm). Collection The Museum of Modern Art, New York. Gift of the artist.

what are probably Motherwell's earliest mature drawings, which directly precede his first important paintings.

Not surprisingly, the method of these early drawings is the "psychic automatism" that Motherwell inherited from the surrealists, especially Matta. And not surprisingly, the imagery of all but one of the drawings is a surrealist-inspired blend of the abstract and the semi-representational: abstract forms mixed with suggestions of actual things and figures, and abstract space played against and modified by extensive passages of perspectively described space. What *is* surprising is that the least surrealistic, most abstract and most original drawing in the sketchbook is the one that was done first.

For anyone familiar with the history of Motherwell's development, however, this surprise is not so surprising. Throughout his career, some of his most important images have come to him in what appear to have been flashes of inspiration. Instead of slowly groping his way toward fully realized images, Motherwell tends to arrive suddenly at a realized image, and then to work variations around that image. Usually this involves a richening process — subsequent variations of the original theme explore and elaborate the possibilities inherent within it. Sometimes, on the other hand, the process is reversed, and the artist seems to grope his way back through the bypassed possibilities that he might have tried had he not hit on the fully realized theme right at the start.

The "Mexican Sketchbook" is an excellent case in point. In the very first drawing, the interplay of lines and areas and the strong all-over surface tension of the total space are quite well realized. The next six drawings — apparently executed the same day — become progressively more representational. Their space becomes increasingly plastic, the balance between surface and image becomes less sure, and a certain narrative content makes itself felt. The seventh page of the sketchbook, in fact, is a fairly straightforward depiction of figures in a landscape. In the last four pages, a similar search is evident. The drawing on the eighth page, with its ladder forms and evocation of multiple figures, is somewhat reminiscent of Picasso's 1930 *Crucifixion,* while the imagery of pages 9 and 11 is very close to Matta's imagery at the time. The single polychrome image (on page 10) is painted in the black, white, ocher, and reddish earth tones that will characterize so much of Motherwell's later work, but the forms

are vaguely reminiscent of Miró, or Arp. It is as if, having hit on a personal and intelligible syntax on the very first page of the notebook, Motherwell then felt obliged to touch base with other kinds of imagery that were on his mind at the time.

This point bears stressing because much of the method, and even some of the basic assumptions about image-making that we find in Motherwell's later work are already present, albeit in somewhat rough form, in the "Mexican Sketchbook." We find there the predominant use of black and white, and restricted palette; the experimentation with different pictorial syntaxes and spatial modes; the use of automatism to generate imagery; the limited technical means employed, so that the importance of the syntax of the imagery is never overwhelmed by technique for technique's sake; and finally, the tendency of the artist, when faced with a moving experience, to turn inward and to depict not the physical experience but his reaction to it. In Mallarmé's famous phrase, "To paint not the thing but the effect it produces."

The "Mexican Sketchbook" gives us one of our earliest glimpses of Motherwell's maturity as an artist, and it anticipates many aspects of his later imagery. Shortly after Motherwell's return from Mexico, he was to accomplish something very like the success of that first drawing in the "Mexican Sketchbook," but on an even grander scale: one of the very first oil paintings he did after his return to New York, *The Little Spanish Prison,* was to be one of the most original pictures of his early career.

*

The reference to Mallarmé is not gratuitous. The example of Mallarmé, and of the French Symbolists in general, has had an enormous effect on Motherwell's thought and art. In the early 1940's, when he was starting out, it seems to have acted as a kind of pole star, and to have given Motherwell a firm internal sense of intention that allowed him to absorb and synthesize the various and powerful outside influences to which he was being exposed. Even before he had discovered what he wanted his art to look like, he seems to have had a firm idea of what he wanted it to do. He wanted to create an art that would deal with the universal rather than the specific, yet be charged with feeling; that would be true to its medium, be quintessentially what it was physically, yet also evoke powerful reverberations beyond its mere physical appearance.

The goal of Motherwell's art, like that of Symbolist poetry, has been one of compression and condensation, of making apparently simple relationships of form and color be charged with as much feeling, and as much meaning, as possible. "I think that one's art is one's effort to wed oneself to the universe, to unify oneself through union," Motherwell wrote in 1951. "Sometimes I have an imaginary picture in my mind of the poet Mallarmé in his study late at night — changing, blotting, transferring, transforming each word and its relations with such care — and I think that the sustained energy for the travail must have come from the secret knowledge that each word was a link in the chain he was forging to bind himself to the universe. . . ."[23] More recently, Motherwell has asserted that "Painting is a means of thinking for me, but the thinking is *a priori* and has much more to do with French ideas of *correspondences.*"[24]

Possibly because his previous training had been in philosophy and he had not been exposed to the extensive art school background of most of his contemporaries, Motherwell was in

a good position to confront the ideas of modernism *per se,* without agonizing a great deal over whether to keep or abandon the figure. "I have continuously been aware that in painting, I am always dealing with, and never not, a relational structure. Which in turn makes permission 'to be abstract' no problem at all. . . . So that I could apprehend, for example, at first sight, my first abstract art. For painters with either literary or art school backgrounds, at least in my time, to make a transition from figuration to abstraction was a threatening problem. . . . I understood too that 'meaning' was the product of the relations among elements, so that I never had the then common anxiety as to whether abstract painting had a given 'meaning.'"[25] As a result, in the early 1940s Motherwell was open to, and able to synthesize, the syntactic and aesthetic possibilities of three strong but disparate styles: those of Surrealism, Mondrian, and Picasso.

From Surrealism, Motherwell developed his technique of automatism, his early vocabulary of organic forms, and his susceptibility to an aesthetic of strong personal feeling, dynamism and flux. From Mondrian he developed a sympathy for the vocabulary of rectilinear geometry and limited color, and an aesthetic of objective or "plastic" feeling. And from Picasso, especially the tough, Goyaesque Picasso of the late 1930s, he developed his own pictographic imagery and his violent subject matter of the early 1940s.

As Motherwell developed each of these modes, forging from them a personal and distinctive style, he also made significant refusals. He refused the Surrealists' deep descriptive space and anecdotal subject matter. He refused Mondrian's extreme limitations of touch, format and color. And he refused — except in his later collages, and then realized in a very different way — the Cubist space and narrative subject matter of Picasso.

What Motherwell took and built upon from these three styles is fascinating. For while they offered him a broad range of formal possibilities, they also allowed him to develop and use to his advantage powerful contradictory impulses within himself. Motherwell, both as artist and man, is a very contradictory person. He is extremely intelligent, well read, and articulate, and

he holds all three of these qualities in high esteem. At the same time, he recognizes that the true content of his art is feeling, not thought, and when he paints and draws he tries to work as intuitively as possible, giving free rein to his impulsiveness and sensuality, and to the curiously graceful clumsiness that is characteristic of his person as well as his art.

This polarity between thought and feeling, culture and individuality, historical awareness and faith in the vivid necessity of the moment, seems to underlie an enormous amount of his imagery. We have already seen how it makes itself felt in his use of color. It also seems to be a determining factor in his vocabulary of forms. Right from his earliest works, there has been a strong opposition between organic and geometric forms — at first under the influence of Surrealism and Mondrian, later reconciled into particularly Motherwellian imagery. This opposition was already manifested in his earliest mature drawings, in the 1941 "Mexican Sketchbook," where the organic held sway. But most of the oil paintings Motherwell did in 1941 — such as *The Little Spanish Prison* and *Spanish Picture with Window* — are based on an austere right-angle geometry. It was not until the mid-1940s that Motherwell began fully to master the balance between organic and geometric forms in the same picture, in the distinctive dialogue between ovoid and rectlinear forms that eventually led to the format of the small 1948 drawing that became the first *Spanish Elegy.*

Until around 1945, the imagery of Motherwell's pictures was usually figurative and linear. Even as he began to develop his characteristic oval-and-rectangle formal vocabulary, in such works as *Pancho Villa, Dead and Alive* (1943), and in the numerous watercolor and brush and pen drawings he did at that time, his subject matter and graphic manner were still clearly related to Picasso. Over the next few years, as he synthesized Picasso's influence and his imagery became more abstract, he began to think more in terms of area than of line, and to work almost exclusively in oil paint and collage. He did fewer line drawings than he had previously; the process of drawing was absorbed by the technically more complicated procedures of painting and collage.

Much of his energy in the early 1950s went into the large *Spanish Elegy* paintings that grew out of the small drawing he had done in 1948 to illustrate a poem by Harold Rosenberg. In that *Elegy* drawing, Motherwell developed the dialogue of rounded and rectilinear forms as a graphic equivalent to the chromatic polarity of black and white. This dual vocabulary of extremes eventually provided the basis for the nonspecific but highly charged iconography of the *Elegies.* It provided a consistency of syntax and a level of intensity that could be carried from canvas to canvas, while allowing for great diversity of expression in each individual canvas. The little 1948 drawing, originally done to "decorate" a poem, turned out to be Motherwell's most seminal single image, and to contain within its relatively simple forms the basis on which Motherwell would be able to construct a new pictorial poetics.

*

Motherwell's first mature drawings, as we noted, were done under Surrealist-inspired automatism, and he continued to rely on automatism to provoke his imagination and to act as what he has called "a plastic weapon with which to invent new forms."[26] Automatism was thus both a way of probing the subconscious and a way of confronting the medium itself.

By the 1950s, however, Motherwell had distanced himself from Surrealism. His post-*Elegy* automatic drawings had lost nearly all vestiges of Surrealist imagery, and he began to move toward an idiom of spontaneous brushwork and bold simple forms that appears to have been strongly influenced by Chinese and Japanese brush painting. This synthesis of psychic automatism and Oriental brush painting provided Motherwell with a way to combine several long-time pictorial concerns, and to merge his mystique of individual consciousness with a mystique of universal consciousness — to bring together his interests in Western and Eastern metaphysics, in psychoanalysis and Zen.

Once again, Motherwell was able to effect a synthesis of divergent modes. The long historical and theoretical tradition that lay behind Oriental brush painting, and its cultural exoticness, gave a new dimension to the practice of the historically recent and specifically Western mysticism of psychic automatism. It also seems to have opened him to the possibilities of drawing and painting as forms of writing. For if, in the West, the act of picture-making had been primarily descriptive, in China and Japan painting had for several centuries been a form of writing, and writing a form of picture-making.

When Motherwell began to write words, notably "*Je t'aime*," into a series of images that were themselves like a form of writing, word and pictorial utterance were brought together, each reinforcing and enlarging the other's field of meaning.

8.

The modern artist, unlike his artistic ancestors, is in a sense forced to invent his own pictorial language before he can even think about elaborating that language. He has the problem of both invention and elaboration. This is one thing that separates a modern artist from Oriental artists, who to a large degree inherited a preexisting language that they then each elaborated in a subtly different way. But there is an affinity between certain Oriental — especially Japanese Zen — painting and some of my own work. Aside from the obvious reduction of color, the predominance of black and white, and the importance of gesture, essentially it is the concept . . . of the metaphysical void. This is perhaps the strongest in the Opens, built on a conception analogous to the Oriental conception of the absolute void: that you start with empty space, and that the subject is that which animates the great space, the void. The amazing discovery is that it takes relatively little to animate the absolute void. For example, if you are sitting by a flagstone pathway staring at the path as an ant comes along dragging a piece of something, and you begin to focus on it and watch it struggling along up and down a blade of grass in a crack, or moving this way and that, but always keeping more or less in the direction it is headed in, you realize that one little ant is animating everything around you: the surrounding lawn, the birds in the sky, the nearby pond, and all the rest. That single little ant (if you regard all those other spaces as the void, as the background to the ant's activities) is animating the world. More, the Orientals lead you to discover that the void is beautiful in itself.

Another thing I absorbed from Oriental art is the crucial role of viscosity in painting. Oriental painting is done with ink, often with rare inks, a hundred or two hundred years old. The inks come in hard bars, and you mix, by disintegrating them in water to various degrees of darkness and lightness, so that the consistency of the ink when it is right is crucial, like the difference between a store-bought violin and a Stradivarius.

Third, and probably most importantly in actual practice, is calligraphy in the sense of the hand taking off by itself, so to speak. You learn from Japanese calligraphy to let the hand take over: then you begin to watch the hand as though it is not yours, but as though it is someone else's hand, and begin to look at it critically. I find myself making it jump more, or making it become more rhythmic or making it drive off the edge at a certain moment; that is a whole different way of drawing compared to looking at something and marking its shapes down. More like training yourself to play the violin. It becomes a kind of critical self-analysis, of how your body is functioning in relation to a plane surface. That is where viscosity becomes so crucial. If the medium is thick and you want to move quickly, it will not move quickly enough — it will be too inert. If the medium is too thin, it will drip, or run. But if it is exactly right, my hand just flies and I do not even have to think; my hand just does it, as though I am not there. The instant the viscosity is wrong, it is like a death battle with a snake — touch and go as to whether it is going to poison me or I am finally going to be able to get it by the neck and tear its head off. When the viscosity is right, it is close to (as the Orientals are always trying to express) mindlessness, or to pure essences, with nothing between your beingness and the external world. As though your beingness were transmitted without intervention; so that you think of the hand as not being yours. It is more what you unconsciously know than what you think. In fact, I would say that most good painters don't know what they think until they paint it.

In Western art, the central concerns have been different, essentially iconographic, and of course have exerted a tremendous influence on me, especially in the Elegies. Western artists, instead of thinking of an absolute void, think in terms of so-called "positive" and "negative" space. The art of drawing in the European tradition — or the art of composition — is that the negative and positive spaces be equally well shaped. There Piero della Francesca is in a class by himself. Nobody has even come close to him. Not even Cézanne. He is inexhaustible. His organization is so implacably there, and yet not over-emphasized. His color, his spatial sense, his enigmatic figures — he has so many stunning conceptions organized together that its effect is ultimate mystery, as unbelievably complex and moving as Mozart's last Requiem Mass.[27]

9.

Nowhere is Motherwell's concern with placement more clearly demonstrated than in the collages that he has been making since 1943, when Peggy Guggenheim invited him to submit work for a collage show at the "Art of this Century" gallery. Since then, collage has played an important role in his development and his collages form a major part of his oeuvre.

For Motherwell, the process of making collages has always been associated with directness and discovery. In a sense, the collage process has been a kind of complement to the "psychic automatism" from which many of his paintings and drawings have been generated. In the process of automatic drawing, the artist discovers new forms by allowing his hand free play, calling forth images and feelings that exist below the level of consciousness. It is a way, among other things, of inviting the unexpected. In the collage medium, Motherwell seeks similar

ends through nearly opposite means. In making collages, the unexpected comes from without rather than from within. Instead of engaging in the essentially interior monologue that is characteristic of most abstract painting, the artist interacts directly with the outside world, incorporating fragments of it in the picture: scraps of paper, labels, envelopes, wrappers, tickets, sheets of music, and pages from books.

In collages, these products of the real world are used in somewhat the same way that nature was used by traditional artists, as an outside referent that can be incorporated into the picture. But in collage, the process of incorporation is very different. Instead of depicting nature within the picture, parts of nature are literally picked up from outside the picture and recontextualized within it. These parts of nature, moreover, are not "natural." They are man-made, and for the most part they are industrially manufactured rather than hand-made objects. The medium of collage is thus very much an industrial medium, an extension of the world of mass-produced, consumable objects; something like the opposite of the art objects into which they are put. This contradiction was apparent in the first collages that Picasso and Braque did in 1912 and it still contributes to the tension that one feels in virtually all collages between what is one of the most recondite forms of "high art" and the stuff of the street.

The collage medium, in fact, seems to be (among other things) a means of symbolically dominating and personalizing the external world, by personalizing the impersonal detritus of industrialized production. It is also a way of dominating the passage of real things through time. In collages we always have the sense that the things that have been glued into (or onto) the composition were not only manufactured for some other reason but have already actually been used for something else. This gives them the sense that they have of being fragmentary remainders, and reminders, of the passage of time — tangible evidence not only of past experience but of the very notion of passing time. (Small wonder that collage was invented around the same time that Proust was describing the effect of the "*petites madeleines*" and the cup of tea, a striking instance of time recaptured through the presence of concrete objects.) Since visual imagery exists in space and can only *imply* time (unlike music and poetry, which actually *take* time to be heard or read), these tokens of the past are understood as implicit symbols of the presence of time itself.

Motherwell's collages seem to occupy a somewhat different territory from his paintings in a metaphysical as well as in a physical way. The imagery in his paintings — despite the use of certain universal forms and the by-now familiar formats that they frequently employ — is essentially quite subjective. Moreover, because of their generally somber mood, the paintings often seem to question the whole nature of existence, and seem themselves to exist at the edge of a void or an abyss. His collages, on the other hand, affirm the existence of the real world and of the artist's having passed through it. And in so doing, they seem to affirm the notion that something like an objective reality might also exist.

Collage also plays another important role in Motherwell's artistic consciousness. Not only does it allow him to give free rein to his highly developed sense of placement and his love of ellipsis, it is also associated with high modernism, and more than once Motherwell has described it as a quintessentially modern medium. The disjunctive quality of collage, the way it takes disparate elements — some from the real world, some

clearly artificial — and places them in a flagrantly artificial world, seems typical, even emblematic, of the range of experiences we associate with modern life. It is as if there is something about the disjunctive, contradictory quality of modern life that positively demands such radically disruptive pictorial means; as if the structure of the one becomes a metaphor for the other. Or, perhaps more accurately, it is as if the metaphor for the one becomes a necessity within the structure of the other. This quality of discontinuity is in many ways the most quintessentially modern aspect of modern life, and also of modern art. For Motherwell, it seems to typify the ethos and the experience of the modern world.

Motherwell's later collages also provide a field of response for his interest in the Cubist collages of Picasso and Braque and the late cutouts of Matisse. And here it is interesting to see how the complexity of Motherwell's response to earlier art results in images that at once pay homage to that art and resist and transform it. Although the language that he employs in most of the collages takes its point of departure from Cubist collage, especially in its rectilinear geometrical structure, Motherwell's collages look quite different from Cubist collages. They are for the most part more densely filled, and they tend to employ brighter and more opaque colors, as do Matisse's cutouts. Furthermore, although the arabesque-like curve is more or less proscribed in Cubist collage, Motherwell sometimes uses arabesque-like curvilinear movements of the sort that we sometimes see in Matisse's cutouts, but usually set within a rectilinear structure that grows out of Cubism.

Moreover, while the Cubist collages of Picasso and Braque are more like drawings than paintings, often employing large areas of blank paper as background and usually confining handmade marks to lines, Motherwell's collages are almost always more like paintings. They are pictorially very dense and in them painterly gestures are often combined with the pieces of cut and torn paper.

Even when Motherwell uses only cut or torn paper in his collages, with little or no painting or drawing around them, they frequently have a rich painterly effect because of their pictorial density. This is strikingly apparent in the *Night Music* collages done in 1988, in which the paper surfaces are somehow made as rich and sensuous as the densely worked surfaces of Motherwell's paintings.

Because of their pictorial and referential richness, Motherwell's collages are engaged with "representation" on several levels. A collage *represents,* in the sense of depicting, because the collage elements that it contains are also in a sense depicted within the composition. A collage also involves, by definition, the *re*-presentation of things (in the sense of presenting again, or presenting in a new way). This in turn is related to the notion of re-*presenting,* in the sense of presenting things in a different context. And in re-*presenting* things, a collage is also involved in *represent*-ing things, in the sense that the pieces that are glued into the composition sometimes stand for things other than their literal selves. A page of a musical score, for example, is also understood as representing music; a cigarette wrapper, or the label from a wine bottle, as representing what the package or bottle contained. There is implied in this whole process a nuanced range of mental illusionism that is endlessly intriguing and that makes us rethink our relationships to the very notion of "representation."

Moreover, since the fragments of things in collages tend to function synecdochically, in that they suggest the wholes of which

they are parts, their further fragmentation can also be used to create strong pictorial and psychological dissonances. In a work like *Cantata XIII* (1980), the fragments of the drawing around the music suggest broken-off melodies, and lost wholenesses, somewhat in the way that Beethoven exploits a similar interruption of melodic expectation in the Opus 59 "Rasumovsky" quartets. This "expressionistic" aspect of Motherwell's collages is one of their greatest strengths. As in his other work in other mediums, it is indicative of the non-categorical, "open" quality of so much of his imagery.

10.

Delacroix said that nature is a dictionary — by which he meant all of the world, from nudes or landscapes or violent animals to still-life. There is a whole vocabulary in nature; all you have to do is look and you will find it. I would say that, in that sense, I do not look at nature very much. The part of my vocabulary that is not from inner pressure, but that is drawn from the external world, is from the social world. To pick up a cigarette wrapper or wine label or an old letter or the end of a carton is my way of dealing with those things that do not originate in me, in my I. Max Ernst once told me that his father, who was a Sunday painter, liked to paint the courtyard of his house. The courtyard had a tree in the middle, and the father always had difficulty with the damned tree; everything else he did in the picture satisfied him, but not the tree. Finally one day he went out and cut the tree down, so that it would not interfere with his composition. I think collage works so. Instead of having to fuss with drawing things and reworking and changing them, you pick up objects that are in the room and simply put them in the picture — or take them out — whatever you like. Collage is both placing and ellipsis.

Most of the papers I use in my collages are random. Even the sheet music. In fact, I don't read music. I look at printed music as calligraphy, as beautiful details. I do not smoke Gauloise cigarettes, but that particular blue of the label happens to attract me, so I possess it. Moreover, the collages are a kind of private diary — a privately coded diary, not made with an actual autobiographical intention, but one that functions in an associative way for me, like Proust's madeleine. For a painter as abstract as myself, the collages offer a way of incorporating bits of the everyday world into pictures. Some of my collages make past years and places in all their concreteness arise in my mind in a manner that the paintings do not: the paintings are more timeless.[28]

11.

Theoretically, an abstract painter has complete freedom in the choice of his forms and themes, in that he is not bound by the appearances of the outside world or by fixed iconographic conventions. But in fact, the inner world imposes its own limits, and those limits, in their way, are as strong as those of the outer world. They remind us that although we are capable of considering many different possibilities and versions of self, we are in fact firmly bound within a single self and within a relatively narrow set of possibilities — physical, temporal, and psychological. No one knows this better than a serious artist.

Moreover, abstract imagery does not spring forth only from inside an individual but involves a series of dialogues: with other art, with literature, and even with the outside world. "Every intelligent painter carries the whole culture of modern painting in his head," Motherwell has written. "It is his real subject, of which everything he paints is both an homage and a *critique*, and everything he says a gloss."[29]

A paradigm of abstract imagery, especially for artists of Motherwell's generation, is Piet Mondrian. Mondrian is also an excellent example of an artist whose development seems to follow a kind of straight-line organic growth. It is relatively easy to discuss his works in terms of rather specific periods of time. We can speak, for example, of a 1912 Mondrian, a 1914 Mondrian, a 1922 Mondrian, or a 1935 Mondrian, and the types of images to which we are referring will be well understood by anyone who knows Mondrian's work reasonably well. The time at which a picture was done marks a specific point within the evolution of the pictorial language and conjures up specific kinds of images. In Mondrian's work, moreover, this development has to do with a gradual process of reduction or taking away — a process that is in fact one of the definitions of the word "to abstract": to take away from, to remove, to select.

One aspect of modernist painting which differentiates it most clearly from traditional painting is that modernist painting has been conceived of primarily as a philosophical endeavor rather than as a means of description. To the modernist artist, painting is a cognitive act, a way of knowing, a search for forms that are adequate to express feelings about new perceptions, new insights, new knowledge.

Mondrian, for example, saw his painting as a way of knowing ultimate reality, based on concepts of dynamic equilibrium that in some way accorded with the forces that underlay the surface appearances of true reality. For Mondrian, painting was a way of imaging true reality by creating concrete metaphors for the forces that underlay the creation and maintenance of the universe. In a way, his subject matter was not so different from Michelangelo's depiction of the Creation of the Universe on the ceiling of the Sistine Chapel. Except that Mondrian rejected the traditional means of metaphor, which employed anthropomorphic depiction of events that stood for abstract forces. "It is my conviction," Mondrian wrote in 1941, "that humanity, after centuries of culture, can accelerate its progress through the acquisition of a truer vision of reality. Plastic art discloses what science has discovered: *that time and subjective vision veil the true reality.*"[30]

To the twentieth-century mind, which has been so deeply engaged with the analysis of the abstract, often invisible forces that make up the universe, the anthropomorphic representation of abstract forces has come to lack conviction. At a time in history when so much thought and energy have been dedicated to inventing abstract systems for expressing and manipulating knowledge — from atomic theory to computer systems — the notion of representing God in the manner of Michelangelo, as an old man with a white beard flying through the air, is no longer viable, even though the basic spiritual concerns that underlie such representations are still compelling to artists. One of the central undertakings of modernist image-making has been to find abstract pictorial equivalents for ideas that earlier had been acted out through narrative subjects embodied in anthropomorphic imagery.

One of the new possibilities offered by early modernist art was that of a metaphysical language based on form alone, embodied

in a pictorial language that would parallel rather than imitate the natural world. And crucial to this notion of re-presenting the world in an abstract language was the closely related notion of *absenting* the subject matter of painting.

This process of absenting, of moving the subject matter of painting away from the arena of description, was a central concern of the most advanced painting at the beginning of the twentieth century. The process itself seems first to have been worked out in Picasso's paintings around 1910, but is even more clearly seen in a painting like his *Ma Jolie* of 1911–12, in which the process of absenting seems indeed to be the central theme of the picture.

In this painting, one senses the presence of a subject — as suggested in the title, *ma jolie,* "my pretty one" — but the subject itself is provocatively "missing" from the picture. In fact, there is a kind of reversal here of the whole process by which a picture traditionally conveys information about its subject. In the Picasso painting, it is the title, *Ma Jolie,* inscribed at the bottom of the picture, rather than the image itself, that tells us what the painting is about. This is an amusing and ironic reversal of the old saying about a picture being worth a thousand words, since what we are given here are two words that are much more *descriptive* than the rest of the picture, though not more *expressive.*

A picture like this is a kind of paradigm of the act of absenting — the beginning of a process of abstraction and reduction that seems to have come to painting via the poetry of Mallarmé and which artists of Motherwell's generation inherited from the early modernists. Moreover, Motherwell himself seems to have been very much aware of the implications of this process right from the beginning of his maturity as a painter. As has been noted, Motherwell's early paintings were different from those of his contemporaries in that he had come to painting through his interest in poetry and philosophy. When he decided to become a painter, he did not have an extended realistic or naturalistic phase to put behind him, and the problem of abstracting was not problematical to him in the way that it was to many of his contemporaries — that is, in terms of the question as to whether "one should be abstract or not."

Equally important, the different manners of handling abstract form — such as the opposition between the coolly rendered strict geometry of Mondrian and the expressively rendered biomorphic forms of early Kandinsky — did not present a conundrum to Motherwell either, because of his intense focus on the structural relationships that underlay the invention of abstract forms.

This seems to be one of the factors behind the surprising originality of Motherwell's early works, such as *The Little Spanish Prison* (1941), or *Pancho Villa, Dead and Alive* (1943). In *The Little Spanish Prison,* the influence of Mondrian is felt quite strongly. But at the same time, one senses a strong resistance to Mondrian, what Motherwell later characterized as his "effort to come to terms with Mondrian but still keep Picasso's hand-made sensibility, so the lines are handmade and drawn. . . . It was to make Mondrian sensuous and sinuous."[31]

This notion of resistance is particularly important in considering Motherwell's work of the 1940s. During his formative years, Motherwell was profoundly impressed by a number of artists — most especially Mondrian, Picasso, Miró, Matisse, and the Surrealists — who exerted varying degrees of influence upon his development. But at the same time that Motherwell engaged himself with and took from these other artists, he also resisted them. In *The Little Spanish Prison,* as we have seen, the dominant influence was obviously Mondrian, but Mondrian

tempered by Picasso, among others. In effect, what Motherwell has done with Mondrian here has been to "misread" him for his own purposes. For though *The Little Spanish Prison* is a kind of homage to Mondrian, the painting is more remarkable for the ways in which it differs from Mondrian than in the ways in which it resembles him. Even the compositional format is quite different from Mondrian, as is the sense of touch and surface.

Moreover, in this painting we also see in nascent form many of the qualities that will characterize Motherwell's later work. There is already present the somewhat awkward gracefulness that will characterize so much of his later work, and also a theme that will be a persistent one in his later work, that of confinement and of struggle. It is expressed here in the relationship between the pale, bar-like vertical field of yellow and white, and the horizontal red form that seems to struggle against that field chromatically as well as in terms of its orientation and position within the picture. As in many of Motherwell's later pictures, this is a dramatic painting, but the drama is acted out by form rather than in terms of a narrative subject.

In *Pancho Villa, Dead and Alive,* Motherwell is also engaged with a kind of trope on an early modernist style, in this case, the linear style that Picasso had evolved during the late 1920s and which is so well articulated in his 1930 *Crucifixion.* Yet at the same time, the inspiration for *Pancho Villa, Dead and Alive* is more complex than that. In fact, the specific image seems to have been inspired by a photograph of the assassinated Mexican revolutionary's body riddled with bullet holes, and there is a kind of narrative content set forth in a condensed way between Pancho Villa alive and whole, and the dead and disfigured Pancho Villa riddled with bullet holes. "I was fascinated not only with Mexican popular folk art," Motherwell later said when discussing this painting, "but also with Posada and Anita Brenner's fabulous book of photographs of the Mexican Revolution, called *The Wind Swept Over Mexico.* One picture showed Pancho Villa after he was shot, spread out — sprawled out, really — in a Model T, covered with blood."[32]

The painting thus goes beyond purely artistic sources for both its subject and its style (and to a large degree absents its subject by transforming it into a suggestive ensemble of abstract symbols). And even in the matter of artistic precedents, one senses the presence of Miró as well as of Picasso. What we seem to be dealing with here — as in so many cases of artistic "influence" — is the definition of a strong artistic ego (quite literally, a sense of "I"-ness or self) through interaction with other strong artistic egos.

Equally interesting is the way Motherwell resisted the artists whom he admired and by whom he was influenced — the ways in which Motherwell's artistic ego defined (and defended) itself by emphasizing the ways in which it was different from that of an artist like Picasso, despite the allusions to and similarities with the Spanish master's work.

In fact, this seems to be true in virtually all cases of artistic influence, though in this instance Motherwell offers himself as a particularly interesting individual case. For although the word "influence" is commonly used in a general way when discussing the interactions between the work of different artists, in fact there are many different kinds of interaction — hence, many different kinds of "influence." There is the sort of passive influence in which an artist absorbs ideas from another artist almost against his own will, and there is a more active kind of influence in which an artist is inspired by another artist and consciously goes after what the earlier artist has to offer *uniquely to him in particular,*

thus transforming the earlier artist's work at the same time that it is being absorbed — what the critic Harold Bloom has referred to as a "strong misreading" of another artist's work.[33]

These notions of simultaneous acceptance and resistance are especially important when dealing with abstract images, the source of which is largely internal, or specifically rooted in its dialogue with earlier art — in what Motherwell referred to as "the whole culture of modern painting" that the artist carries around in his head. (And here, it should be noted, it is precisely this rich painting culture that the informed viewer and the artist have in common. In fact, when dealing with modern art, this shared painting culture serves a function similar to that of literature in traditional painting: it is the common reference point in relation to which the meaning and resonance of individual pictures is mediated and enhanced.)

In this light it is evident that resistance to the art of the past, which is so crucial to the definition of self, especially in abstract art where that natural world is largely excluded, also leads to the idea of defining the artistic self, or in any case the concrete products of the artistic self, through the idea of artistic antithesis. If, as Motherwell has affirmed, the continuity of the modernist tradition underlies so much later modernist art, then it also has to be recognized that when artists respond to earlier work by other artists they often do so in what might be called an *antithetical* fashion; that is, by responding in a way that not only goes against what they see in the work of the earlier artist but which builds meaning on that opposition. *Pancho Villa, Dead and Alive* seems to have this kind of antithetical relationship to works like Picasso's 1930 *Crucifixion,* or to his *Artist's Studio* of 1927–28.

During this Picassoesque phase of Motherwell's art, moreover, he was also very much aware of the possibilities offered to him by other artists, in particular Miró and Matisse. This melding together of different pictorial possibilities through a combination of eclecticism and resistance can be seen particularly well in Motherwell's *Mallarmé's Swan* (1947). If we compare *Mallarmé's Swan* with *Pancho Villa, Dead and Alive* we realize that their basic vocabulary is actually quite similar: each is based upon a dialogue of rectangular and ovoid forms played against each other in a kind of counterpoint, and each combines painting and collage. Unlike *Pancho Villa, Dead and Alive,* however, *Mallarmé's Swan* has no narrative content. Instead, the image is evocative but is not quite graspable; one cannot really pin it down as one can with *Pancho Villa, Dead and Alive* in terms of a specific subject matter.

In fact, even the title of this painting was chosen somewhat arbitrarily, and the reference to Mallarmé, himself a master of ambiguity and nuance, actually serves to reinforce the ambiguity of the picture.[34] Motherwell, paraphrasing Odilon Redon, has remarked that works like this, "place us, as does music, in the ambiguous realm of the undetermined, they are a kind of metaphor."[35] Not a specific, precisely determined metaphor, but "a kind of metaphor."

The sense of metaphor in this case is also enhanced by a reference to Matisse's *Piano Lesson* of 1916, which was put on view in the lobby of the Museum of Modern Art in 1946. What the Motherwell and the Matisse have in common is fairly obvious when they are directly compared: the use of the cool greyish ground; the general warm-cool color harmony; the way in which the forms seem to be suspended from the top of the canvas; and the extreme verticality of each composition. Here again, however, Motherwell has not only absorbed Matisse, but has in a sense moved against him, and in a very interesting way.

Unlike the *Piano Lesson,* in which abstraction and description are set off against each other, *Mallarmé's Swan* is a completely abstract painting, in which there are no recognizable objects, despite the evocative title. Moreover, in *Mallarmé's Swan* there are other clear signs of resistance against the ordered and the known. One of the most striking of these is seen in the way that Motherwell tropes the horizontal area that contains the arabesques of the grillwork in the Matisse painting, which can be read metaphorically as the sound of the music coming from the piano. In *Mallarmé's Swan,* Motherwell also reserves a small horizontal area in the lower part of the painting for irregular forms: the areas of splashed paint are a kind of answer to the arabesques in the *Piano Lesson.* The formal contrast between the large, flat, rectilinear — and predominantly vertical — areas of the painting, and the smaller, curving forms of the grillwork (in the Matisse) and the splashes (in the Motherwell) is quite striking. But although the grillwork and the splashes have similar structural functions within each painting, they of course represent very different kinds of marking systems. The arabesques of the grillwork are controlled and ordered, whereas the splashes are purposely random — splashed within their horizontal rectangle in a manner that recalls the modulated randomness of Mallarmé's *Un coup de dés.* Hence, Motherwell's response to Matisse's painting is in part an antithetical one — playing the random against the determined and the ambiguous against the specific, the abstract against the representational.

This kind of dialogue with the early modernist masters is particularly intense in Motherwell's work around 1947–48. We see it in both the *Homely Protestant* (1947) and the *Homely Protestant Bust* (1947–48), in which a suggestion of a figure is articulated with simple geometrical drawing and in a muted, ocher-dominated color harmony that recalls Picasso's Cubist paintings, such as *Ma Jolie.* Even the way in which the paint is applied here — in a densely applied but tender, lyrical way — is reminiscent of Picasso's Analytic Cubism. And, in fact, the brushstroke and the surface texture of the painting carry its expressive meaning in a way that uses the Picasso paintings that the viewer carries in his mind as points of reference — as a series of allusions that enrich the meaning of the image, just as the dense allusive structure of T.S. Eliot's poetry enriches and intensifies our experience of it.

Eliot, in fact, also serves as an excellent example of antithetical allusion, in that the allusions he uses often create specific antitheses, in which the harshness of the modern world is ironically contrasted with the harmony and order of the past. The famous passage in *The Wasteland* that alludes to Andrew Marvell's *To His Coy Mistress* is a good example of this. Eliot's lines,

> But at my back from time to time I hear
> The sounds of horns and motors which shall bring

directly echo a couplet in the Marvell poem:

> But at my back I always hear
> Time's wingèd chariot hurrying near;

But Eliot's couplet purposely "disappoints" the reader, by failing to deliver the expected rhyme and by reducing the grandiose image of Pheobus's chariot to the sounds of traffic in a modern city — by substituting dissonance for harmony.

A similar device has frequently been used in modern paintings, at least since Manet. The allusions to Titian's *Venus of Urbino* in Manet's *Olympia*, or to Goya's *Third of May 1808* in Manet's *Execution of the Emperor Maximilian* are similarly antithetical allusions, in which the virtues and moral clarity presented in the earlier paintings are contrasted with the much more ambiguous moral terms of the historical present — a matter that we shall return to shortly.

*

At the same time that Motherwell was absorbing and responding to the imagery of the early modernists, he was also moving toward the diversity of image that would characterize his later work. In the pictures we have discussed so far, we have seen the ways in which Motherwell experimented with different pictorial languages in order to evoke different kinds of feeling. In doing this, Motherwell seems to have been reacting against the straight-line organic model of development exemplified by Mondrian and to be following instead the model of stylistic variety that was associated with Picasso, who also worked in many different modes, sometimes in quite divergent modes at the same time, as evidenced in his much-discussed alternation between Cubist and Classicizing manners during the 1920s.

Picasso also provided Motherwell with a living embodiment of the "Spanishness" that so excited his imagination. As we have seen, several of Motherwell's strongest early images had either Spanish or Mexican themes and titles, which served him as an emotional point of reference. A particularly interesting painting in this context is *Viva* (1946), which appears to be the first picture in which Motherwell used an actual written word as an integral part of the composition. The word itself is not only Spanish but is quite literally half of the life-death opposition that Motherwell associated with things Spanish: *Viva*: Live. The word here is forcefully integrated into the formal structure of the picture. The aggressive way that the angular forms of the letters erupt across the surface evokes a kind of imploring — almost as if the artist is imploring *himself* to live, to choose life over death. And this, it seems, relates to one of the underlying themes of Motherwell's most famous series of images, the *Elegies to the Spanish Republic,* which were begun a year or so after *Viva*.

12.

The *Elegy* series is one of Motherwell's most ambitious undertakings, and its black and white, oval and rectangle format has come to serve almost as a kind of signature for him — in the sense that these are the images that first come to mind when one thinks of his work, even though the *Elegies* represent only a relatively small part of his entire output.[36] Nowhere else in his oeuvre has he created such large and complex pictures based on a relatively fixed vocabulary of what almost always remain relatively simple, basic forms.

The formal title of the series is *Elegies to the Spanish Republic,* though as we have seen, Motherwell's intention in them has not been to evoke a specific political situation so much as to use the tragedy of the Spanish Republic as emblematic of the idea of tragedy in our time. The *Elegy* paintings, though not necessarily concerned directly with the Spanish Republic, are nonetheless always elegiac in tone and tragic in feeling, and convey what Motherwell has often characterized as a particularly

"Spanish" range of emotion: the tragic sense of pride and passion suggested in *cante jondo,* in the spectacle of the *corrida,* and in the notion of *duende.*

"Motherwell," as Dore Ashton has written, "is an expressionist in its most simple connotation, but one who knows the corrective of geometry and measure. There is in him the *grito* (cry) of pain and of pleasure. . . . He strains to expel the blackest of sounds, but also the trill."[37] And nowhere in Motherwell's oeuvre is the cry of pain stronger, blacker, more personal — and yet more universalized — than in the *Spanish Elegies*.

The *Elegies,* perhaps even more than Motherwell's other work, also involve a complex system of allusions. They refer, as we have noted earlier, in a very evocative way to numerous forms in the real world, and they also make powerful, though indirect, literary allusions. In fact, the evolution of the *Elegies* is intimately related to Motherwell's interest in poetry, and Spanish poetry in particular.

The format of the *Elegies* was developed in a small drawing in ink on paper, now known as *Ink Sketch, Elegy No. 1,* which Motherwell did in 1948 as an illustration, or decoration — or what he himself has called an "illumination" — intended for publication in the second issue of the revue *Possibilities,* of a poem by Harold Rosenberg, entitled "The Bird for Every Bird." The limitation of the color scheme to black and white was originally necessitated by the economics of printing *Possibilities*. The idea of mixing handwriting with drawing seems to have been inspired by Motherwell's interest in the French revue *Verve,* especially in the elaborately illustrated Matisse issue, "De la Couleur," published in 1945.

The notion of "illustrating" a poem without directly illustrating any of the images that appear in it had its basis in the Symbolist principle of *correspondance,* in which Motherwell was already deeply interested. Motherwell himself, when asked about the relationship between his image and the poem, has said, "It has literally nothing to do with the poem — except perhaps for their both having brutal qualities — certainly not its images. . . . Certain critics [for example] have read the phrase 'wire in my neck' as being described by the lines between the ovals. No wire or neck is there."[38]

As it turned out, the second issue of *Possibilities* did not appear and for a time the sketch with the poem was more or less forgotten by the artist. About a year later, however, Motherwell came across it again and decided to rework the image in casein, without any words. The resulting image, *At Five in the Afternoon,* also had a poem behind it, this time a poem by Federico García Lorca, the great Spanish poet who had been killed during the Spanish Civil War. This poem was the powerful "Llanto por Ignacio Sánchez Mejías," a lament — in a sense, an elegy — for a bullfighter killed in the ring.

The relationship between this poem and Motherwell's painting is extremely interesting and reveals a good deal about the way Motherwell makes associations. According to Motherwell, when he began *At Five in the Afternoon* he did not have the Lorca poem specifically in mind. But he was immersed in Lorca's poetry at the time and when he finished the painting the refrain from the Lorca poem seemed to him an appropriate and evocative title. Speaking of the relationship between the pen and ink sketch and the casein painting, Motherwell has said, "When I painted the larger version — *At Five in the Afternoon* — it was as if I discovered it [the image] was a temple, where Harold's [the *Possibilities* illustration] was a gazebo, so to speak. And when I recognized this, I looked around for whom represented

what the temple should be consecrated to, and that was represented in the work of Lorca. . . . To be more concise the 'temple' was consecrated to a Spanish sense of death, which I got most of from Lorca, but from other sources as well — my Mexican wife, bullfights, travel in Mexico, documentary photographs of the Mexican revolution, Goya, Santos, dark Hispanic interiors.''[39]

Originally then, the painting was meant neither as an illustration of the Lorca poem nor as a visual equivalent to it. But by referring to the poem in the title of the painting, Motherwell has evoked a whole network of allusions that do enrich our viewing of the painting — by connecting us specifically to the emotional tissue of the poem and by bringing to the fore specific qualities inherent in the painting.

In other words, it is possible to ''decode'' this painting in ways that go beyond the conscious way that the forms of the painting were originally ''encoded.'' And in fact, by giving the painting such an allusive title, Motherwell has to some degree begun the process of ''decoding'' himself. For any system of allusions is, among other things, an aid to decoding, or in any event the indication of a direction in which decoding can proceed.

This, I think, is a central issue in the interpretation of modern art in general, and Motherwell's work provides a particularly fruitful instance of it. The viewer or reader of a work is to some degree always involved in a process of decoding; but what the viewer decodes in a given work will not always be exactly the same as what has been intentionally encoded by the artist. This open-ended process of interpretive decoding is at the very core of symbolist practice. The ineffable quality of the truly effective symbol is a function of its complexity, in the sense of presenting virtually limitless possibilities for decoding — which is why the truly effective symbol *must* offer more possibilities for decoding than could possibly have been consciously encoded in it.

Part of this process of decoding depends on our capacity to understand things — and forms — metaphorically. And part of this process also depends on our willingness to understand that certain kinds of decoding, contradictory as they may seem, can be complementary to each other. To be sure, there are what we might call stronger and weaker ways of decoding, just as there are stronger and weaker works of art. In fact, it seems that one of the characteristics of a strong work of art is that it supports, and at times even invites, contrary decodings or interpretations.

These issues are particularly germane to Motherwell's *Elegies,* which have been interpreted quite variously, in decodings which include reading the forms literally as an arcane form of the artist's signature, or as phallic symbols, or as functioning as architectural or musical elements.[40] As has been remarked earlier, a good case can be made for many of these readings, but none of them can be proposed as *the* preferred reading of the paintings. For part of the effectiveness of the *Elegies* lies precisely in the fact that in them Motherwell has invented a kind of archetypal image which is extremely rich in suggestions and overtones — which functions precisely as a symbol should: inviting, but in the last analysis successfully defying, rational interpretation. True symbols come from and speak to the unconscious mind, are based on unpredictable relationships and are ineffable, and they are intuited through our apprehension of them in the particular medium in which they are embodied. While the creation of such symbols is non-rational, the means of analyzing them are always grounded in rational discourse and therefore always fall short of encompassing the symbol. One can point to such a symbol, one can describe it, situate it

biographically or historically, and one can attempt to analyze how it works — but all of these processes speak around the symbol, which by its very nature and definition is too fine and too complex to be caught in any such analytical net.

But since these are the only tools available to us, we persist, not because we think we shall ever be able to explain it all, but because we hope to be able to explain some of it, to make a start at explanation, to point the viewer toward the possibilities inherent in the images that are being discussed.

And so we return to the Lorca poem, noting that the part of the poem which seems most to have impressed Motherwell, and the part on which he based his title, was the opening section, ''La cogida y la muerte,'' with its repeated refrain of the time that the matador was killed, ''*a las cinco de la tarde*'' (''at five in the afternoon''). In fact, this phrase or some variation of it is repeated no less than twenty-eight times in the fifty-two lines of the first section of the poem, recurring like a repeated drumroll or like a chord strummed repeatedly on a guitar:

> A las cinco de la tarde.
> Eran las cinco en punto de la tarde.
> Un niño trajo la blanca sábana
> *a las cinco de la tarde*.
> Una espuerta de cal ya prevenida
> *a las cinco de la tarde*.
> Lo demás era muerte y sólo muerte
> *a las cinco de la tarde*.
>
> Las heridas quemaban como soles
> *a las cinco de la tarde,*
> y el gentío rompía las ventanas
> *a las cinco de la tarde*.
> A las cinco de la tarde.
> ¡Ay, qué terribles cinco de la tarde!
> ¡Eran las cinco en todos los relojes!
> ¡Eran las cinco en sombra de la tarde!

> (At five in the afternoon.
> It was exactly five in the afternoon.
> A boy brought the white sheet
> *at five in the afternoon*.
> A frail of lime ready prepared
> *at five in the afternoon*.
> The rest was death, and death alone
> *at five in the afternoon*.
>
> The wounds were burning like suns
> *at five in the afternoon*.
> and the crowd was breaking the windows
> *at five in the afternoon*.
> At five in the afternoon.
> Ah, that fatal five in the afternoon!
> It was five by all the clocks!
> It was five in the shade of the afternoon!)

The most striking parallel between the painting and the poem is the sense of intense, ineluctable repetition — although upon close examination, we realize that the painting gives a much

greater impression of repetition than it actually contains physically. We are also struck by the starkness of the forms and of the black and white format — which in this first true *Elegy*, as in many of the later ones, was originally modified by the presence of another color, in this case a blue that the artist later painted over, and of which only traces now remain. But even more striking is the psychological effect that the painting has on us, the sense of strong passion austerely expressed — a sense of passion, and a voice that is so much like the passionate voice of the Lorca poem — what Motherwell later characterized as an existential "trial of nerves, a running the gauntlet" that he felt was especially Spanish and that was most closely approached in Lorca's poem.[41]

The poem then was taken as a paradigm of a certain kind of cadence and feeling, and the allusion to it was meant to point the viewer in the direction of a "Spanish" tragedy, of the kind that would be used more formulaically in the *Elegies* proper. The next painting in the generic *Elegy* series was entitled *Granada* (1948–49), after the city in which Lorca was killed, and was much larger than the first two *Elegy* images. During the next year or so, Motherwell worked with the format on a scale considerably larger than that which he had worked on before, maintaining the Spanish identity of the series with titles such as *Spanish Drum Roll, Sevilla, Málaga, Madrid, Barcelona,* and *Catalonia*. It was not until his exhibition at the Samuel Kootz Gallery toward the end of 1950 that Motherwell first gave the paintings in the series the collective title "Elegies to the Spanish Republic."

One of the most interesting things about Motherwell's *Elegies* is the way they develop away from the personal to the public. In *At Five in the Afternoon,* the subject matter was in a sense absented from the painting by the reference to a specific poem. That is to say that the painting was in effect given a subject after the fact, but a subject that lay outside the painting, unlike *Ink Sketch, Elegy No. 1,* in which the poem was part of the picture itself.

Most crucially, this was the moment at which Motherwell invented his own pictorial language.

Of course from our present perspective we can see that the elements of this invention were there at least as early as 1943, in the oval and rectangle format of *Pancho Villa, Dead and Alive.* In *At Five in the Afternoon* this format is transformed in a way that is not dissimilar to the transformation of the pictorial vocabulary of *Pancho Villa, Dead and Alive* in relation to Picasso paintings that inspired it. Which is to say that in the first *Elegies* there was a kind of troping, a kind of absorption, resistance, and reabsorption by Motherwell of his own imagery, which in the *Elegy* format becomes more refined, more personalized, and more structurally independent of any specific embodiment of it.

After Motherwell's discovery of the *Elegy* format, he was able to adapt it to a number of different kinds of images, as in the *The Voyage* (1949). Here he makes the same pictorial language move across the picture in such a way as to suggest both a physical voyage and a spiritual quest, similar to that suggested in Baudelaire's poetry. Although *The Voyage* employs the same formal vocabulary as the *Elegy* paintings, that vocabulary is used in a somewhat different way, with a different kind of voice, stark but lyrical, somber but not tragic.

*

So far we have been considering poetic allusion in Motherwell's *Elegy* imagery. There is also the question of pictorial allusion to be considered. As many writers on the subject have

Henri Matisse, *Bathers by a Stream*, 1916. The Art Institute of Chicago.

noted, the painting that first comes to mind in relation to the *Elegies* is Picasso's mural-sized, black and white evocation of the Spanish Civil War, *Guernica* (1937) — which, like some of the early *Elegy* paintings, is also named for a place in Spain. In fact, the entire *Elegy* series may be seen in a certain sense as a kind of homage to, and trope of, and at the same time as an act of monumental resistance against, Picasso's masterpiece — which at the time hung in New York's Museum of Modern Art and was generally considered to be the most important single picture that Picasso had produced. (Now, some forty years later, the painting has lost some of that cachet; but it still remains one of the most widely-discussed and variously interpreted paintings of the century.)

Another painting that served as an important precedent was Matisse's *Bathers by a Stream* (1916), another mural scale, predominately black and white painting that was highly regarded by advanced New York painters at the time. This painting employs a basic vocabulary of oval and rectangular forms, and a vertical banding similar to that in the *Elegies,* and also has a similar kind of pictorial starkness and separation of parts (much more so than *Guernica,* which employs a Baroque pyramidal composition and is filled with interlocking pictorial incidents).

Once again, what Motherwell has refused is as interesting as what he has accepted, and although both *Guernica* and *Bathers by a Stream* are obvious sources of inspiration for the *Elegy* series, Motherwell's resistance to them is as elaborate as his borrowings.

Even more to the point here, especially with regard to the process of "decoding" the *Elegies,* is the presence in the viewer's mind of another very important body of work from the beginning of the modernist tradition — the "Spanish" paintings of Edouard Manet, another artist for whom a certain idea of Spain was an important source of inspiration and who was an innovator of the hard-edged, black and white-dominated sort of imagery that Motherwell employs in the *Elegies.*

This is not to suggest that Motherwell was necessarily directly "influenced" by a painting like Manet's *Execution of the Emperor Maximilian,* although it is surely a painting that he would have known in reproduction. What is striking about the Manet painting in the present context is its starkness, its predominately black and white and ocher color harmony, and the way in which the vertical forms are suspended from the horizontal of the wall near the top of the painting — all features that anticipate the *Elegy*

format to a remarkable degree. Another striking parallel may be made between the "voice" of the *The Execution of the Emperor Maximilian* and that of the first *Elegy* paintings — the combination of the highly emotional and the utterly impersonal, of the tragic and the cool, qualities that the paintings share in varying degrees with the Lorca poem.

A similar "Spanish" sense of tragedy, conveyed through starkly delineated forms dominated by a black and white color harmony, is also present in Manet's *Dead Toreador,* one of the least sentimentalized images of death in the whole history of art. Here again, Manet uses an extremely limited palette but makes every nuance and variation of color tell, as in the way that he plays the black and white of the toreador's costume against the pink of the cape and the small spots of dark red blood — which are in a sense foretold in the pink. (This kind of restrained color symbolism is not uncommon in Manet's paintings of the 1860s. In *The Execution of the Emperor Maximilian,* the sergeant who will administer the *coup de grace* wears a red hat, another indirect but moving symbol of the blood that is about to be shed. It is fascinating to remark a similar use of color in one of Motherwell's most recent, and most powerful *Elegy* paintings, *Elegy to the Spanish Republic No. 171,* 1989.)

In fact, Manet was a pioneer in the use of the kind of allusion that we have been discussing. *The Execution of the Emperor Maximilian,* for example, is frequently compared to Goya's *The Third of May 1808* (1814) — another tragic Spanish picture — on which Manet based his composition. For many years, Manet's quotation of the Goya was considered to be an indication of his lack of imagination and originality. But in recent years, we have come to realize that the allusion to Goya is an integral part of the *originality* of the Manet painting — just as similar kinds of allusions are in the poetry of T.S. Eliot. For what Manet does here is to interpret Goya in an "antithetical" way — a way in which he includes a kind of critique of the strong sense of good and evil in the Goya painting, as well as of the intense emotional involvement, the strong sense of light and atmosphere, and the strong Christian overtones. The scene that Manet depicts, by contrast is remarkable for its coolness and impersonality, for its lack of emotional involvement, and its lack of clear-cut moral values. The chilly, impersonal nature of the assassination of the Mexican emperor is intensified precisely because one inescapably has the Goya painting in the back of one's mind when one looks at Manet's picture.

Here as in his *Olympia,* with its allusions to Titian's *Venus of Urbino,* Manet increases the strength of his own painting by an allusive framework that enlarges and intensifies our understanding of it. In fact, in modern painting, the whole framework of allusion, of absented subjects, and of antithetical "influence" is basically one of discourse with "the whole culture of modern painting" that every intelligent painter carries in his head. The nature of the discourse is such that there is both affirmation and antithesis, that which is taken and that which is refused, that which is directly appropriated and that which is resisted.

The *Elegy* series is the result of a complex vectoring of forces and interests on the part of the artist: the poetry of Lorca, Baudelaire, and Mallarmé; the painting of Manet, Goya, Matisse, and Picasso; and the dialogue between present and absent images, between affirmative and negative recognitions. In traditional painting, artists used fixed iconographical conventions, based on literature (the Bible, the classics, historical narratives) that was extrinsic to the paintings themselves but was carried around in the heads of the people who looked at them. In modern painting, especially in abstract painting, these "more than merely visual" meanings in individual paintings often come from a secular literary culture and from other paintings. This is the culture which in the largest sense allows us to understand the "more than merely visual meaning" of what is before our eyes when we look at paintings that seem at first to contain only the "merely visual."

Moreover, strong artists translate things in unexpected ways and see things, so to speak, out of the corners of their eyes. Sometimes these things are brought to the center of their own art without their being particularly conscious of it. It has been remarked, for example, that some of the forms seen in the window of Cézanne's *Portrait of Ambroise Vollard* (1899) bear a striking resemblance to Motherwell's *Elegy* imagery, but the artist himself was unaware of this until it was pointed out to him.[42] With the widespread reproduction of all kinds of visual imagery in the twentieth century, the whole question of influences, borrowings, and the pool of imagery on which visual allusions can be based has become much more complex than ever before.

*

From 1948 to 1965 Motherwell did more than a hundred variations on the *Elegy* theme. What had started out as a little decoration for a poem yielded one of his richest veins of imagery. He invented not only a specific kind of image, as a poet may be said to invent a particular poetic form, but also a kind of personal poetics that would serve as a point of departure for a good deal of his subsequent imagery, whether *Elegies* or not. The *Elegies* represented not only a certain kind of image, but also a certain kind of touch, and a certain approach to painting, incorporating such diverse features as the physical roughness of the imagery, the use of apparent pentimenti, and an apparently "unfinished" effect, as well as a codification of the general oval and rectangle format that runs through so much of Motherwell's work. The experience of the *Elegies* also paradoxically seems to have set Motherwell firmly upon his course of working with a delimited vocabulary of forms and colors. It provided him with a language which, like the notes on the musical scale, was limited but which could produce enormously varied effects.

13.

Making an Elegy *is like building a temple, an altar, a ritual place. The* Elegies *are never "a throw of the dice." They are almost the only pictures I do in the way one traditionally thinks of a Western artist working on a large scale, whether Leonardo or Rubens or Seurat, of starting with sketches, or using all one's resources to make a complete image, not improvised.*

Unlike the rest of my work, the Elegies *are, for the most part, public statements. The* Elegies *reflect the internationalist in me, interested in the historical forces of the twentieth century, with strong feelings about the conflicting forces in it. The collages, by contrast, are intimate and private; the* Opens *tend to be more strictly involved with artistic problems — problems in the viscosity of the paint, of color fields, of the skin of the world, highly abstracted. The instant I put in the U-shaped geometry in the* Opens, *it gives them a masculinity to complement the sheer*

sensuousness of the feminine. It gives completion, the union of opposites.

The Elegies *use a basic pictorial language, in which I seem to have hit on an "archetypal" image. Even people who are actively hostile to abstract art are, on occasion, moved by them, but do not know "why." I think perhaps it is because the* Elegies *use an essential component of pictorial language that is as basic as the polyphonic rhythms of medieval or African or Oriental music. To put it another way, if you give a child something very complex to paint, such as a bouquet of flowers or a natural landscape, if he is very good, eventually he will go back — like Cézanne — to the essential forms of what he sees. If you start out with basic forms, it is more sensible and efficacious. That is perhaps the reason I was myself, my I, the first year I painted, and did not have to go through the drudgery of seeking out the essential. I was possibly lucky in that I came to painting through technical philosophy, so the question of whether one could "be abstract" and meaningful was never a problem for me. I started with straight, basic, symbolic structures. My problem now is opposite; as I get older, I try to make my paintings more contrapuntal, richer. But not always.*[43]

14.

During the 1960s, at the same time that he was elaborating the *Elegy* series, Motherwell produced two of his most memorable series of drawings, *Beside the Sea* (1962) and *The Lyric Suite* (1965), and began to work on a radically new series of paintings, the *Opens*. If the first of these series is a virtuosic exercise in evocative metaphor, and the second a virtuosic display of Motherwell's powers of graphic invention, the third is a masterful demonstration of something like the opposite of virtuosity.

The thirty-odd *Beside the Sea* drawings were done at Provincetown during the summer of 1962, with oil paint on heavy rag paper. Motherwell has described their execution as follows: "For years my summer studio has been directly on the bay in Provincetown on Cape Cod. There is a 900-foot tidal flat, and . . . at high tide the sea in a high wind breaks against the bulkhead in violent spray. In the *Beside the Sea* series I made the painted spray with such physical force that the rag paper split, and it was only when I found rag paper laminated with glue in five layers that the surface could take the full force of my shoulder, arm, hand, and brush without splitting. One might say that the true way to 'imitate' nature is to employ its own processes."[44]

The colors of these drawings, like the forms, operate in a realm somewhere between description and metaphor. Just as the splashed lines of paint that rise above the horizontals almost — but do not quite — describe water whipped by wind, so the ochers and blues that frequently play against the black and white forms suggest — but do not quite describe — the colors of sand, water, and sky. The subtlety of the metaphor is further enhanced by the way in which the oil in the paint has sometimes separated from the pigment and bled into the paper, suggesting the fluid state of both paint and water. The artist's signature written across the forms also suggests a fluid presence, like writing on beach sand, and emphasizes the graphic, "written" quality of the surrounding forms.

If the *Beside the Sea* drawings are depictive metaphors for a natural process, in which the artist is imitating something in the real world, the drawings of *The Lyric Suite* are acts of pure abstraction, completely hermetic, which, taken together are like an extended series of musical variations. In the spring of 1965, Motherwell bought a thousand sheets of Japanese rice paper, with the thought of doing a thousand automatic ink drawings in which his only intention would be "to avoid intentions."[45] Working on the floor on the little rectangles of squarish white paper, Motherwell was aware of a certain resemblance between his actions and Mallarmé's *Un coup de dés*, "an aesthetic dice game, incorporating the elements of chance, in which there was always more than one throw of the dice."[46]

The simplicity of the technical means combined with the large number of projected drawings appears to have played a double role. It was an enormous challenge to Motherwell's powers of invention, but it also provided him with an open situation in which, because there were so many chances, he could give himself the freedom — that most awesome freedom! — to do whatever he wanted to. Here again he was not working "alone," but in response to the exigencies and even, in a sense, the *will* of his medium. Aside from the will of the brush, he also had to take into account the will of the inks and of the particular paper he had chosen. As these interacted, the inks tended to bleed into the paper in a consistent but not entirely predictable way, giving a distinctive, slightly soft edge to all the forms. The predominantly black and blue inks also produced halos of red, orange, and violet as they bled into the paper. As a result, the range of mood, feeling, color, and texture is surprisingly broad, despite the clearly delimited technical means. And as it turned out, still another act of chance, the accidental death of Motherwell's close friend, the sculptor David Smith, cut short the enterprise a little more than halfway through.

Beside the Sea and *The Lyric Suite* had both been conceived primarily in terms of free and vigorous drawing, as planned enterprises whose execution would involve a certain amount of chance. The *Open* series, on the other hand, initially grew out of Motherwell's reaction to the chance juxtaposition of two of his canvases which suggested a window-ground, inside-outside relationship, and developed as a series of color field paintings in which the role of drawn line would be essential but essentially reductive. Unlike much of Motherwell's previous work, here the expressive quality of the drawing seems to reside in its apparent lack of "expressiveness." Line divides and extends, opens and closes, but remains mute and inseparable from the mysterious field in which it is inscribed.

15.

Since the fifteenth century, painting has been compared to a window: a rectangle that opens onto another space, another world. This comparison, by emphasizing the view *through* the picture surface, assumed that a painting allows us direct visual access to what it represents, the actual painted surface of the picture functioning as a more or less transparent intermediary between the space in which we actually stand and the space represented within the rectangle of the picture. Leone Battista Alberti referred to the surface of the picture as a plane upon which the forms of seen things are represented, "exactly as if it were made of glass, and transparent, as if the visual pyramid were intersected by it."[47] Leonardo da Vinci, following Alberti, compared the surface of the picture to a wall of glass (*pariete*

di vetro), through which the depicted objects can be seen.[48] Over the next four centuries, this conception of painting was the dominant one in Europe, it being understood that *complete* transparency of the picture plane was in fact no more desirable than radical opacity would have been. The formal or stylistic elements of painting (its abstract, pictorial qualities of design), and the facture of a painting (the evidence within the image of the action or manner of its making), were taken for granted as integral components of any painted image.

Not until the nineteenth century was this notion of the semi-transparent picture plane seriously called into question, in two opposing ways. The academic painters, such as Meissonier, Gérôme, and Bouguereau, aspired toward highly naturalistic and detailed description of objects rendered on a smoothly painted surface which was meant to appear almost as transparent as the surface of a photograph. Academic painting also eschewed the reality of contemporary life and so provided a transparent window that opened onto an ideal, theatrical world.

The avant-garde, by contrast, insisted ever more strongly on the surface reality of painting and addressed itself to motifs taken from real life. Paradoxically, as the act of painting became more and more dependent upon direct perception of real life, as in Impressionism, the means by which those perceptions were recorded became more abstract. The marks on the surface of the picture and the syntax that determined their distribution called unprecedented attention to themselves. The rectangle of the canvas still remained a window giving onto another space, but a window that called more and more attention to its own surface, and the "subject matter" of painting came to include, to an unprecedented degree, the act of painting itself. Eventually this sort of painting came to function more like a wall on which marks had been made, with little or no illusion of space behind it, than as a window that one could look through.

As we have seen, Motherwell's painting, right from the beginning of his career, was conceived of in this way, as a kind of wall. Window motifs also figure in his work almost from the beginning (as in *Spanish Picture with Window*), but for the most part they are windows which refer back to the picture plane rather than offering us a view into an illusionistic space.

In 1967, Motherwell began to address this question of inside/outside more directly than he had before, in the series of paintings known as the *Opens*. By his own account, the *Opens* grew out of what he characterized as "a continual problem in painting," which had to do with uniting the disparate elements in his work:

"It used to cross my mind from time to time that it would be much more intelligent to go the other way — *to begin with unity* and then, within unity, create (through dividing) disparate elements. An idea floating around in my mind for maybe a decade. Now, one day I had a vertical canvas about seven by four feet; I had decided not to use its white ground, and had painted it flat yellow ochre. By studio chance, leaning against it was a smaller canvas with its back side showing — the wooden stretchers — and in looking at the wooden chassis of the smaller rectangle against the larger one, the two together struck me as having a beautiful proportion. . . . So I picked up a piece of charcoal and just outlined the smaller canvas on the larger one. At the time, I had the notion of either putting imagery outside the smaller space or within it. One day it occurred to me that it really didn't need imagery, that it was a picture in itself, a lovely painted surface plane, beautifully, if minimally, *divided, which is what drawing is.* The image association was 'an opening,' and

as I made more, the series came to be called the *Open* series; *cf.* the Random House unabridged dictionary entry 'open'."[49]

The *Opens* occupy a very interesting position within Motherwell's work. The use of simple rectilinear motifs goes back virtually to the beginning of his career, as can been seen in such works as *The Little Spanish Prison* and *Spanish Picture with Window*, both of 1941; indeed, the latter actually contains at the upper left a variation on the "open" motif of the U-shaped rectangle. The *Open* paintings also coincided with the peak of "minimalism" in American art. Hence if Motherwell was rethinking some of his earliest motifs, he was doing so under the impetus of a specific historical situation, which had given minimalist means of expression a new currency and a new validity.

Moreover, the *Opens* also seem to have been part of a new engagement on Motherwell's part with Matisse, and two paintings by Matisse seem to have had a particularly important effect on Motherwell's rethinking of the relationships between inside and out, between window and wall: *Open Window, Collioure* and *View of Notre Dame*, both painted in 1914, at a time when Matisse was himself deeply involved with such issues. Both paintings were first exhibited in America for the first time (and conspicuously reproduced in catalogs) in 1966. These two pictures are two of Matisse's most reductive and abstract paintings, and they also address the dichotomy between window and wall more directly than most other works by Matisse.

The relationship between some of the *Opens* and the *View of Notre Dame* is quite striking, in the dialogue between drawn line and the field of color, and even in the monochromatic use of the exquisitely brushed and nuanced blue. Motherwell has obviously drawn inspiration from Matisse's carefully modulated balance between flatness and plasticity, and between order and chaos.

Equally interesting is the relationship between Matisse's *Open Window, Collioure* and Motherwell's *Garden Window* (1969), which evokes the Matisse through a direct allusion that is once again modified by antithesis, in that the Motherwell painting, despite its title, refuses to describe the view through the window in question. It is noteworthy that the Matisse painting also seems to have been conceived of antithetically, in relationship to Matisse's own earlier paintings of windows, which were distinctly more descriptive than this one. When Matisse painted the *Open Window, Collioure* in 1914 he appears to have been alluding directly to his own *Open Window, Collioure* of 1905, which has the same title and is ostensibly of the same window. Part of what is so striking in this comparison is the contrast between the reticent, laconic quality of the 1914 picture — which refuses to describe, in a place that has traditionally been reserved for description — in relation to the loquacious description contained within the window of the 1905 picture.

*

The *Opens*, like the *Elegies*, are based on a number of oppositions, but they are oppositions of a very different sort: not between rectangles and ovals but between the amorphous field of color and the simple straight lines that divide it. As Motherwell uses this polarity between amorphousness and geometry, it is infinitely suggestive, evoking both opposition and ultimate harmony, as between nature and culture, emptiness and thought, passivity and action — and, on a larger scale, between

chaos and cosmos. The oppositions in some of the *Opens,* as in *In Plato's Cave No. 1* (1972), or *In Beige with Charcoal* (1973) seem to set emptiness against the mark of man in a way that recalls the oldest paintings known, those on the walls of prehistoric caves, especially the mysterious and moving pictographs on the walls of Lascaux and Altamira.

There is at once something both very sophisticated and modern about these pictures and also something essentially primitive and timeless. Here, as in the *Elegies,* Motherwell has invented a format which seems to function in a deeply archetypal way, which is both pictorially concrete and fraught with multiple layers of abstract meaning. Like the *Elegies,* the *Opens* make evident the surprisingly wide range of expressive possibilities that can be evoked with a severely delimited basic format.

The *Open* series can be seen as a response to a period of crisis in Motherwell's personal life, as a response to a crisis in his career as an artist, and most especially as a response to a moment in the history of painting. But on a deeper level, the *Opens* also seem to reflect a resolution of impulse and intellect, and an inner serenity that was not often evident in Motherwell's previous work. Earlier, Motherwell's work frequently conveyed a strong sense of violence, anxiety, and desperation, and also a profound mistrust of conscious thought. His use of automatism and his insistence on spontaneity can be seen as part of a strategy to free and release his energies beyond the bounds of the riverbed that his ruminative mind might have dug for itself if he had spent his career developing and refining a single kind of image.

For decades Motherwell has also been involved in a continuous confrontation with the idea of spiritual and physical death. *Viva. Je t'aime.* The phrases, written into his paintings and drawings are like exhortations to himself to accept life and feeling. In the *Open* series, these tensions are resolved in a new way. Anxiety gives way to serenity, impulse and intellect merge, and yet there is no loss of feeling.

In the serenity of their silence, and in the sparseness of their utterance, the *Open* pictures marked a major turning point in Motherwell's art, equivalent in importance to the beginning of the *Spanish Elegies.*

16.

An artist loves what he can afford to love. Or rather, he gives his love freedom only where he can afford to: always feeling the need to afford more, yet constantly knowing that a careful — if inexact — accounting must be kept. One must neither be too attached to the concrete, to the poignant but fleeting situations that make up a man's life and root him in the commonplace, nor be too much enamored of the purely abstract aspirations that serve philosophy better than art. Somewhere a balance must be struck between the tension of life as it is lived and of life as it is conceived.

In the history of painting the most awesome resolution of this tension is perhaps found in the art of Piero della Francesca — in the almost inconceivably fine balance that Piero achieves between the incidental and the essential, the commonplace and the cosmic. No form or shape is too small to escape the relentless order and patterning of the whole, yet the whole itself is rife with eccentricity and surprise and constantly allows free play to even the smallest form or shape.

Robert Motherwell's own high regard for Piero della Francesca appears to be related to his perception of just how well balanced are thought and feeling in Piero's art, and how utterly pictorial are his expressive means. Those are the qualities that have also been at the core of Motherwell's ambition right from the beginning of his venture as an artist. The tension between life as it is lived and life as it is transformed into art has for a long time been evident in Motherwell's work. It is this tension that underlies his concern with subject matter, and has to a large degree determined the range of color and imagery he has set for himself in the various mediums in which he works. And it is probably this tension that has impelled him to keep his almost obsessive concern with autobiographical detail — the scraps of paper, souvenirs, invitations, certificates, labels, envelopes, and wrappers that he saves — confined to the single autobiographical medium of collage. His collages, in a sense, are almost the opposite of his paintings. They reconstitute an actual lived life, whereas the paintings invent a parallel one.

I am who? I am what? I am where? I am when? The answers to these specific questions are sometimes given in the collages, frequently in relation to other individuals who by chance or design have come into Motherwell's life. But the paintings are images in a solitary world. Even the *te* in *Je t'aime* remains unnamed and elided, engulfed by the ''I'' and the ''love.'' As if to say: Because of this image, I am. I paint, I draw, therefore I feel.

How aware of this might Motherwell be? More, probably, than one might suppose. Throughout his career, Motherwell seems to have been aware that the demands of his medium — his love for it, and his way of working in it — would necessitate certain preclusions; that certain aspects of his life and of his awareness of life could not be included in his art if what he would include was to have the intensity and the resonance that he wanted it to have. An artist is known as much by what he will not permit as by what he includes in his painting, as Motherwell himself once remarked.[50] And as long ago as 1951 he wrote: "One of the most striking aspects of abstract art's appearance is her nakedness, an art stripped bare. How many rejections on the part of her artists! Whole worlds — the world of objects, the world of power and propaganda, the world of anecdotes, the world of fetishes and ancestor worship. . . . Nothing as drastic an innovation as abstract art could have come into existence, save as the consequence of a most profound, relentless unquenchable need."[51] And, one might add, what a relentless courage it takes to love so passionately and to keep one's love so austere.

Yet what is also striking is how much Motherwell has managed to include in so abstract an art, how much of the complexity of the man comes across in his work: the puritan and the sensualist, the social being and the recluse, the thinker and the force of nature. And how much culture is evident in those works. How many references — both overt and recondite — are woven into his paintings and drawings; references to myth and poetry, to politics and history, to philosophy and to other art.

It sometimes seems that abstract art has found such fertile ground in America in part because the intellectual and sensual life of the nation have for so long been found in some way lacking. Abstract art, in its move around history straight to myth, has provided the possibility of a way to leave behind the incidental and the temporal, and to deal directly with the universal and the timeless. To deal with life on art's terms.

For more than fifty years now, Robert Motherwell has not only been a key figure in this movement but has produced some of its finest images.

Notes

1. The Documents of Modern Art series was begun in 1944, published by Wittenborn, Schultz, Inc. The first book was published in 1945 and from then until 1953, when Wittenborn, Schultz discontinued the series, Motherwell was general editor and wrote prefaces to eight of the volumes, as well as editing *The Dada Painters and Poets* (1951). In 1968 Motherwell reactivated the series, with Arthur A. Cohen as co-editor, under the new name of the Documents of Twentieth Century Art, published by the Viking Press, Inc. In 1979, G.K. Hall & Co. became publisher of the series, with Jack Flam as co-editor.

2. Robert Motherwell, in Jack D. Flam, "With Robert Motherwell," in Dore Ashton and Jack D. Flam, *Robert Motherwell* (New York: Abbeville Press-Albright Knox Art Gallery, 1983), p. 12. Cf., Stephanie Terenzio, *Robert Motherwell and Black* (Storrs, Connecticut: The William Benton Museum of Art, 1980), p. 128.

3. Robert Motherwell, *Robert Motherwell Prints, 1977–1979* (New York: Brooke Alexander, Inc., 1979), n.p.

4. Robert Motherwell, "The Significance of Miró," *Art News* 58, 4 (May 1959), p. 66.

5. See Robert Motherwell and Ad Reinhardt, eds., *Modern Artists in America* (New York: Wittenborn, Schultz, 1951), p. 20.

6. Ibid.

7. Robert Motherwell, in H.H. Arnason, *Robert Motherwell,* 2nd edition (New York: Harry N. Abrams, 1982), p. 199.

8. Robert Motherwell, "A Conversation at Lunch," in *An Exhibition of the Work of Robert Motherwell* (Northampton, Mass.: Smith College Museum of Art, 1963), n.p.

9. Motherwell and Reinhardt, *Modern Artists in America,* p. 20.

10. Motherwell, "A Conversation at Lunch," n.p.

11. Conversation with the author, November 27, 1989.

12. These remarks were made in an interview with the author on November 5, 1982, while Motherwell was choosing works for his 1983 retrospective exhibition, which was seen at six major American museums. The exhibition opened at the Albright-Knox Art Gallery, Buffalo, in October 1983 and closed at the Guggenheim Museum, New York City, in February 1985.

13. A reference to Rousseau's remark to Picasso: "We are the two great painters of the age, you paint in 'Egyptian' style, I in the modern." See Fernande Olivier, *Picasso and His Friends* (New York: Appleton-Century, 1963), p. 92.

14. Motherwell's recollections about his early years have been made in numerous conversations with the author during the past twelve years.

15. I posed the question of a possible relationship between his early asthmatic experiences and his art during a conversation with Motherwell on May 10, 1990. He replied that he thought there probably was one and it was he who suggested that his habit of painting at night may have in some way been determined by his traumatic nocturnal asthmatic attacks.

16. See Robert Saltonstall Mattison, *Robert Motherwell: The Formative Years* (Ann Arbor and London: UMI Research Press, 1987), p. 6.

17. Interview with R.S. Mattison, December 11, 1979, as cited in Mattison, *Robert Motherwell,* p. 7.

18. Motherwell, "A Conversation at Lunch," n.p.

19. Robert Motherwell, "The Rise and Continuity of Abstract Art," lecture at Harvard University, April 1951, as cited in Mattison, *Robert Motherwell,* p. 11.

20. Interview with Richard Wagener, Los Angeles, June 14, 1974, as cited in Robert C. Hobbs, *Motherwell's Concern with Death in Painting: An Investigation of his Elegies to the Spanish Republic, Including an Examination of his Philosophical and Methodological Considerations,* Ph.D. dissertation, University of North Carolina, Chapel Hill, 1975, p. 179.

21. Robert Motherwell interviewed by Bryan Robertson, December 15, 1964, as cited in Hobbs, *Motherwell's Concern with Death,* p. 127.

22. Robert Motherwell interviewed by the author, November 5, 1982.

23. Robert Motherwell, "What Abstract Art Means to Me," *The Museum of Modern Art Bulletin* 18, 3 (Spring 1951), p. 12.

24. Conversation with the author, January 27, 1989.

25. Bryan Robertson, "Interview with Robert Motherwell, Addenda," 1964. Motherwell Papers, Greenwich, Connecticut.

26. Motherwell, "The Modern Painter's World," *Dyn* 1, 6 (November 1944), p. 13.

27. Robert Motherwell interviewed by the author, October 2, 1982.

28. Ibid.

29. Robert Motherwell, "The School of New York," in *Seventeen Modern American Painters* (Beverly Hills: Frank Perls Gallery, 1951), n.p.

30. Piet Mondrian, "Toward the True Vision of Reality," as reprinted in Harry Holtzman and Martin James, eds., *The New Art — The New Life: The Collected Writings of Piet Mondrian* (Boston: G.K. Hall & Co., 1986), p. 341.

31. Conversation with the author, September 30, 1989.

32. See Arnason, *Robert Motherwell,* p. 105. The title of the Brenner book is actually *The Wind That Swept Mexico.*

33. See Harold Bloom, *The Anxiety of Influence* (New York: Oxford University Press, 1973); and *A Map of Misreading* (New York: Oxford University Press, 1975).

34. In fact, Motherwell originally titled the work *Mallarmé's Dream,* but later changed the title in response to Joseph Cornell's having mistakenly remembered it to have been called *Mallarmé's Swan,* evoking the French poet's well-known symbol of artistic purity. See L. Bailey Van Hook, "Robert Motherwell's *Mallarmé's Swan,*" *Arts Magazine,* 57, 5 (January 1983), pp. 102–106.

35. Robert Motherwell, "The School of New York," in *Seventeen Modern American Painters* (Beverly Hills: Frank Perls Gallery, 1951), n.p.

36. See E.A. Carmean, Jr., "Robert Motherwell: The Elegies to the Spanish Republic," in E.A. Carmean, Jr., Eliza E. Rathbone, and Thomas B. Hess, *American Art at Mid-Century: The Subjects of the Artist* (Washington, D.C.: The National Gallery of Art, 1978), pp. 94–123.

37. Dore Ashton, "On Motherwell," in Ashton and Flam, *Robert Motherwell,* p. 30.

38. Carmean, "The Elgies," p. 96.

39. Robert Motherwell, conversation with E.A. Carmean, August 17, 1977, as cited in Carmean, "The Elegies," p. 98.

40. See Carmean, "The Elegies," passim, and Mattison, *Robert Motherwell,* pp. 197–207.

41. Carmean, "The Elegies," p. 99.

42. See Marcelin Pleynet, *Robert Motherwell* (Paris: Edition Daniel Papierski, 1989), p. 40.

43. Robert Motherwell interviewed by the author, October 22, 1982.

44. Robert Motherwell, in Arnason, *Motherwell,* p. 147.

45. See Robert C. Hobbs, "Robert Motherwell's Open Series," in *Robert Motherwell* (Dusseldorf: Stadtische Kunsthalle, 1976), p. 48.

46. Ibid.

47. L. Mallé, ed., *Leone Battista Alberti, Della Pittura* (Florence, 1950), p. 65.

48. See Edward McCurdy, *The Notebooks of Leonardo da Vinci* (New York: George Braziller, 1954), p. 992; also Jean Paul Richter, ed., *The Literary Works of Leonardo da Vinci* (London: Phaidon, 1970), vol. 1, pp. 127–61.

49. Barbaralee Diamondstein, "Robert Motherwell: An Interview," in Arnason, *Motherwell,* p. 229.

50. Frank O'Hara, *Robert Motherwell* (New York: The Museum of Modern Art, 1965), p. 15.

51. Motherwell, "What Abstract Art Means to Me," p. 12.

CHRONOLOGY

1915 Born 24 January, in Aberdeen, Washington, to Robert Burns Motherwell II and Margaret Hogan Motherwell.

1916 Sister, Mary-Stuart, born 24 August.

1918 Family moves to California.

1929 Develops acute asthma and is sent to the drier climate of central California to attend Moran Preparatory School in Atascadero; he graduates as Valedictorian in 1932.

1932–37. Studies at Stanford University and receives B.A. in Philosophy. Studies painting briefly at California School of Fine Arts in San Francisco.

1935 Travels in Western Europe with his father and sister.

1937–38. Studies at Graduate School of Philosophy, Harvard University.

1938–39. Lives in France. Studies French literature and paints. First one-man show, Galerie Duncan.

1940 Moves to New York. Studies at Columbia University department of Art History under Meyer Schapiro.

1941 Travels to Mexico with Matta. Does "automatic" drawings and paints first mature pictures. Meets actress Maria Emilia Ferreira y Moyers, whom he will marry the following year.

1942 Exhibits in "First Papers of Surrealism," New York.

1943 Does first collages.

1944 One-man show at Peggy Guggenheim's Art of this Century Gallery, New York; catalogue preface by James Johnson Sweeney.

1945 Signs contract with Samuel Kootz Gallery, New York. Moves to East Hampton where he builds quonset hut studio house designed by Pierre Chareau (razed in 1989). Meets Mark Rothko. Begins to direct "The Documents of Modern Art" series of writings by modernist artists.

1946 Included in "Fourteen Americans," at the Museum of Modern Art, New York.

1948 Paints first small *Elegy*. Founds "Subjects of the Artist" school with William Baziotes, Mark Rothko, and David Hare; the school closes after one season.

1949 Paints *Granada,* first large painting of the Elegy to the Spanish Republic theme.

1950 Appointed to graduate faculty at Hunter College, New York, where he will teach until 1959. Meets David Smith. Teaches at Black Mountain College. Marries Betty Little.

1953 Buys house in New York City. Included in "Four Abstract Expressionists" at the Museum of Modern Art, New York. Begins to spend summers in Provincetown, Massachusetts, on Cape Cod. Birth of daughter, Jeannie.

1955 Included in "The New Decade: 35 American Painters and Sculptors" at the Whitney Museum, New York. Birth of daughter, Lise.

1957 Begins to exhibit with Sidney Janis Gallery.

1958 Included in "The New American Painting," Museum of Modern Art, New York. Marries Helen Frankenthaler. Travel in Spain and France. Starts *Iberia* series of paintings.

1959 Included in "Documenta II," Kassel, Germany.

1961 Begins to make prints with Tatyana Grosman. Retrospective exhibition at São Paolo Biennial and Pasadena Art Museum.

1963 Marlboro-Gerson Gallery, New York, becomes his exclusive dealer.

1965 Retrospective exhibition at the Museum of Modern Art, New York; subsequently shown at the Stedelijk Museum, Amsterdam; Whitechapel Art Gallery, London; Palais des Beaux-Arts, Brussels; Museum Folkwang, Essen; Museo Civico, Galleria Civica d'Arte Moderna, Turino. Does *Lyric Suite* ink paintings, halted by the death of his friend David Smith.

1967 Begins the *Open* series.

1969 Elected to National Institute of Arts and Letters.

1970 Moves to old stone carriage house in Greenwich, Connecticut.

1972 Knoedler, New York, becomes his main dealer. Marries the German-born photographer Renate Ponsold.

1975 Retrospective exhibition at Museo Nacional de Arte Moderno, Mexico City.

1976 Retrospective at the Stadtische Kunsthalle, Dusseldorf; subsequently shown at the Kulturhuset, Stockholm; Museum des 20. Jahrhunderts, Vienna; augmented versions at the Royal Scottish Academy, Edinburgh, and the Royal Academy, London.

1977 Retrospective at the Musée d'Art Moderne de la Ville de Paris. Awarded Grande Medaille de Vermeil de la Ville

de Paris. Begins mural commission for the National Gallery of Art, Washington, D.C.

1979 ''Motherwell and Black,'' at the William Benton Museum of Art, University of Connecticut, Storrs. Awarded the Gold Medal of Honor, Pennsylvania Academy of Fine Arts, Philadelphia.

1980 Retrospective at Foundation Juan March, Madrid; subsequently shown at Centre Cultural de la Caixa de Pensions, Barcelona. Retrospective of graphic works at the Museum of Modern Art, New York. Awarded the Medal of Merit from the University of Salamanca.

1981 Receives Mayor's Award for Arts and Culture from the City of New York.

1982 Inauguration of permanent room, Bavarian State Museum of Modern Art, Munich.

1983 Retrospective at the Albright-Knox Art Gallery, Buffalo, New York; subsequently shown at the Los Angeles County Museum of Art, Los Angeles; the San Francisco Museum of Modern Art, San Francisco; the Seattle Art Museum, Seattle; the Corcoran Gallery, Washington, D.C.; the Guggenheim Museum, New York.

1985 Awarded MacDowell Colony Medal of Honor. Receives Great Artists Series Award, New York University. Elected to the American Academy of Arts and Sciences, Cambridge.

1986 Elected to the American Academy of Arts and Letters. Awarded the Medalla de Oro de Bellas Artes, Madrid.

1988 Elected Officier of the French Ordre des Arts et des Lettres.

1990 Receives National Medal of Arts at the White House. Receives Harvard Centennial Medal.

1991 Retrospective at Museo Rufino Tamayo, Mexico City; subsequently shown at Museo de Monterey, Monterey; Fort Worth Art Museum, Fort Worth, Texas.

Robert Motherwell in his studio, 1943.

ILLUSTRATIONS

1. La Belle Mexicaine (Maria). 1941.
 Oil on canvas, 30 × 24 in. (76.2 × 60.9 cm).
 Photo: Ken Cohen.
 Private Collection.

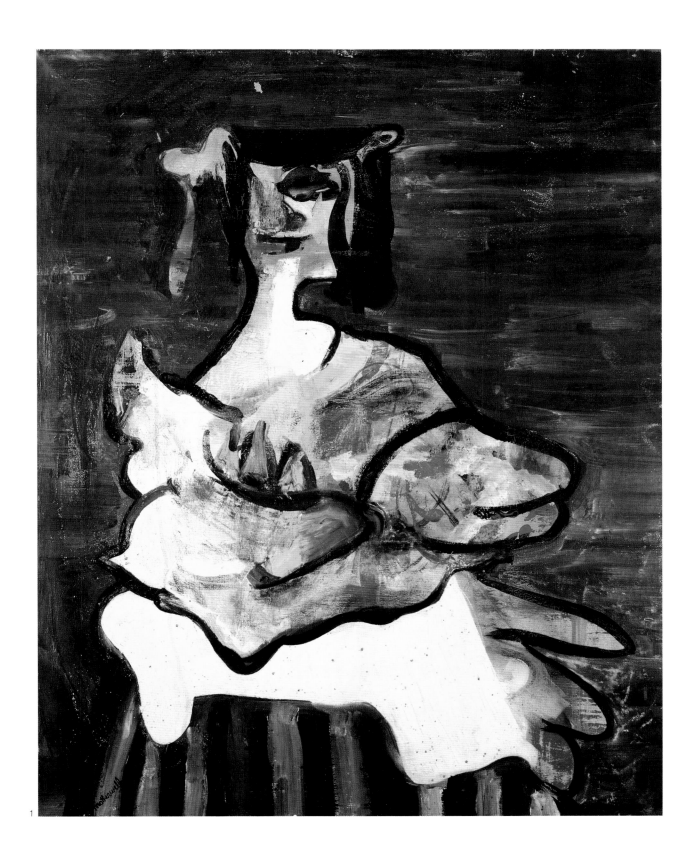

1. La Belle Mexicaine (Maria). 1941.
Oil on canvas, 30 × 24 in. (76.2 × 60.9 cm).
Photo: Ken Cohen.
Private Collection.

2. **The Little Spanish Prison.** 1941–44.
Oil on canvas, 27¼ × 17⅛ in. (69.2 × 43.5 cm).
Photo: Courtesy Museum of Modern Art.
Collection The Museum of Modern Art, New York. Gift of Renate
Ponsold Motherwell.

3. **Pancho Villa, Dead and Alive.** 1943.
Gouache, oil, cut-and-pasted paper on cardboard, 28 × 35⅞ in.
(71.1 × 91 cm).
Photo: Courtesy Museum of Modern Art.
Collection The Museum of Modern Art, New York. Purchase.

4. **Viva.** 1943–44.
Ink, oil, crayon and paper on paperboard, 29 × 21½ in.
(73.7 × 54.6 cm).
Collection James Martone, New York.

5. **Joy of Living.** 1943.
Collage of oil and paper on board, 43½ × 33¼ in. (110.5 × 84.5 cm).
Photo: Courtesy Baltimore Museum.
Collection The Baltimore Museum of Art. Bequest of Saidie A. May.

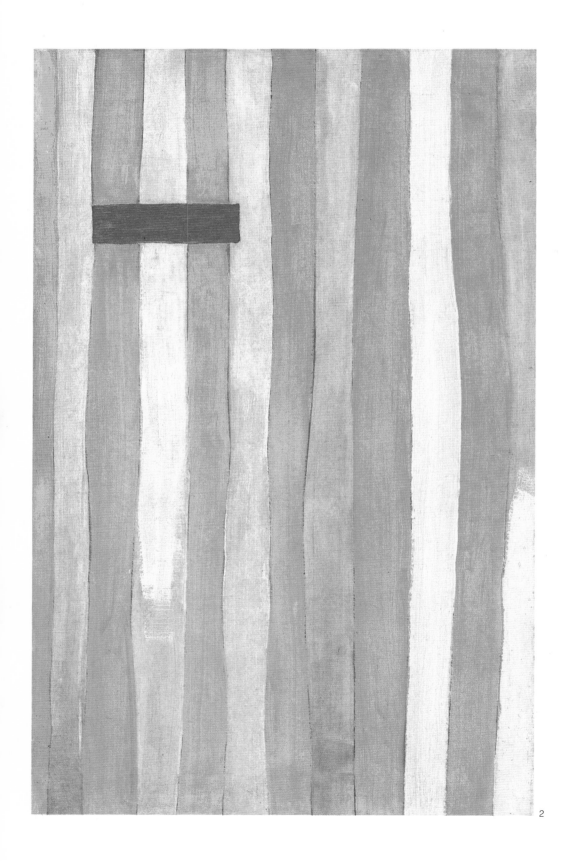

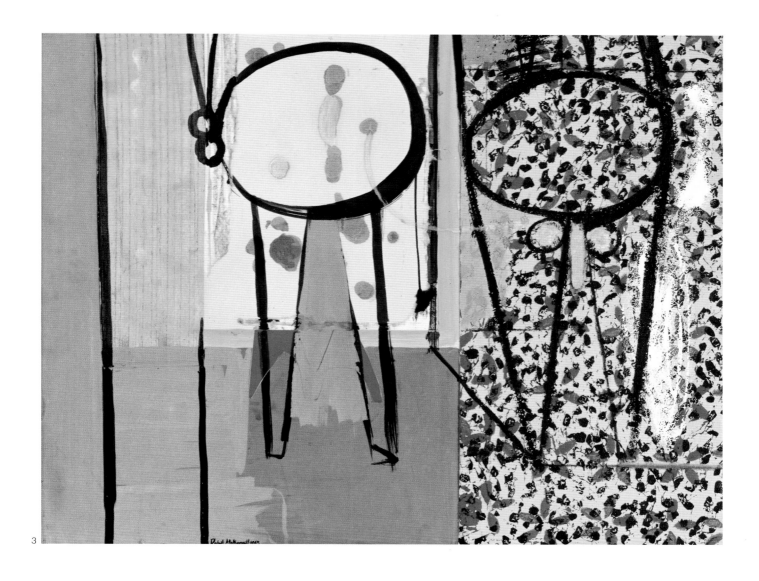

3

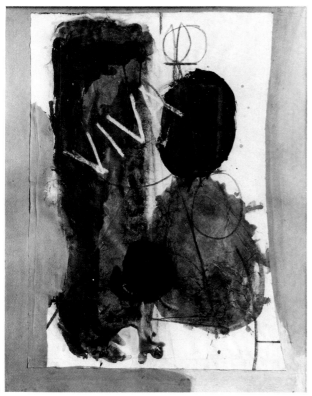

4

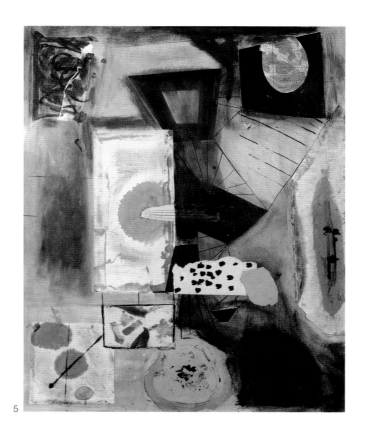

5

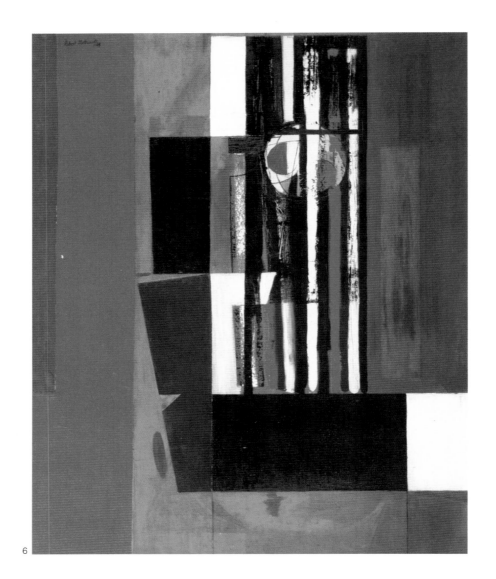

6

7

6. **Spanish Prison (Window).** 1943–44.
 Oil on canvas, 54 × 40 in. (137.2 × 101.6 cm).
 Collection Mr. and Mrs. Meredith Long, Houston, Texas.

7. **View From a High Tower.** 1944.
 Collage of oil and paper on board, 29¼ × 29¼ in. (74.3 × 74.3 cm).
 Photo: Steven Sloman.
 Private Collection.

8. **Mallarmé's Swan.** 1944.
 Gouache, crayon and paper on cardboard, 43½ × 35½ in.
 (110.5 × 90.2 cm).
 Photo: Courtesy Cleveland Museum.
 Contemporary Collection of the Cleveland Museum of Art.

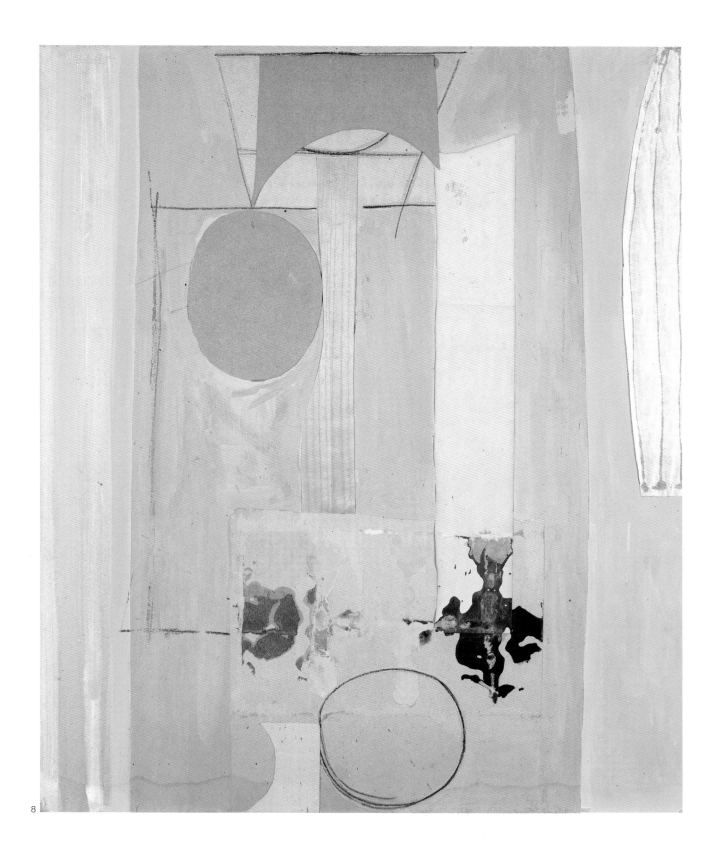

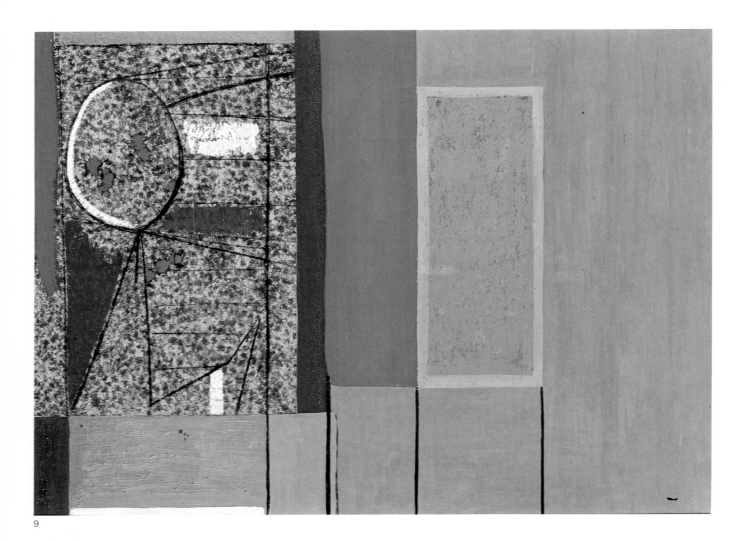

9

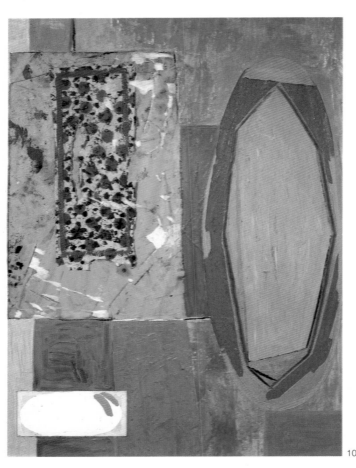

10

9. **La Resistance.** 1945.
 Collage of oil and paper on board,
 36 × 47³/₄ in. (91.4 × 121.3 cm).
 Photo: Joseph Szaszfai.
 Collection Yale University Art Gallery.
 Gift of Fred Olsen.

10. **The Pink Mirror.** 1946.
 Collage of oil and papers on paperboard,
 39 × 29½ in. (99 × 74.9 cm).
 Photo: Guadagno and Heald.
 Collection Barbara and Donald Jonas.

11. **Western Air.** 1946–47.
 Oil on canvas, 72 × 54 in. (182.9 × 137.2 cm).
 Photo: Courtesy Museum of Modern Art.
 Collection The Museum of Modern Art, New York.
 Purchase (by exchange).

12. **Viva.** 1947.
 Collage of gouache, sand and paper on board,
 15 × 20 in. (38.1 × 50.8 cm).
 Photo: Rudolph Burckhardt.
 Private Collection, Germany.

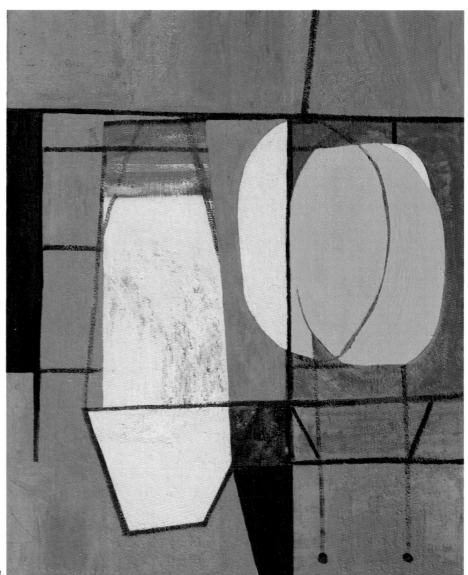

11

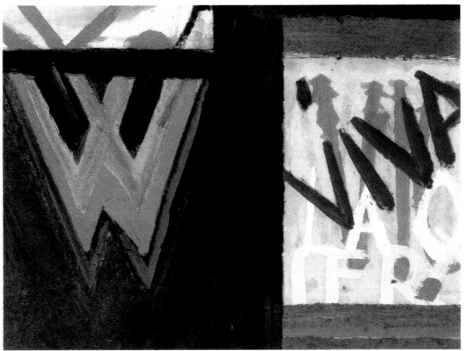

12

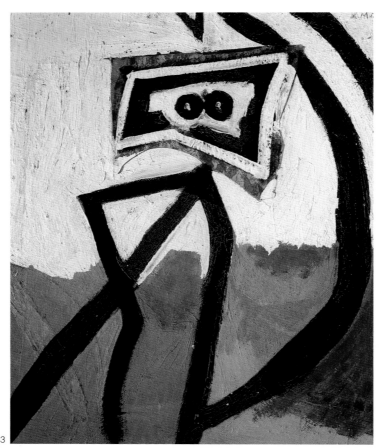

13

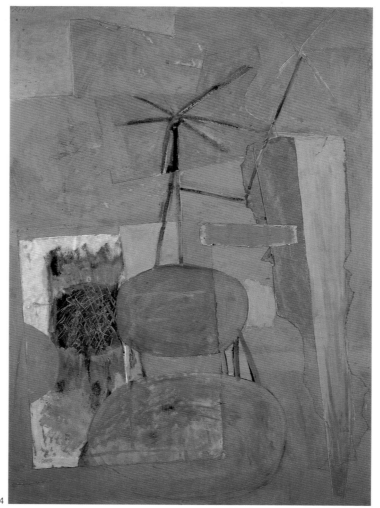

14

13. **Figure in Black.** 1947.
 Oil and collage on board, 24 × 19 in. (60.9 × 48.3 cm).
 Photo: Steven Sloman.
 Private Collection.

14. **The Poet.** 1947.
 Collage of oil and paper on board, 55⅝ × 39⅛ in. (141.2 × 99.3 cm).
 Photo: Duane Suter.
 Collection Kate Rothko Prizel and Christopher Rothko.

15. **Ulysses.** 1947.
 Oil on wood crate, 34 × 23 in. (86.4 × 58.4 cm).
 Photo: Ken Cohen.
 Private Collection.

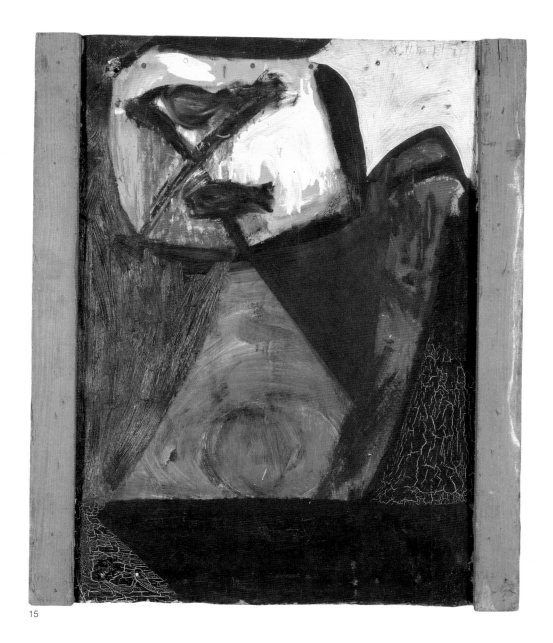

15

16. **The Homely Protestant (Bust).** 1947–48.
Oil on canvas, 30 × 24 in. (76.2 × 61 cm).
Photo: Steven Sloman.
Private Collection.

17. **The Homely Protestant (Smaller Study).** 1948.
Oil on canvas, 47½ × 23½ in. (120.6 × 59.7 cm).
Photo: Geoffrey Clements.
Private Collection.

18. **The Homely Protestant.** 1948.
Oil on composition board, 96 × 48¼ in. (243.8 × 122.5 cm).
Photo: Courtesy Metropolitan Museum.
Collection The Metropolitan Museum of Art. Gift of the artist, 1987.

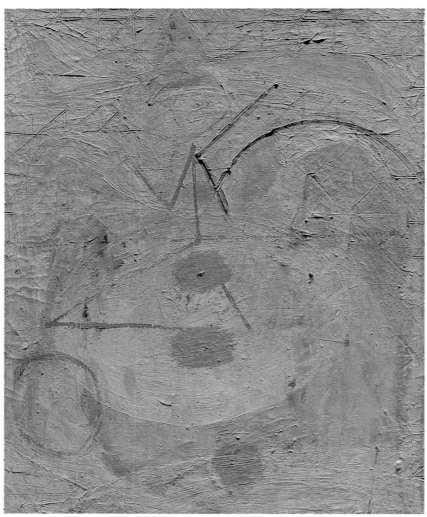

16

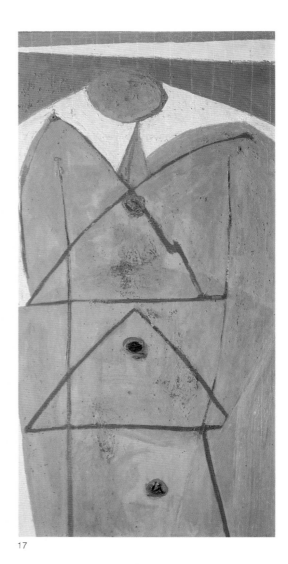

17

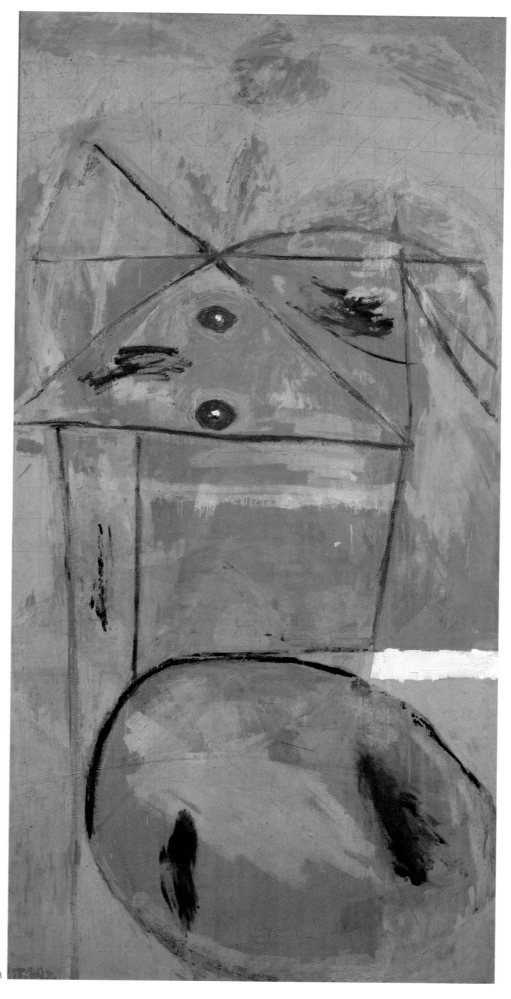

19. **The Best Toys Are Made of Paper.** 1948.
 Collage of oil and paper on board, 48 × 24 in. (121.9 × 60.9 cm).
 Photo: Courtesy Greenberg Gallery.
 Private Collection, St. Louis.

20. **Collage in Yellow and White with Torn Elements.** 1949.
 Collage of casein and assorted papers on board, 47³⁄₈ × 35½ in.
 (120.3 × 90.2 cm).
 Photo: Steven Sloman.
 Collection Acquavella Contemporary Art, Inc., New York.

21. **At Five in the Afternoon.** 1949.
 Casein on paperboard, 15 × 20 in. (38.1 × 50.8 cm).
 Photo: Juley.
 Collection Helen Frankenthaler, New York.

22. **Ink sketch, Elegy to the Spanish Republic No. 1.** 1948.
 India Ink on paper, 10³⁄₄ × 8½ in. (27.3 × 21.6 cm).
 Photo: Courtesy Museum of Modern Art.
 Collection The Museum of Modern Art, New York. Gift of the artist.

19

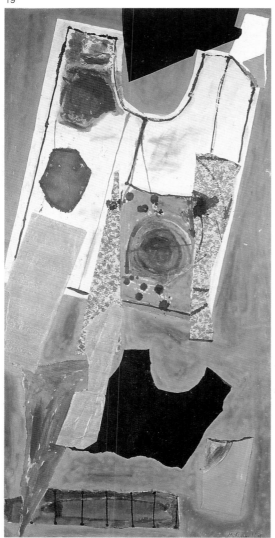

20

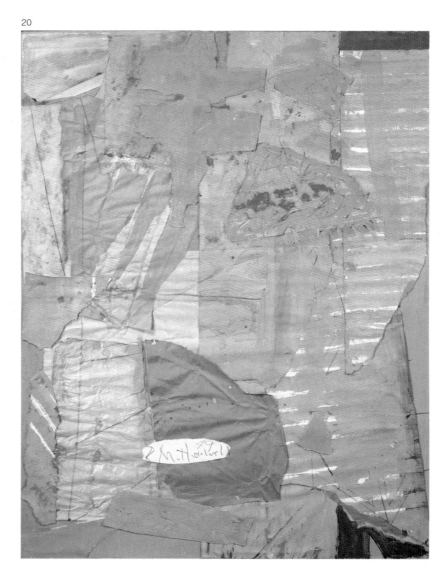

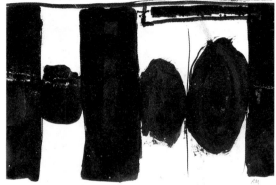

I knew who had sent them in those
green cases.
Who doesn't lose his mind will receive
like me
That wire in my neck up to the ear.

22

21

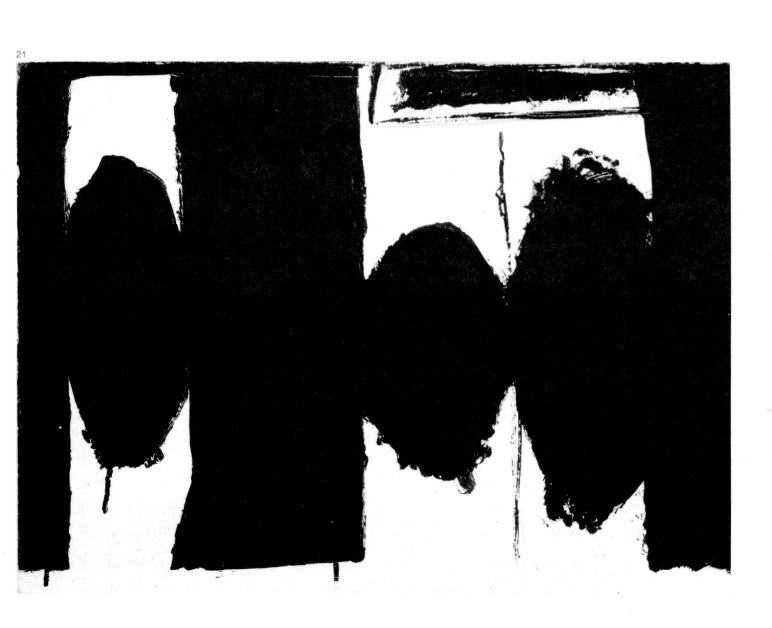

23–24. **The Voyage.** 1949.
Oil and tempera on paper mounted on composition board,
48×94 in. (122×238.8 cm).
Photo: Courtesy Museum of Modern Art
(with installation view).
Collection The Museum of Modern Art, New York.
Gift of Mrs. John D. Rockefeller 3rd.

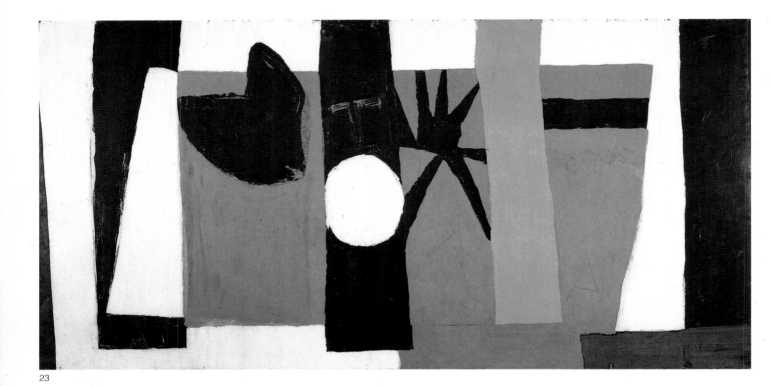

23

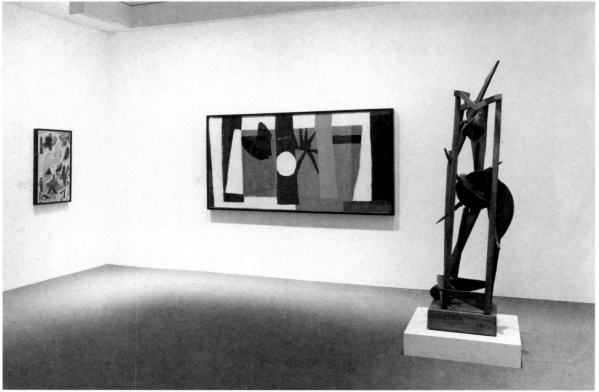

24

25. **Pregnant Woman Holding Child.** 1953.
Casein and ink on paper, 10×9 in. (25.4×22.9 cm).
Photo: Ken Cohen.
Private Collection.

26. **Elegy.** 1949.
Paper collage and gouache on masonite, 29½×23½ in.
(74.9× 59.7 cm).
Photo: Courtesy Fogg Art Museum.
Courtesy of The Fogg Art Museum, Harvard University,
Cambridge, Massachusetts, Louise E. Bettens Fund.

27. **Doorway, with Figure.** 1951.
Oil on kraftpaper mounted on board, 48×39³/₄ in.
(121.9×100.9 cm).
Photo: Ken Cohen.
Private Collection.

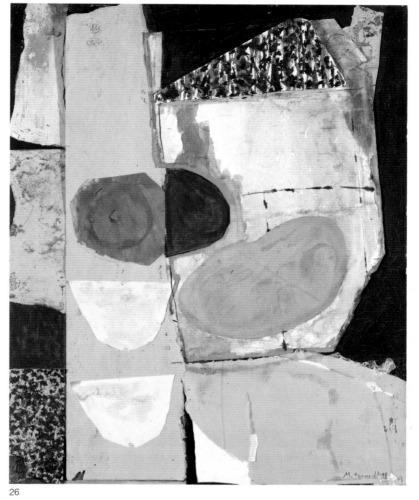

26

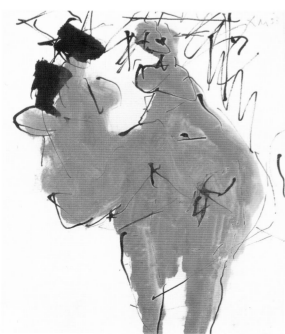

25

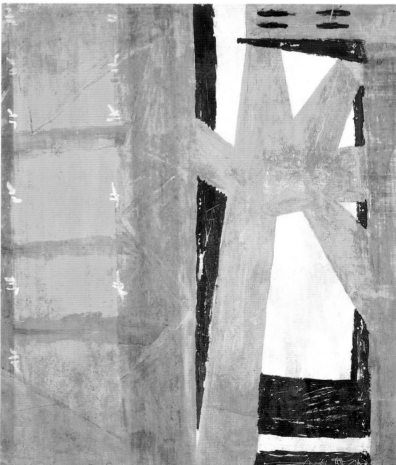

27

28. **Abstract Head.** 1953.
Oil on canvas, 24 × 20 in. (60.9 × 50.8 cm).
Photo: Steven Sloman.
Private Collection.

29. **Wall Painting No. IV.** 1954.
Oil on canvas, 54¹⁄₈ × 72¹⁄₈ in. (137.4 × 183.2 cm).
Photo: Courtesy Anderson Collection.
Collection Mr. and Mrs. Harry W. Anderson.

30. **Orange Figure with Interior.** 1953.
Oil on canvas, 20 × 24 in. (50.8 × 60.9 cm).
Photo: Steven Sloman.
Private Collection.

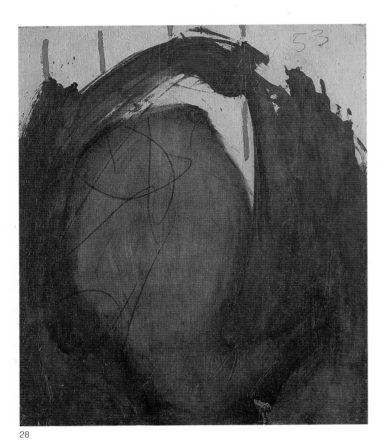

28

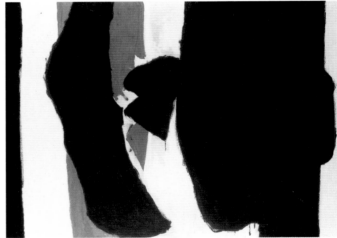

29

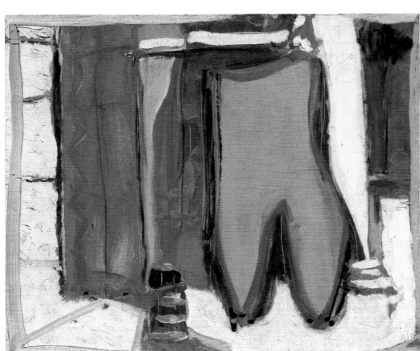

30

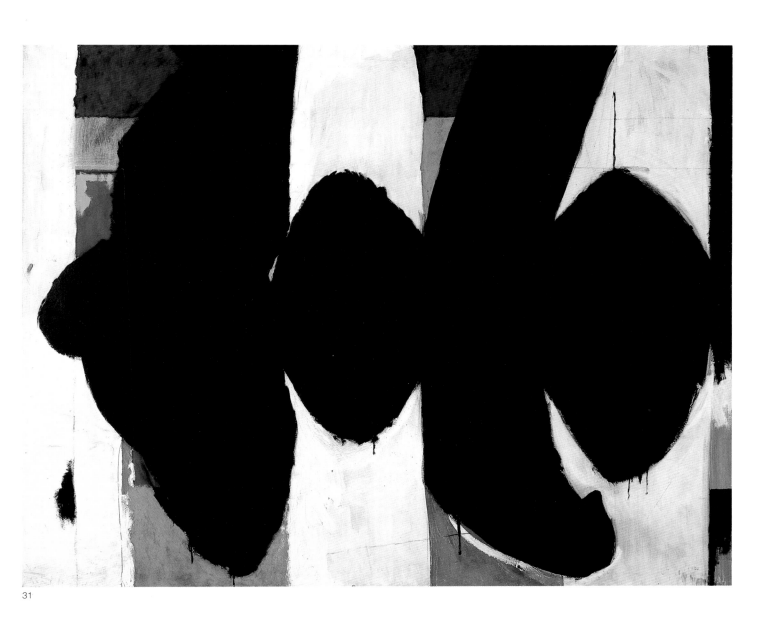

31

31. **Elegy to the Spanish Republic No. 34.** 1953–54.
Oil on canvas, 80 × 100 in. (203.2 × 254 cm).
Photo: Courtesy Albright Knox.
Collection Albright-Knox Art Gallery, Buffalo, New York.

32. **Fishes with Red Stripe.** 1954.
Oil on paper, 42½ × 41⅛ in. (107.9 × 104.4 cm).
Photo: Steven Sloman.
Courtesy Salander-O'Reilly Galleries, New York.

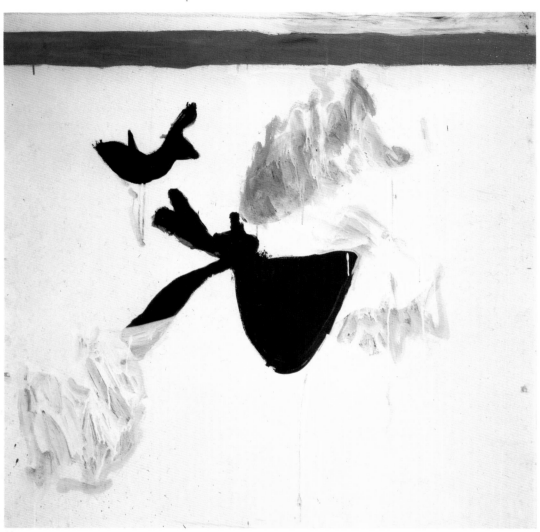

32

33. **Je T'aime No. II.** 1955.
Oil on canvas, 54 × 72 in. (137.2 × 182.9 cm).
Photo: Steven Sloman.
Collection Mr. and Mrs. Gilbert W. Harrison, New York.

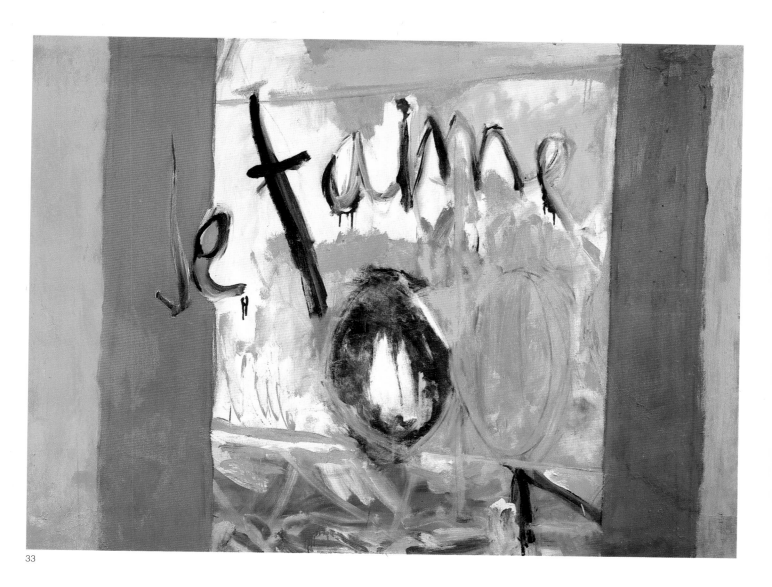

33

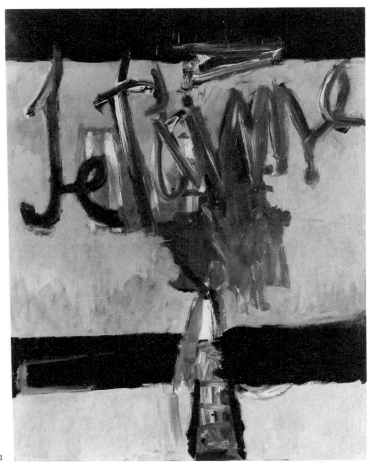

34

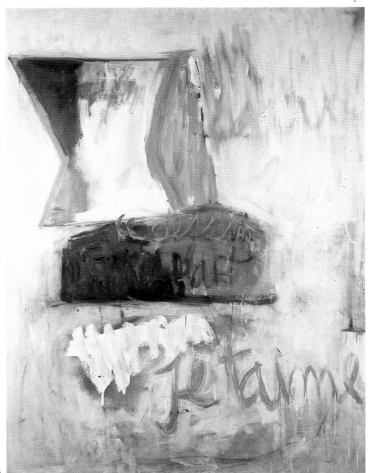

35

34. **Je T'aime No. IIA.** 1955.
Oil on canvas, 72 × 54 in. (182.9 × 137.2 cm).
Photo: Juley.
Collection Mr. and Mrs. I. Donald Grossman, New York.

35. **Je T'aime No. 3 with Loaf of Bread.** 1956.
Oil on canvas, 72 × 54 in. (182.9 × 137.2 cm).
Private Collection, Palm Springs.

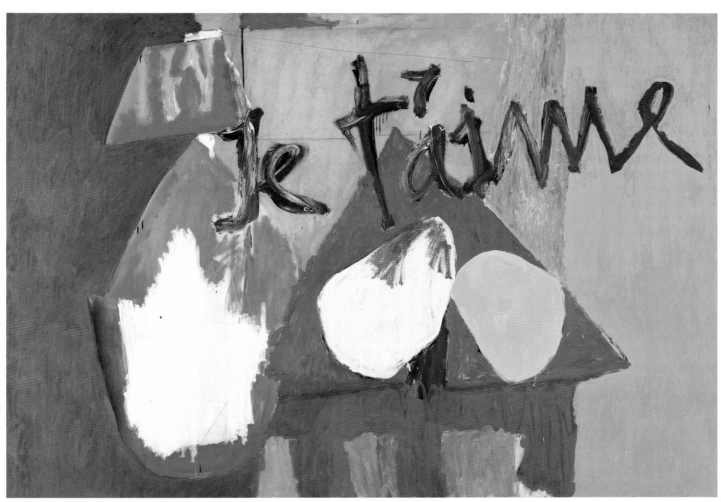

36

36. **Je T'aime No. IV.** 1955–57.
Oil on canvas, 70 × 100 in. (177.8 × 254 cm).
Photo: Autothek.
Collection Bayerische Staatsgalerie, Munich.

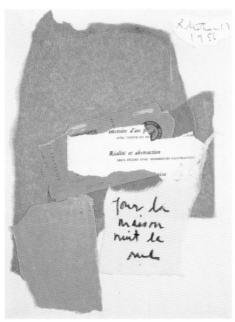

37

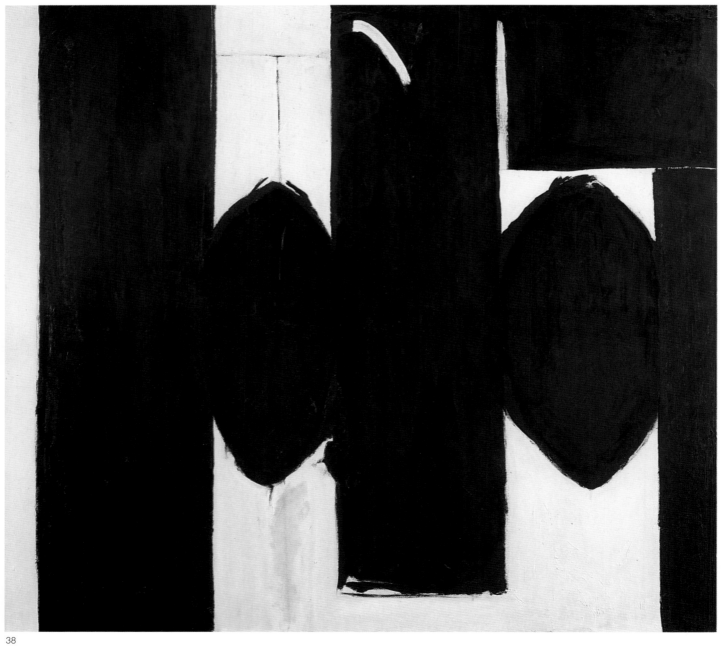

38

37. **Histoire d'un Peintre.** 1956.
Collage of varied papers and crayon on paperboard, 15¼ × 11 in.
(38.7 × 27.9 cm).
Photo: Ken Cohen.
Private Collection.

38. **Elegy to the Spanish Republic No. LV.** 1955–60.
Oil on canvas, 70 × 76⅛ in. (177.8 × 193.3 cm).
Photo: Courtesy The Cleveland Museum.
Contemporary Collection of The Cleveland Museum of Art.

39. **Jour La Maison, Nuit La Rue.** 1957.
Oil on canvas, 69¾ × 89⅝ in. (177.2 × 227.6 cm).
Photo: Juley.
Collection William C. Janss, Sun Valley, Idaho.

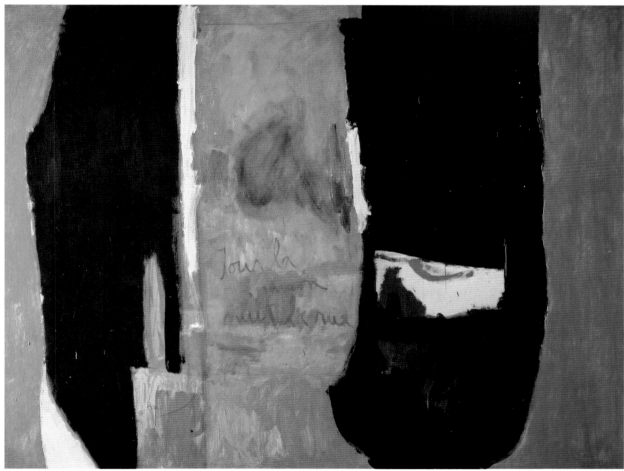

39

40. **Spanish Painting with the Face of a Dog.** 1958.
Oil on primed bed linen, 37⅛ × 75¼ in. (94.3 × 191.1 cm).
Photo: Steven Sloman.
Property of Mr. and Mrs. Gifford Phillips, New York.

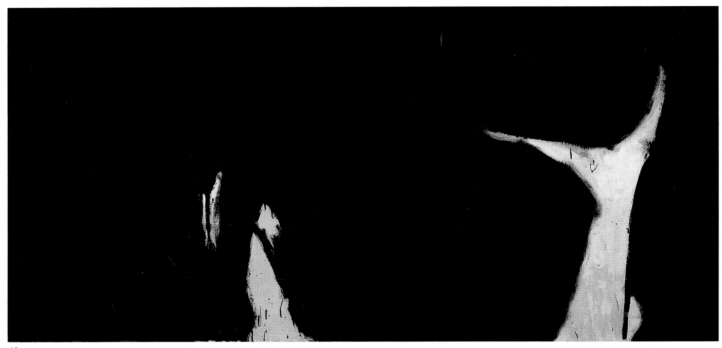

40

41. **Iberia No. 2.** 1958.
 Oil on primed bed linen, 41⅛×80¼ in. (104.4×203.8 cm).
 Photo: Ken Cohen.
 Private Collection.

42. **Two Figures No. 11.** 1958.
 Oil on canvas, 8½×10½ in. (21.6×26.7 cm).
 Photo: Steven Sloman.
 Private Collection.

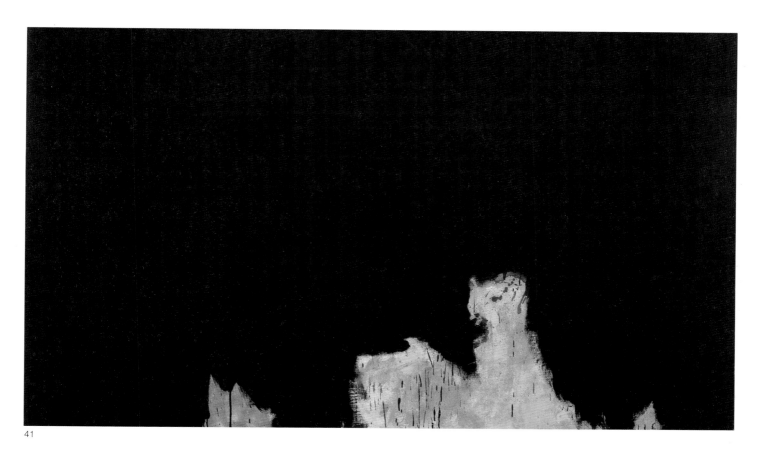

41

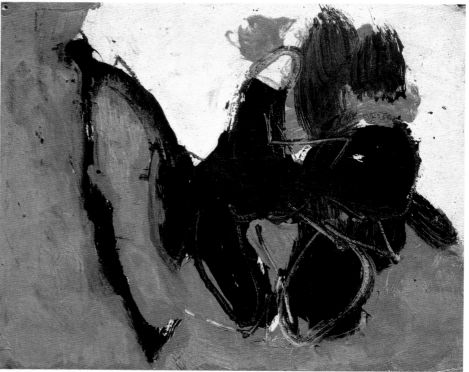

42

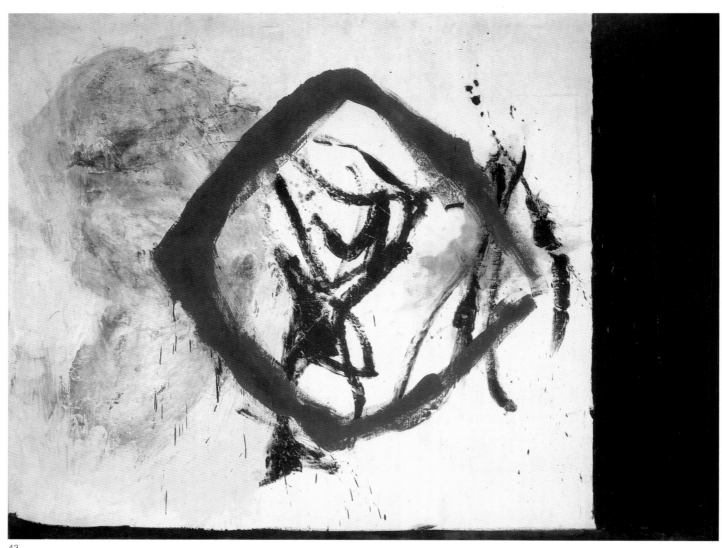

43

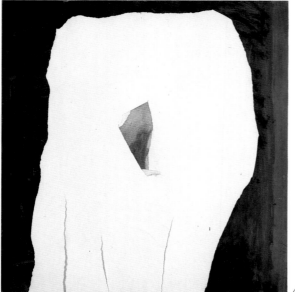

44

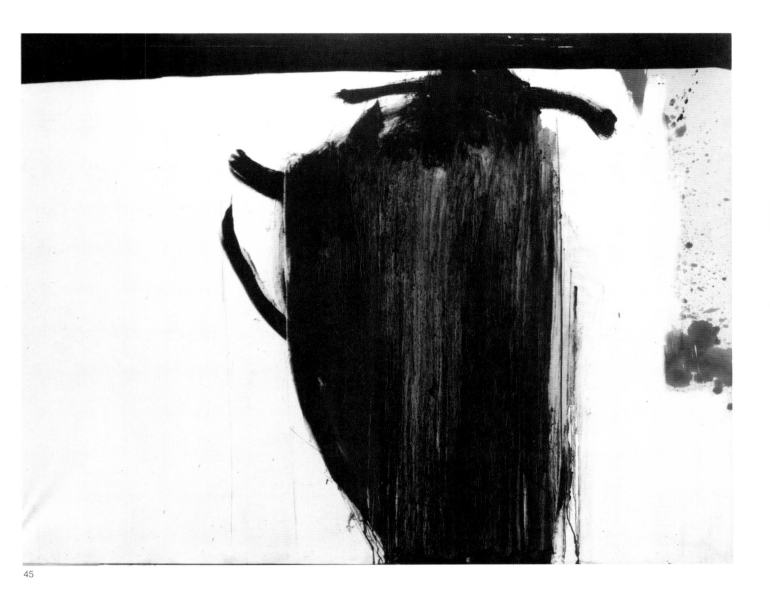

45

43. **A View No. 1.** 1958.
Oil on canvas, 81 × 104 in. (205.7 × 264.2 cm).
Photo: Steven Sloman.
Collection I.B.M. Corporation, Armonk, New York.

44. **Greek Collage.** 1959.
Collage of oil and paper on paperboard, 24 × 23 in. (60.9 × 58.4 cm).
Photo: Artothek.
Collection Bayerische Staatsgalerie, Munich.

45. **Totemic Figure.** 1958.
Oil on canvas, 84 × 109 in. (213.4 × 276.9 cm).
Photo: Ken Cohen.
Private Collection.

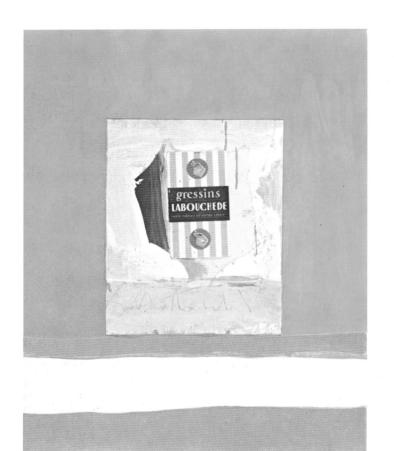

46

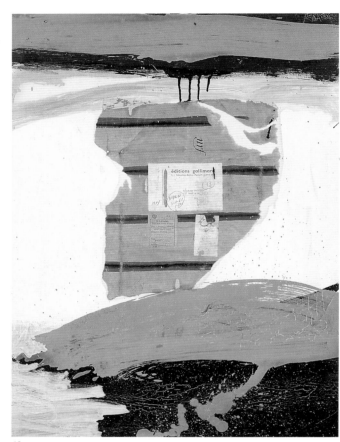

48

47

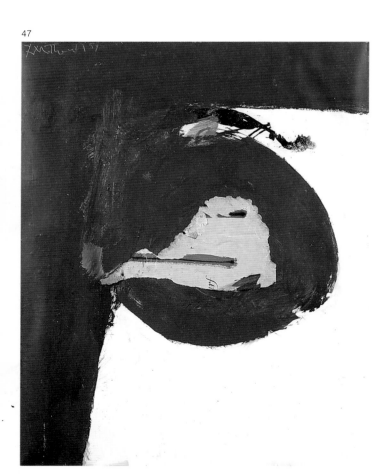

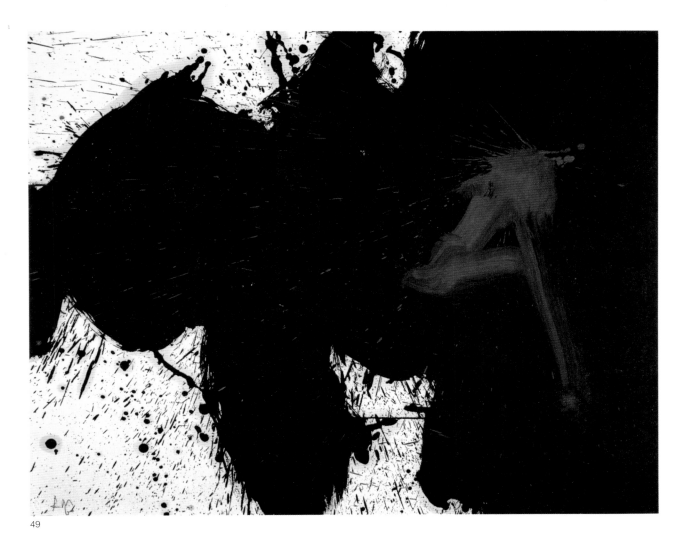

49

46. **The French Line.** 1960.
Collage of oil and paper on board, 30 × 23 in. (76.2 × 58.4 cm).
Photo: Paul M. Macapia.
Collection Mr. and Mrs. Bagley Wright, Seattle.

47. **N.R.F. Collage, No. 1.** 1959.
Collage of oil and paper on board, 28³/₈ × 22³/₈ in. (72 × 56.8 cm).
Photo: Courtesy Whitney Museum.
Collection Whitney Museum of American Art. Purchase, with funds from
The Friends of the Whitney Museum of American Art.

48. **N.R.F. Collage, No. 2.** 1960.
Collage of oil and paper on board, 28 × 21 in. (71.1 × 53.3 cm).
Photo: Victor's Photo, Piscataway, NJ.
Collection Whitney Museum of American Art. Purchase, with funds from
The Friends of the Whitney Museum of American Art.

49. **The Figure 4 on an Elegy.** 1960.
Oil on paper, 23 × 29 in. (58.4 × 73.7 cm).
Photo: Steven Sloman.
Estate of Mr. H.H. Arnason, New York.

50. **Two Figures with Cerulean Blue Stripe.** 1960.
Oil on canvas, 69 × 84 in. (175.3 × 213.4 cm).
Photo: José Naranjo.
Collection Boris and Sophie Leavitt.

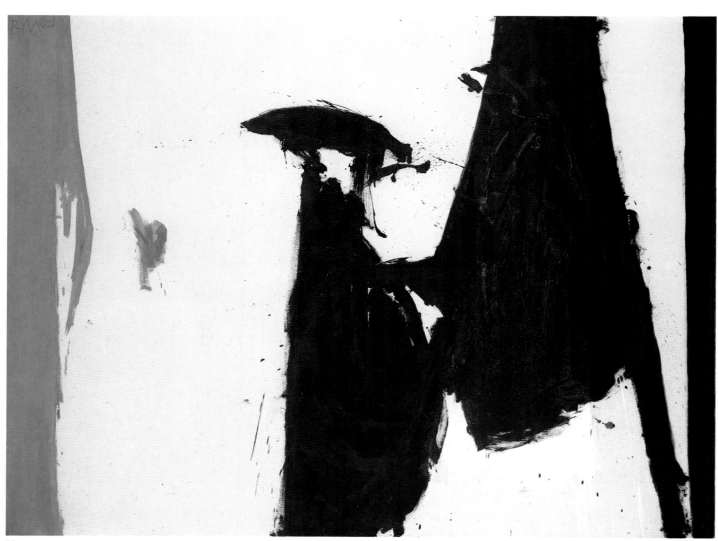

50

51. **Summertime in Italy (Paper Painting).** 1960.
Oil and pencil on watercolor paper, 57¼ × 42¾ in. (145.4 × 108.6 cm).
Photo: Steven Sloman.
Collection the artist.

52. **In White and Yellow Ochre.** 1961.
Collage of oil and assorted papers on board, 41 × 27 in.
(104.1 × 68.6 cm).
Photo: Courtesy Phillips Collection.
Property of The Phillips Collection, Washington, D.C.

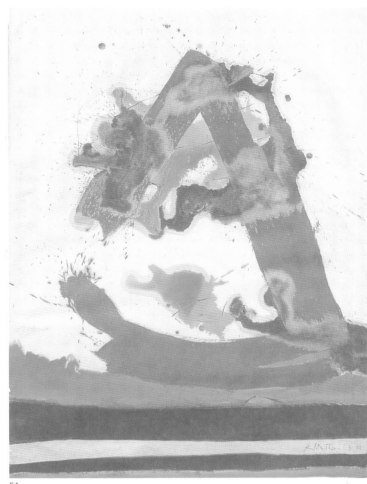

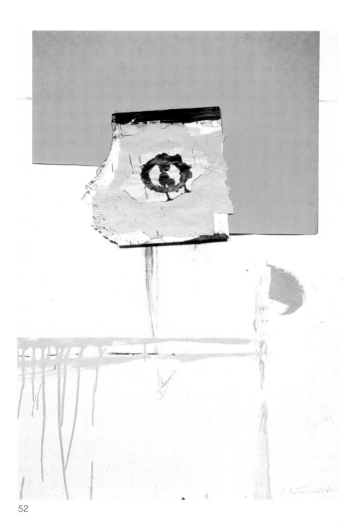

51

52

53. **Elegy to the Spanish Republic No. LXX.** 1961.
Oil on canvas, 69 × 114 in. (175.3 × 289.6 cm).
Photo: Courtesy Metropolitan Museum.
Collection The Metropolitan Museum of Art, New York. Anonymous Gift.

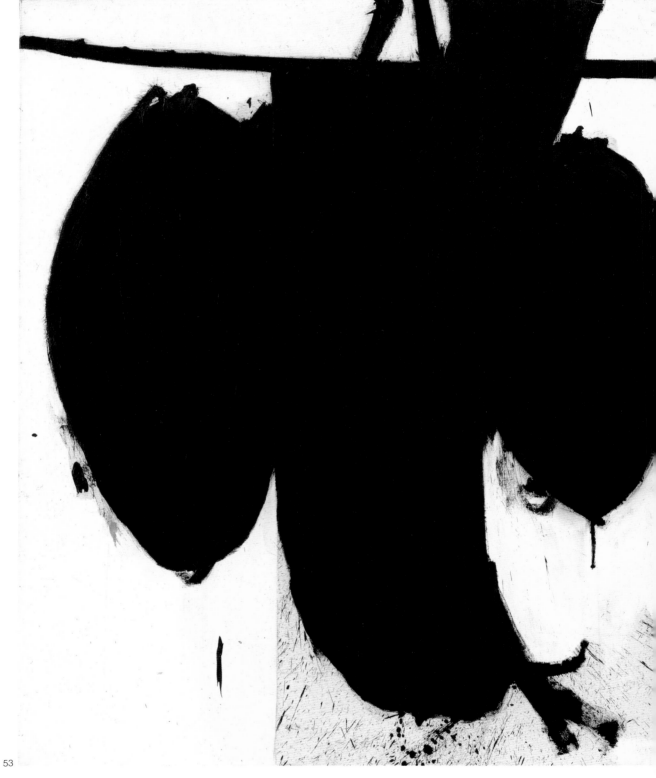

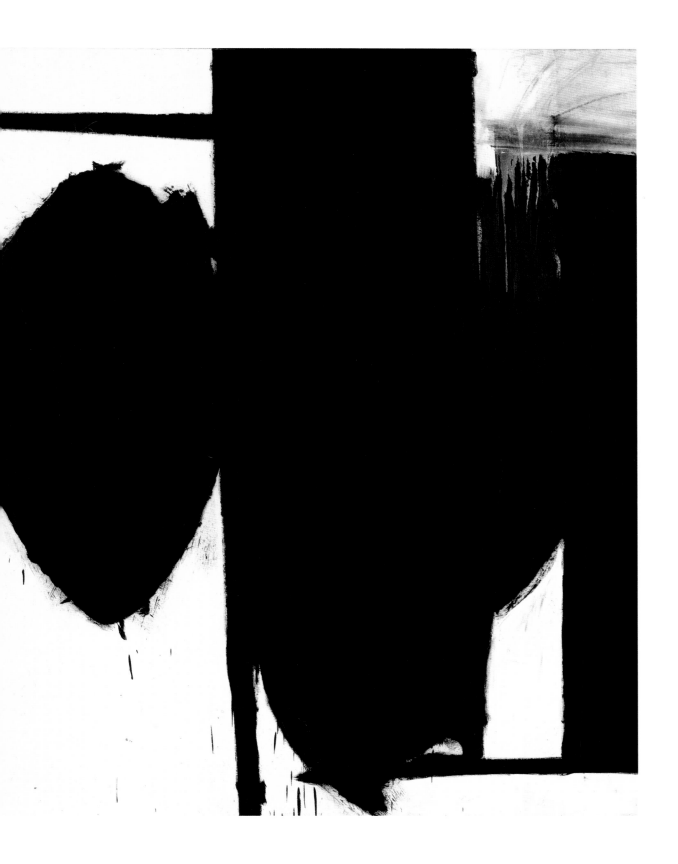

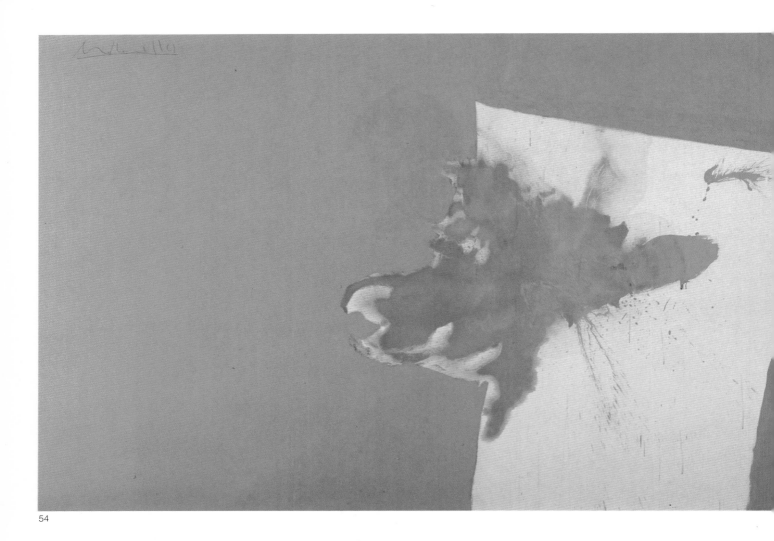

54

54. **The Golden Fleece.** 1961.
Oil on canvas, 69 × 204 in. (175.3 × 518.2 cm).
Photo: Courtesy The Chrysler Museum.
Collection The Chrysler Museum, Norfolk, Virginia.

55. **Black on White.** 1961.
Oil on canvas, 78 × 163³/₁₆ in. (198.1 × 414.7 cm).
Photo: Courtesy Museum of Fine Arts.
Collection The Museum of Fine Arts, Houston. Museum Purchase.

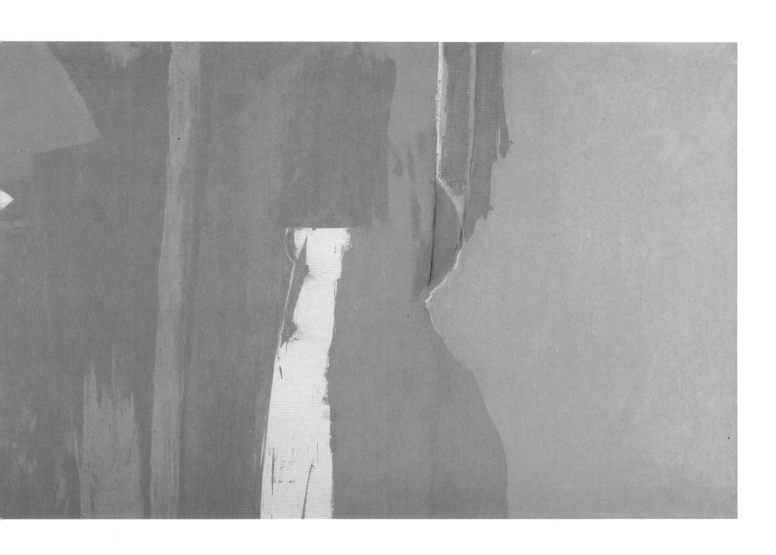

55

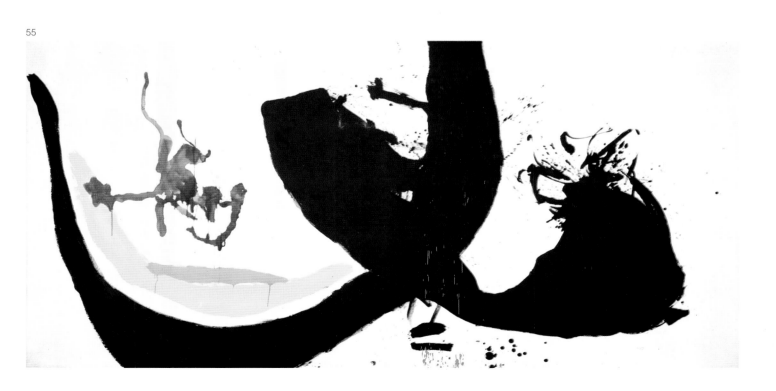

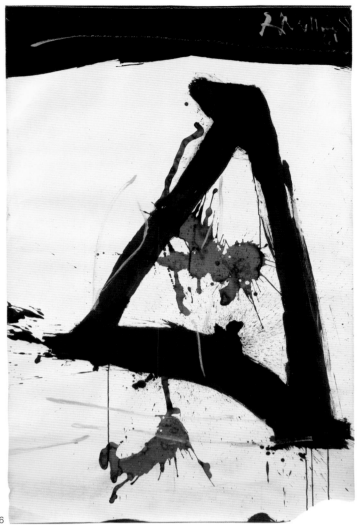

56

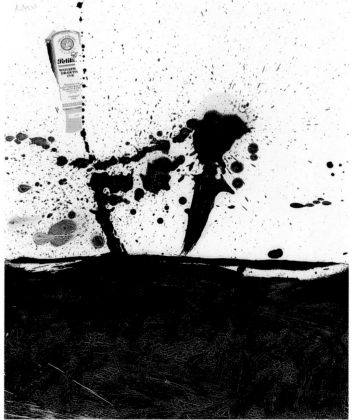

57

56. **Summertime in Italy.** 1961.
Colored ink and oil on paper, 65 × 42 in. (165.1 × 106.7 cm), irregular.
Photo: Steven Sloman.
Private Collection.

57. **Sky and Pelikan.** 1961.
Ink and paper collage on paperboard, 29 × 23 in. (73.7 × 58.4 cm).
Photo: Michael Agee.
Collection Yale University Art Gallery.

58. **Summertime in Italy No. 7 (In Golden Ochre).** 1961.
Oil on canvas, 85 × 69 in. (215.9 × 175.3 cm).
Photo: Ken Cohen.
Private Collection.

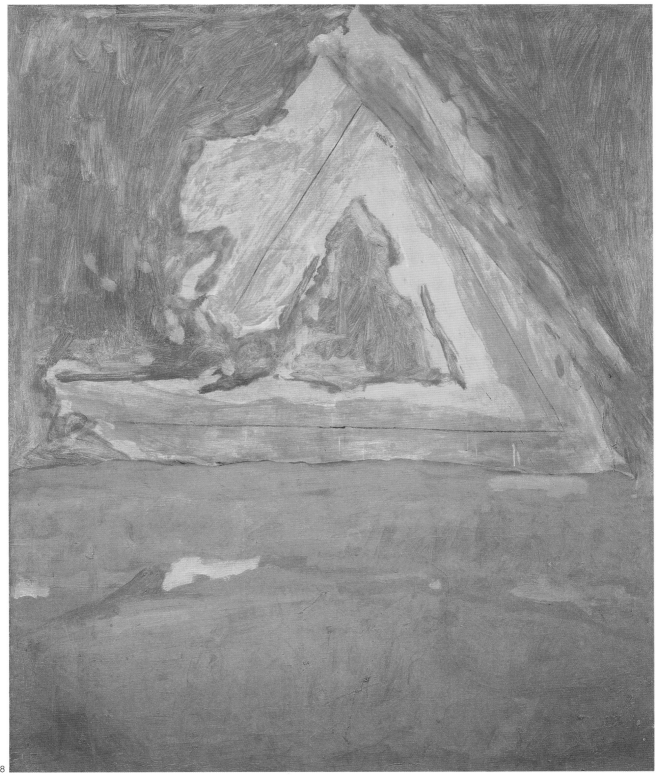

58

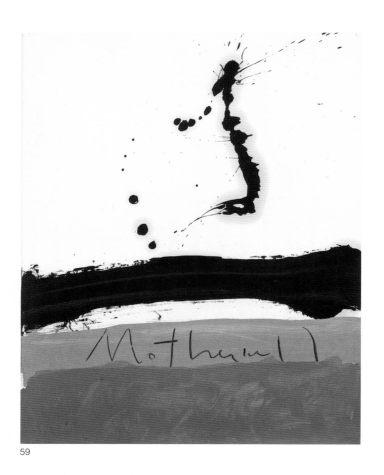

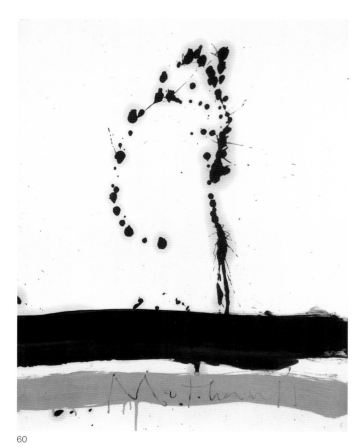

59

60

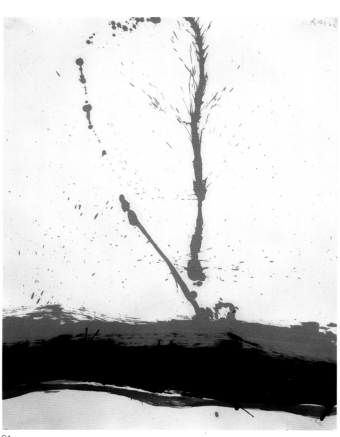

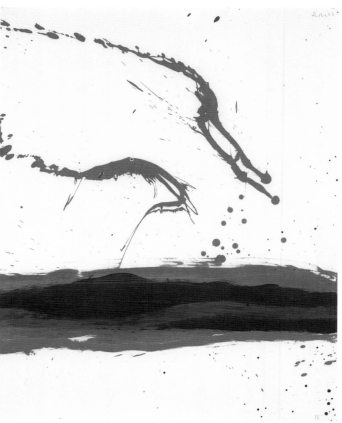

61

62

59. **Beside the Sea No. 2.** 1962.
Oil on rag paper, 29 × 23 in. (73.7 × 58.4 cm).
Photo: Steven Sloman.
Private Collection, Japan.

60. **Beside the Sea No. 5.** 1962.
Oil on rag paper, 29 × 23 in. (73.7 × 58.4 cm).
Private Collection.

61. **Beside the Sea No. 22.** 1962.
Oil on rag paper, 29 × 23 in. (73.7 × 58.4 cm).
Private Collection.

62. **Beside the Sea No. 18.** 1962.
Oil on rag paper, 29 × 23 in. (73.7 × 58.4 cm).
Collection Boris and Sophie Leavitt.

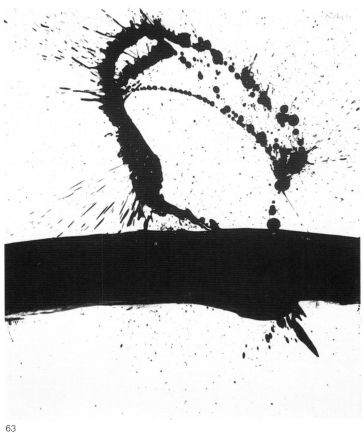

63

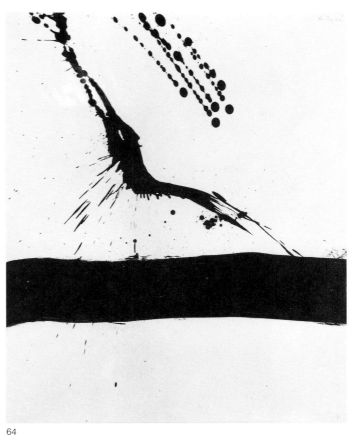

64

63. **Beside the Sea No. 30.** 1962.
Oil on rag paper, 29 × 23 in. (73.7 × 58.4 cm).
Private Collection.

64. **Beside the Sea No. 31.** 1962.
Oil on rag paper, 29 × 23 in. (73.7 × 58.4 cm).
Photo: Juley.
Private Collection.

65. **Chi Ama, Crede.** 1962.
Oil on canvas, 84 × 141 in. (213.4 × 358.1 cm).
Photo: Steven Sloman.
Private Collection.

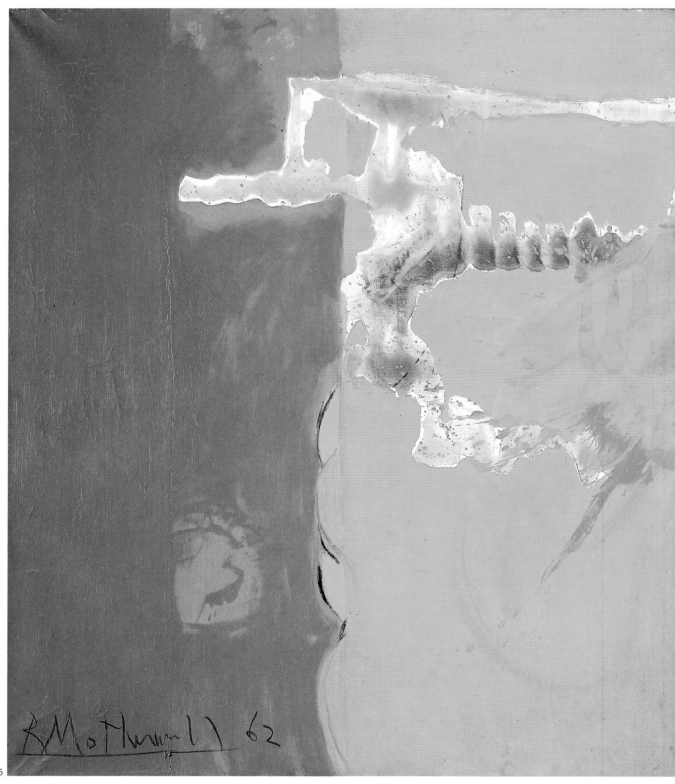

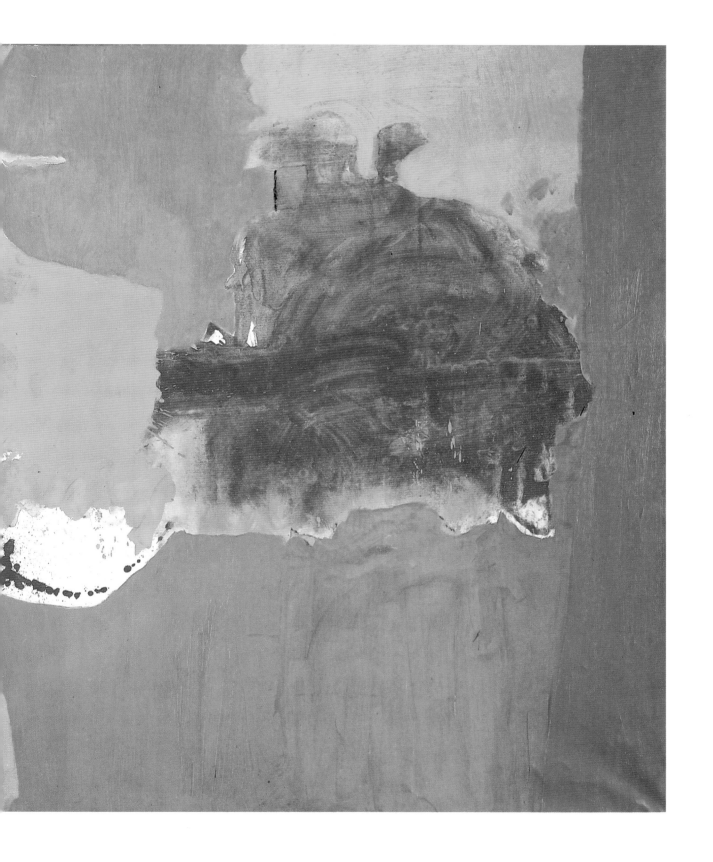

66. **The Yellow Stripe.** 1963.
Oil on paper, 29 × 23 in. (73.7 × 58.4 cm).
Photo: Otto Nelson.
Collection Dr. Kapelsell, New York.

67. **Torn Elegy.** 1962.
Acrylic on cardboard, 10⁵/₈ × 15 in. (27 × 38.1 cm), irregular.
Photo: Ken Cohen.
Private Collection.

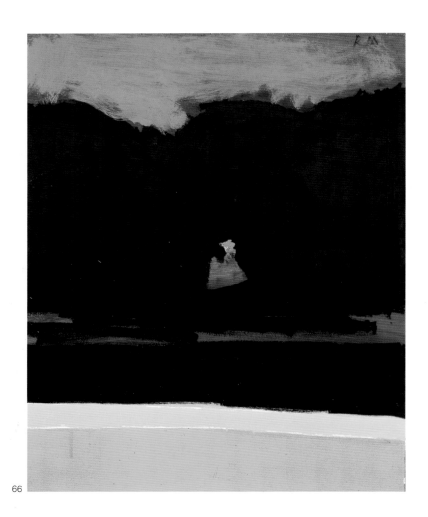

66

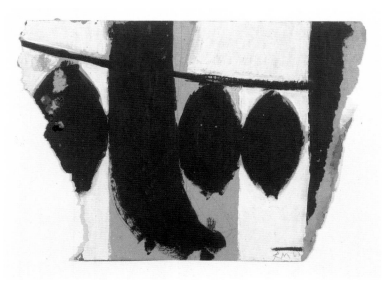

67

68. **Elegy to the Spanish Republic No. 79.** 1962.
Oil on canvas, 48 × 66 in. (121.9 × 167.6 cm)
Photo: Ken Cohen.
Private Collection.

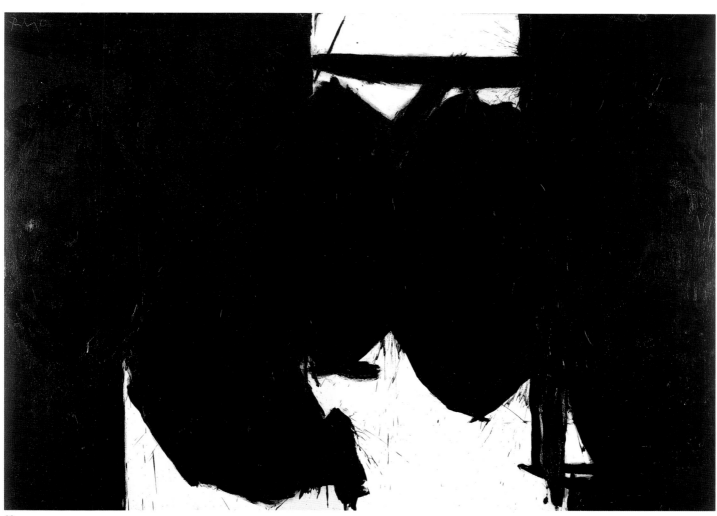

68

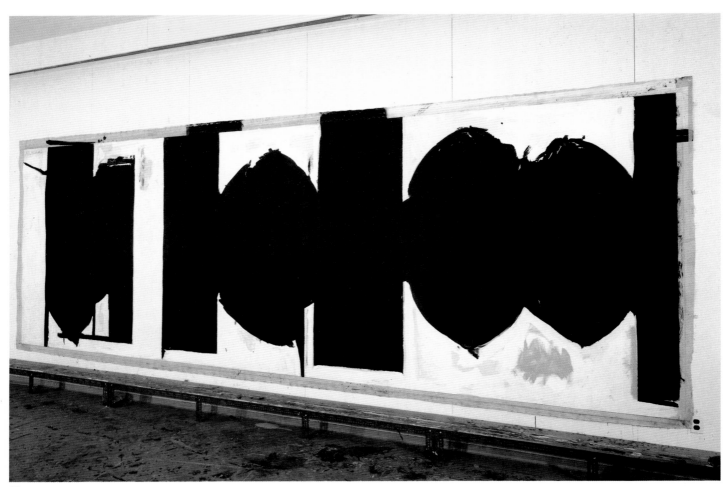

69

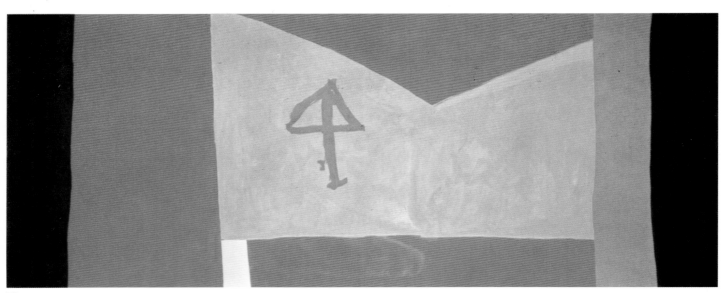

70

69. **Elegy to the Spanish Republic No. 100.** 1963–75.
Acrylic on canvas, 80×240 in. (213.4×609.6 cm).
Photo: Ken Cohen.
Private Collection.

70. **Dublin 1916, with Black and Tan.** 1964.
Acrylic and oil on canvas, 84½×204¼ in. (214.6×518.8 cm).
Property of Rockefeller Collection, Empire State Plaza Art Collection.
Albany, New York.

71. **Lyric Suite.** 1965.
Colored ink on rice paper, 9×11 in. (22.9×27.9 cm).
Photo: Ken Cohen.
Private Collection.

72. **Lyric Suite.** 1965.
Colored ink on rice paper, 9×11 in. (22.9×27.9 cm).
Photo: Ken Cohen.
Private Collection.

73. **Lyric Suite.** 1965.
Colored ink on rice paper, 11×9 in. (27.9×22.9 cm).
Photo: Ken Cohen.
Private Collection.

74. **Lyric Suite.** 1965.
Colored ink on rice paper, 11×9 in. (27.9×22.9 cm).
Photo: Ken Cohen.
Private Collection.

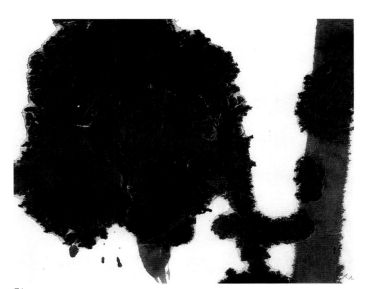

71

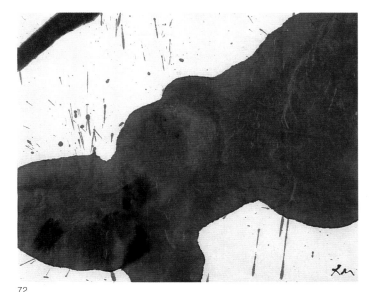

72

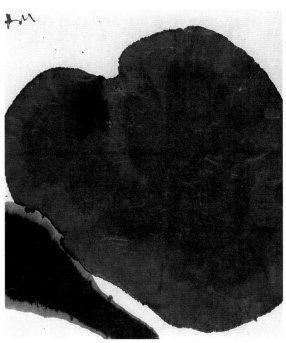

73

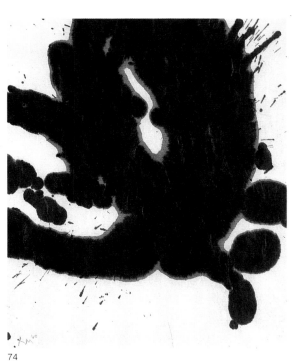

74

75. **Lyric Suite.** 1965.
Colored ink on rice paper, 11 × 9 in. (27.9 × 22.9 cm).
Photo: Ken Cohen.
Private Collection.

76. **Lyric Suite.** 1965.
Colored ink on rice paper, 11 × 9 in. (27.9 × 22.9 cm).
Photo: Ken Cohen.·
Private Collection.

77. **Lyric Suite.** 1965.
Colored ink on rice paper, 9 × 11 in. (22.9 × 27.9 cm).
Photo: Ken Cohen.
Private Collection.

78. **Lyric Suite.** 1965.
Colored ink on rice paper, 9 × 11 in. (22.9 × 27.9 cm).
Photo: Ken Cohen.
Private Collection.

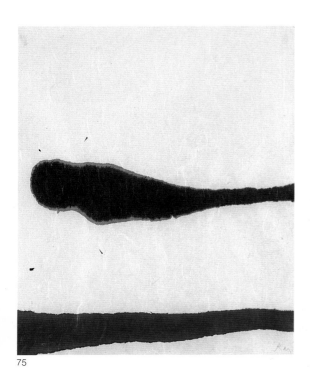

75

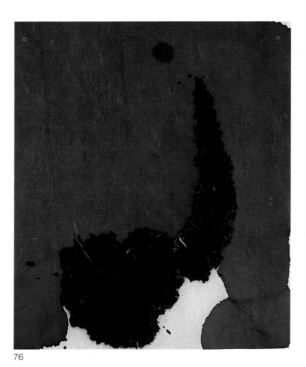

76

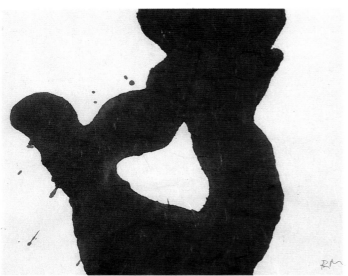

77

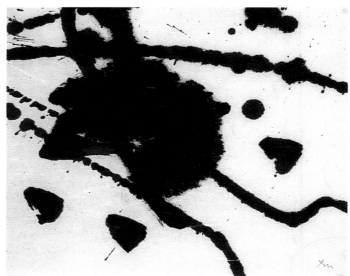

78

79. **Automatism No. 2A (For Frank O'Hara).** 1965.
Acrylic and oil on rice paper, 26 × 20 in. (66 × 50.8 cm).
Photo: Steven Sloman.
Private Collection.

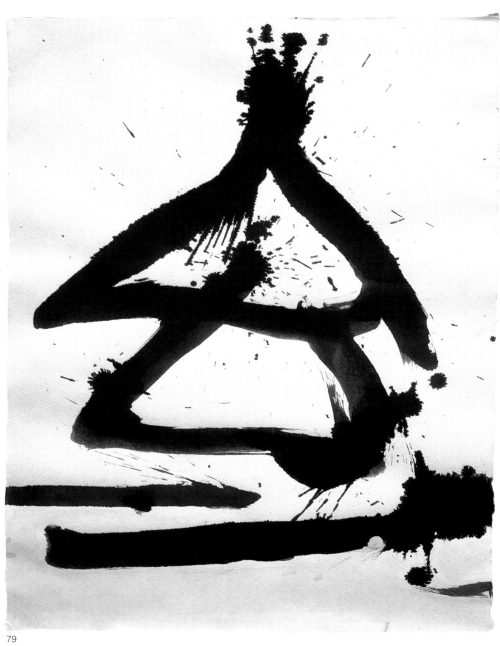

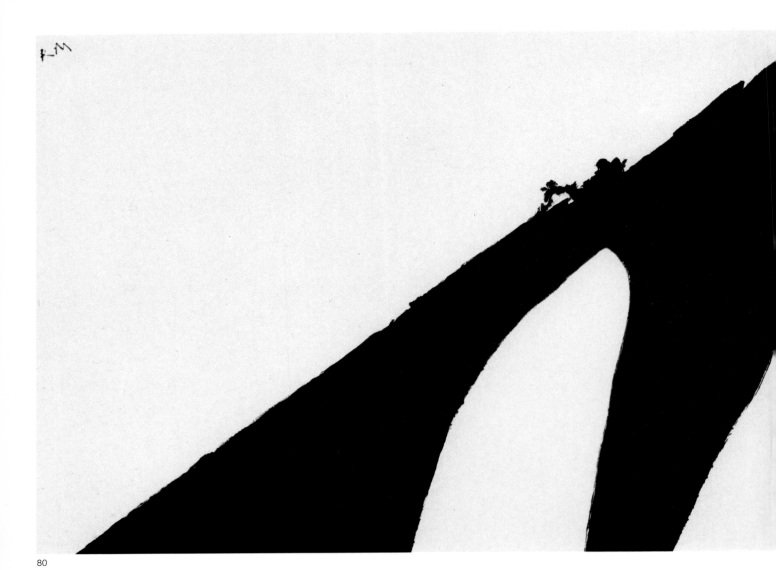

80

80. **Africa.** 1965.
 Acrylic on canvas, 80 × 225 in. (203.2 × 571.5 cm).
 Photo: Courtesy The Baltimore Museum.
 Collection Baltimore Museum of Art, Baltimore, Maryland. Gift of Robert
 Motherwell.

81. **Blue Elegy.** 1966.
 Acrylic on chipboard, 6 × 8 in. (15.2 × 20.3 cm).
 Photo: Steven Sloman.
 Private Collection.

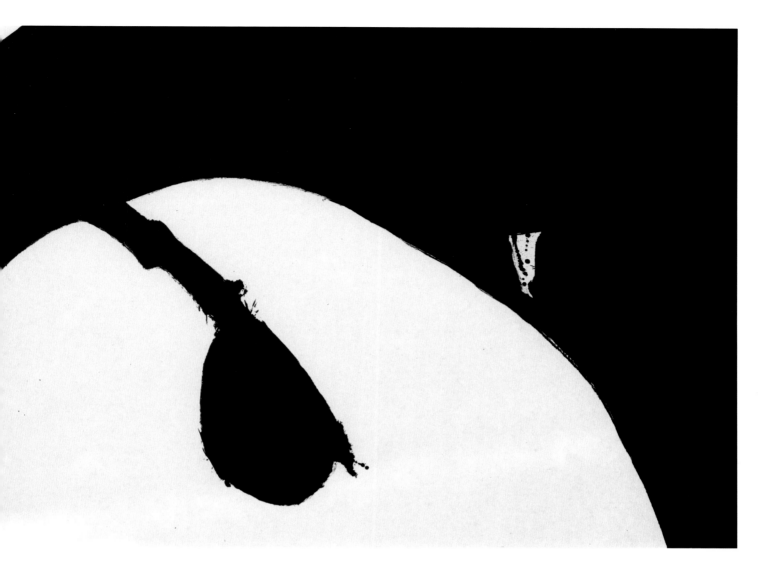

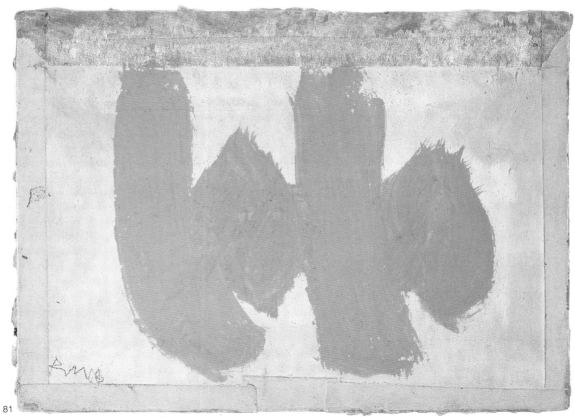

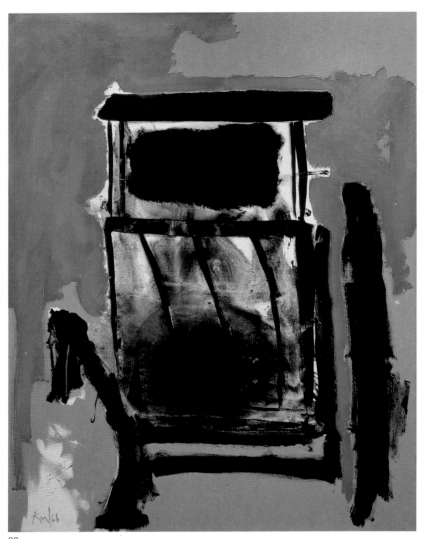

82

82. **Guillotine.** 1966.
Oil and acrylic on canvas, 66¹/₈ × 50 in. (167.9 × 127 cm).
Photo: Steven Sloman.
Private Collection.

83. **Blotting Paper Collage.** 1967.
Acrylic, paper and charcoal on blotting paper, 37¼ × 23³/₈ in.
(94.6 × 59.4 cm).
Photo: Steven Sloman.
Collection Renate Ponsold.

84. **Summertime in Italy.** 1967.
Acrylic on canvas, 82 × 48 in. (208.3 × 121.9 cm).
Photo: Courtesy Greenberg Gallery.
Collection Irving Deal, Dallas, Texas.

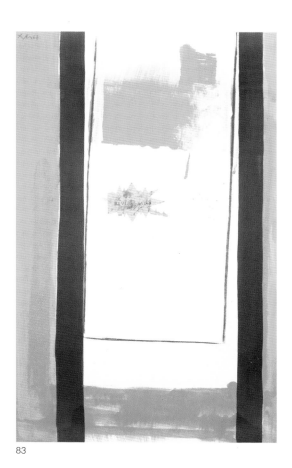

83

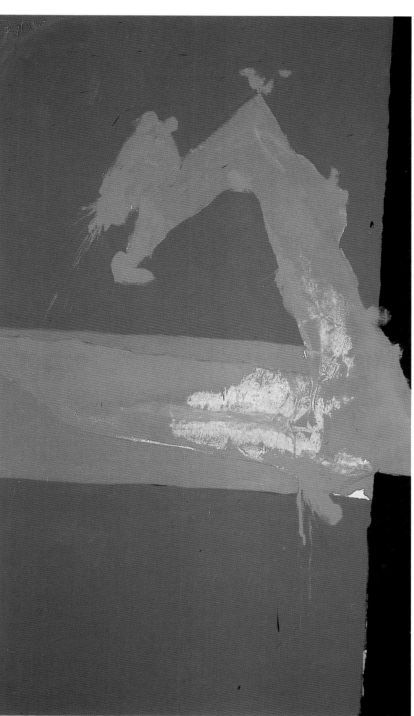

84

85. **Open No. 54 (The Gray Window).** 1967.
Acrylic on canvas, 36 × 24 in. (91.4 × 60.9 cm).
Photo: Steven Sloman.
Collection Tilly and Herbert A. Cahn, Basle.

86. **The Garden Window (Formerly Open No. 110).** 1969.
Acrylic on canvas, 61 × 41 in. (154.9 × 104.1 cm).
Photo: Ken Cohen.
Private Collection.

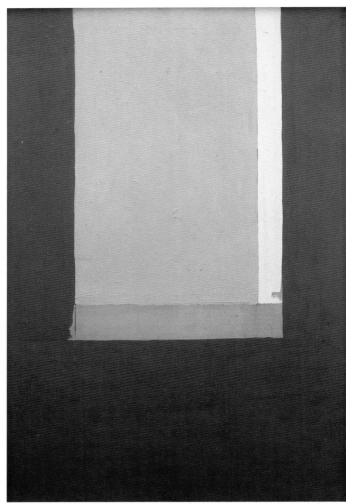

85

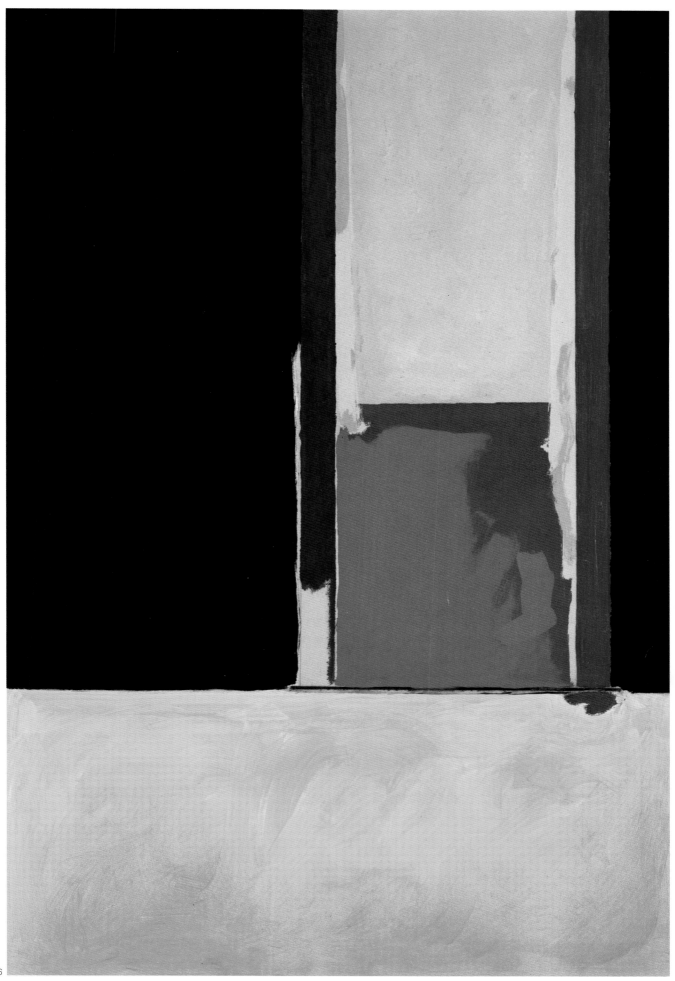

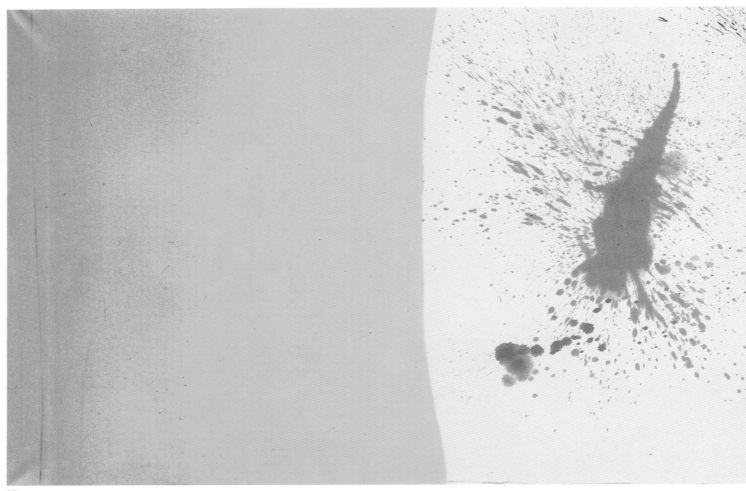

87

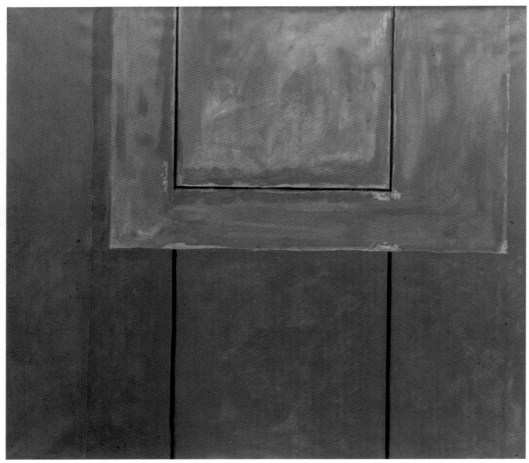

88

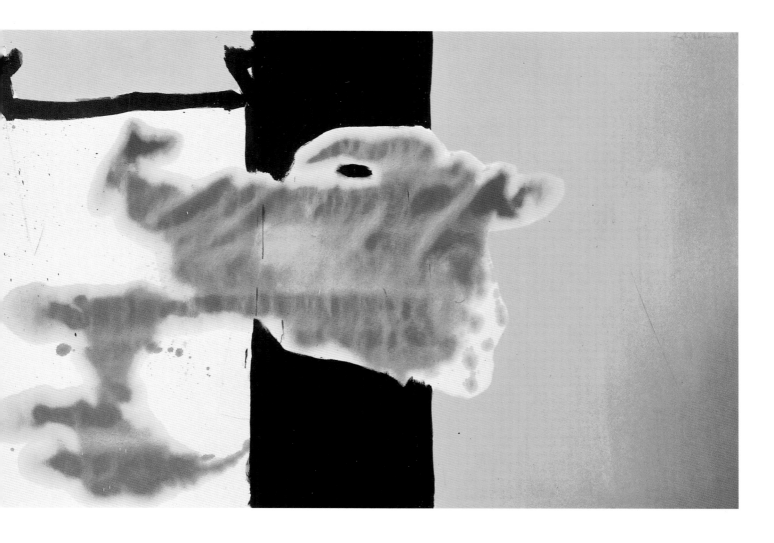

87. **The Voyage: Ten Years After.** 1968.
Acrylic on canvas, 62 × 210 in. (157.5 × 533.4 cm).
Photo: Steven Sloman.
Private Collection.

88. **Open No. 104 (The Brown Easel).** 1969.
Acrylic on canvas, 54 × 60 in. (137.2 × 152.4 cm).
Photo: Steven Sloman.
Private Collection.

89. **Open No. 1.** 1967.
Acrylic on canvas, 114 × 83 in. (289.6 × 210.8 cm).
Photo: Steven Sloman.
Collection Helen Frankenthaler, New York.

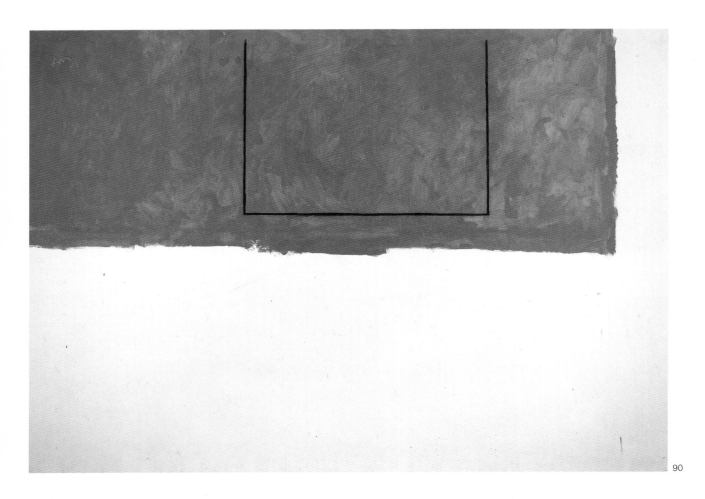

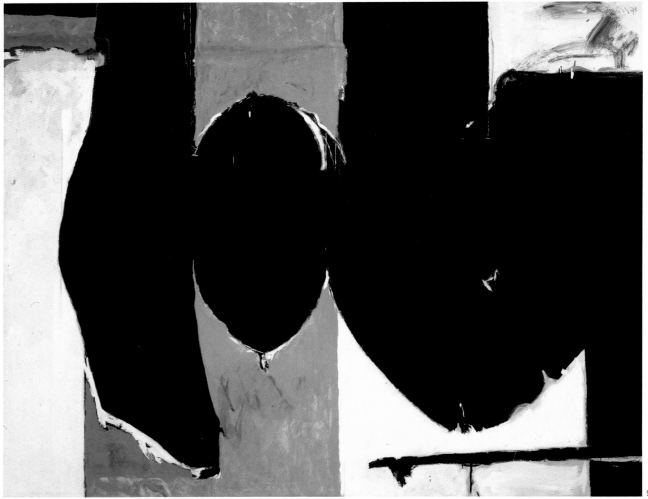

90. **Open No. 111 (Big White and Ochre).** 1969.
Acrylic on canvas, 93 × 129 in. (236.2 × 327.7 cm).
Photo: Otto Nelson.
Private Collection.

91. **Elegy to the Spanish Republic No. 132.** 1975–83.
Acrylic on canvas, 96 × 120 in. (243.8 × 304.8 cm).
Photo: Ken Cohen.
Private Collection.

92. **Open No. 97 (The Spanish House).** 1969.
Acrylic on canvas, 92½ × 114½ in. (234.9 × 290.8 cm).
Photo: Steven Sloman.
Private Collection.

93. **In Beige with Charcoal No. 9.** 1973.
Acrylic and charcoal on board, 36 × 48 in. (91.4 × 121.9 cm).
Photo: Steven Sloman.
Private Collection.

94. **Study for Shem the Penman No. 6.** 1972.
Acrylic and charcoal on board, 15½ × 19½ in.
(39.4 × 49.5 cm).
Photo: Steven Sloman.
Private Collection.

95. **Study for Shem the Penman No. 11.** 1972.
Acrylic and charcoal on board, 15½ × 19½ in.
(39.4 × 49.5 cm).
Photo: Steven Sloman.
Private Collection.

93

94

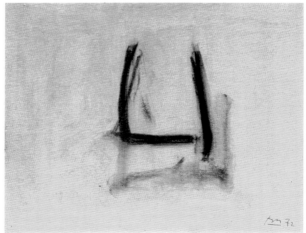

95

96. **In Plato's Cave No. 1**. 1972.
Acrylic on canvas, 72 × 96 in. (182.9 × 243.8 cm).
Photo: Steven Sloman.
Private Collection.

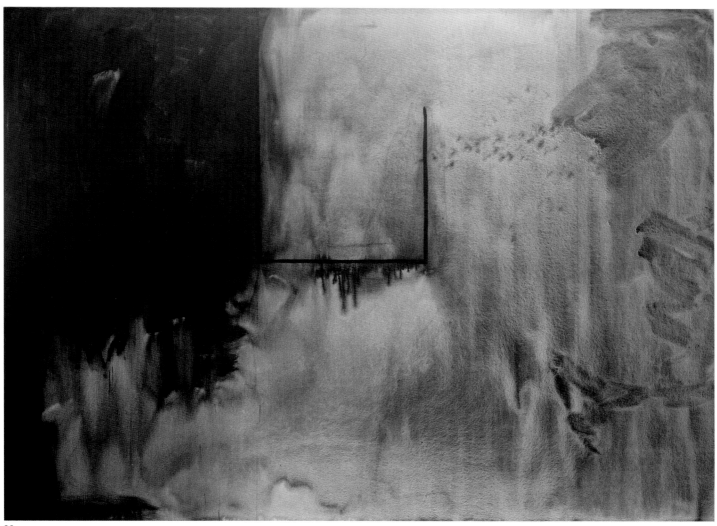

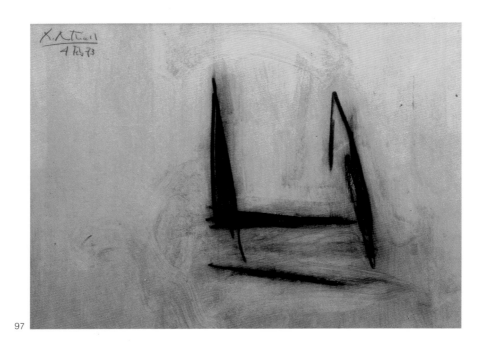

97

98

97. **In Beige with Charcoal.** 1973.
Acrylic and charcoal on board, 35 × 47 in.
(88.9 × 119.4 cm).
Photo: Steven Sloman.
Private Collection.

98. **Yellow Wall.** 1973.
Acrylic on canvas, 72 × 48 in. (182.9 × 121.9 cm).
Photo: Steven Sloman.
Private Collection.

99. **Mexican Window.** 1974.
Acrylic on canvas, 76½ × 96 in. (194.3 × 243.8 cm).
Photo: Steven Sloman.
Collection Mildred and Herbert Lee, Palm Beach, Florida.

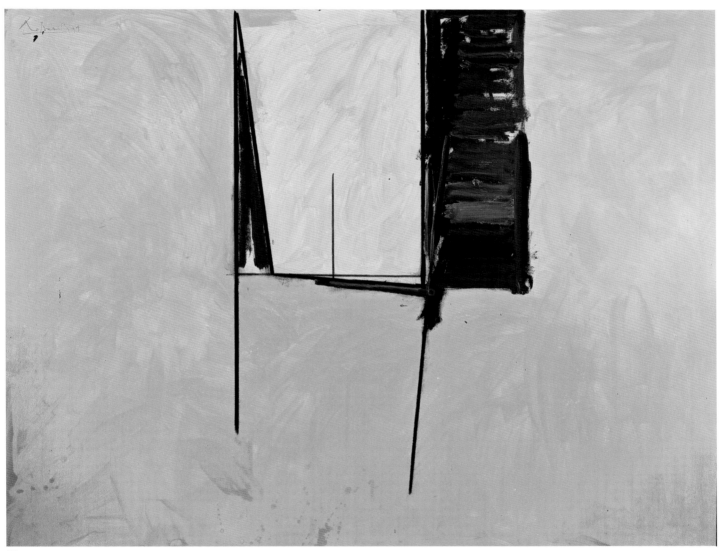

99

100. **The Blue Painting Lesson Nos. 1–5,** in the artist's studio.

101. **The Blue Painting Lesson No. 1.** 1973.
 Acrylic on canvas, 61 × 44 in. (154.9 × 111.8 cm).
 Photo: Steven Sloman.
 Private Collection.

102. **The Blue Painting Lesson No. 2.** 1973.
 Acrylic on canvas, 72 × 42 in. (182.9 × 106.7 cm).
 Photo: Steven Sloman.
 Private Collection.

103. **The Blue Painting Lesson No. 3.** 1973.
 Acrylic on canvas, 84 × 42 in. (213.4 × 106.7 cm).
 Photo: Steven Sloman.
 Private Collection.

104. **The Blue Painting Lesson No. 4.** 1973.
 Acrylic on canvas, 61 × 52 in. (154.9 × 132 cm).
 Photo: Steven Sloman.
 Private Collection.

105. **The Blue Painting Lesson No. 5.** 1973.
 Acrylic on canvas, 72 × 36 in. (182.9 × 91.4 cm).
 Photo: Steven Sloman.
 Private Collection.

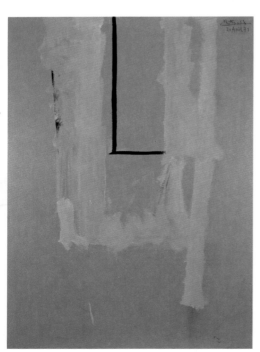

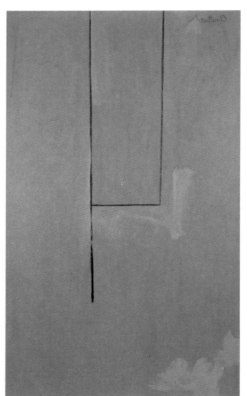

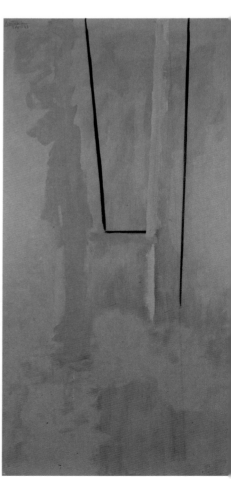

101

102

103

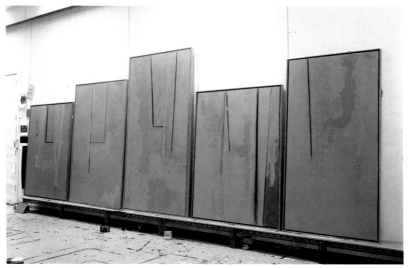

100

04

105

106

106. **Summer Open with Mediterranean Blue.** 1974.
Acrylic on canvas, 48 × 108 in. (121.9 × 274.3 cm).
Photo: Steven Sloman.
Private Collection.

107. **The Blue Window.** 1973.
Acrylic on canvas, 61 × 52 in. (154.9 × 132 cm).
Photo: Steven Sloman.
Private Collection.

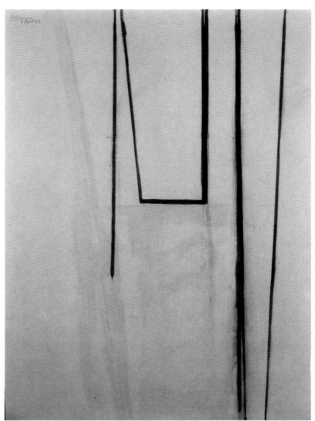

108. **Blueness of Blue.** 1974.
Acrylic on canvas, 72 × 84 in. (182.9 × 213.4 cm).
Photo: Steven Sloman.
Private Collection, Germany.

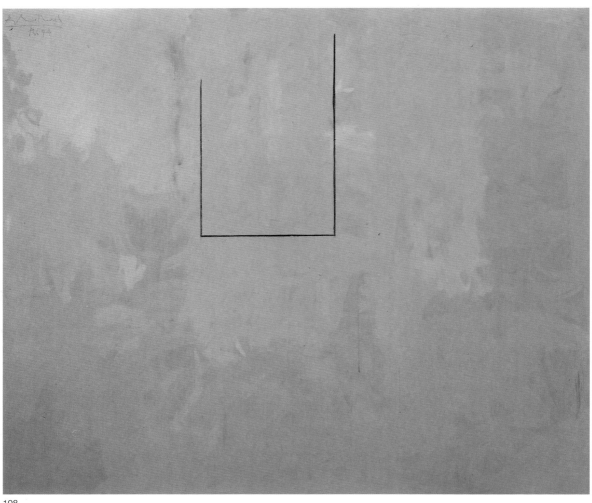

108

109. **Dover Beach III.** 1974.
Acrylic on canvas, 77 × 96 in. (195.6 × 243.8 cm).
Photo: Steven Sloman.
Collection Jean-Paul Barbier-Muller, Geneva.

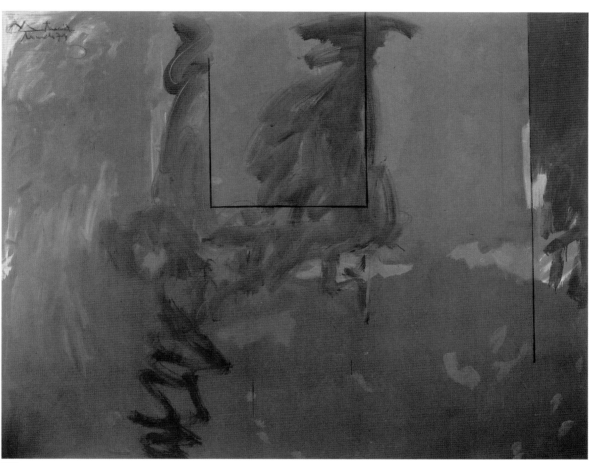

109

110. **Premonition Open with Flesh Over Gray.** 1974.
Acrylic on canvas, 72×84 in. (182.9×213.4 cm).
Photo: Steven Sloman.
Private Collection, Germany.

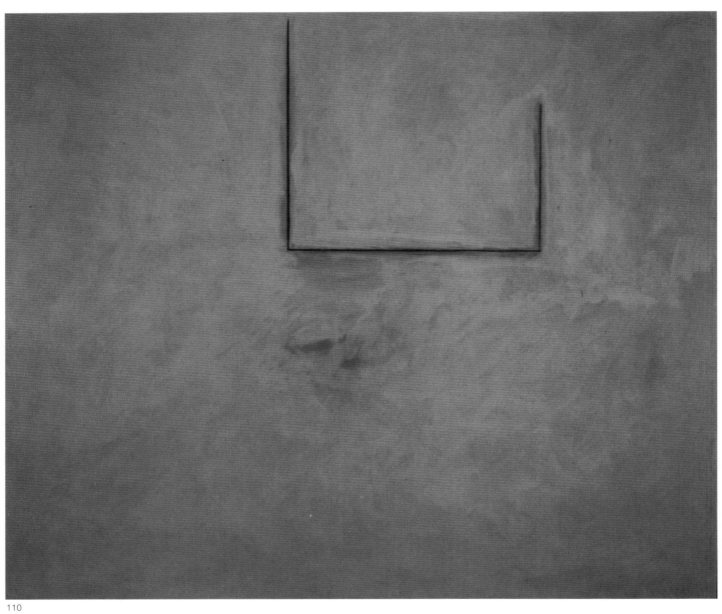

111. **The Persian I.** 1974.
Acrylic on Upsom board, 48 × 36 in. (121.9 × 91.4 cm).
Photo: Steven Sloman.
Private Collection.

112. **The Wild Duck.** 1974.
Acrylic on Upsom board, 36 × 24 in. (91.4 × 60.9 cm).
Photo: Steven Sloman.
Private Collection.

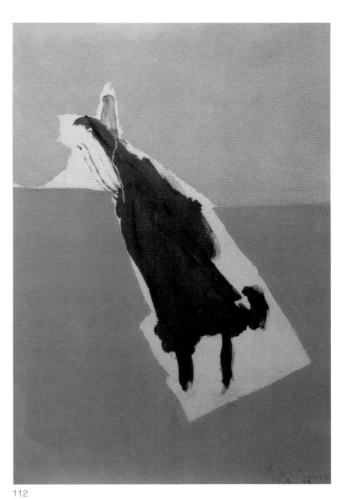

111

112

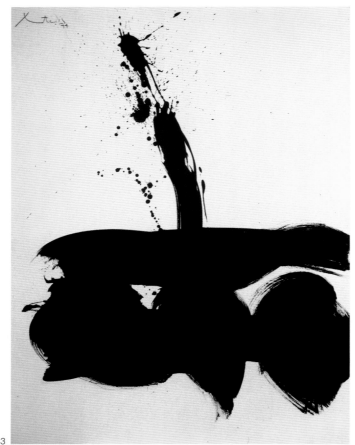

113

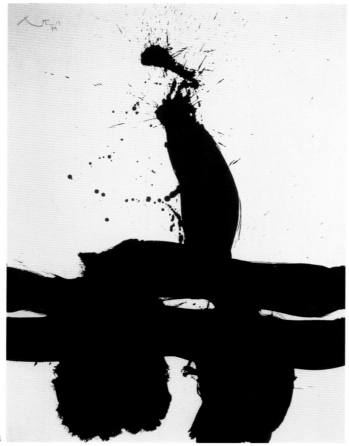

114

113. **Samurai No. 1.** 1974.
Acrylic on board, 48 × 36 in. (121.9 × 91.4 cm).
Photo: Steven Sloman.
Collection Gertrude and Leonard Kasle, Detroit.

114. **Samurai No. 4.** 1974.
Acrylic on board, 48 × 36 in. (121.9 × 91.4 cm).
Photo: Steven Sloman.
Collection Mr. and Mrs. Benjamin Kitchen III, Houston, Texas.

115. **In Memoriam: The Wittenborn Collage.** 1975.
Acrylic and paper collage on canvasboard, 72 × 36 in.
(182.9 × 91.4 cm).
Photo: Steven Sloman.
Private Collection.

116. **River Liffey (Dublin).** 1975.
Acrylic and paper collage on canvasboard, 72 × 24 in.
(182.9 × 60.9 cm).
Photo: Steven Sloman.
Private Collection.

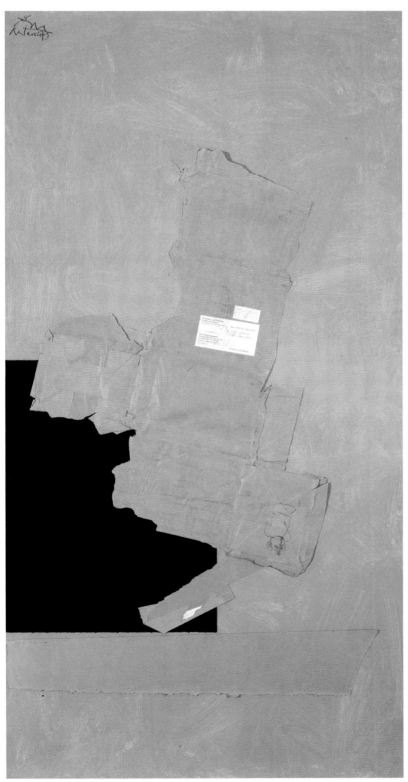

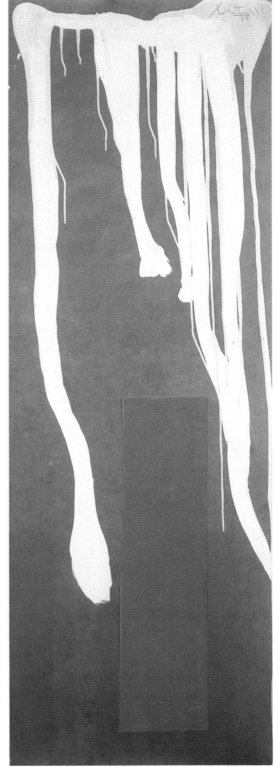

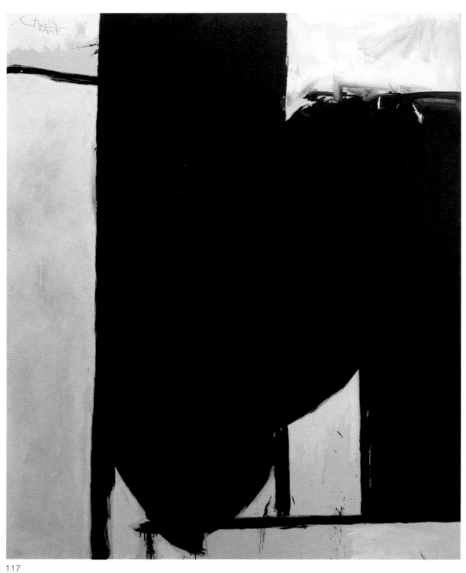

117

117. **The Spanish Death.** 1975.
Acrylic on canvas, 96 × 77½ in. (243.8 × 196.8 cm).
Photo: Steven Sloman.
Collection Museum Moderner Kunst, Sammlung
Ludwig, Vienna, Austria.

118. **Study for Elegy to the Spanish Republic
No. 100.** 1975.
Acrylic on canvasboard, 8½ × 24 in.
(21.6 × 60.9 cm).
Photo: Steven Sloman.
Private Collection.

119. **Elegy to the Spanish Republic No. 110
(Easter Day).** 1971.
Acrylic and pencil on canvas,
82 × 114 in. (208.3 × 289.6 cm).
Photo: Courtesy Guggenheim Museum.
Collection Solomon R. Guggenheim Museum,
New York.
Gift, Agnes Gund.

120. **Elegy Sketch.** 1976.
Ink on watercolor paper, 6¾ × 10 in.
(17.1 × 25.4 cm).
Photo: Steven Sloman.
Private Collection.

121. **Elegy Sketch.** 1977.
Ink on paper, 12 × 16¾ in. (30.5 × 42.5 cm).
Photo: Steven Sloman.
Private Collection.

118

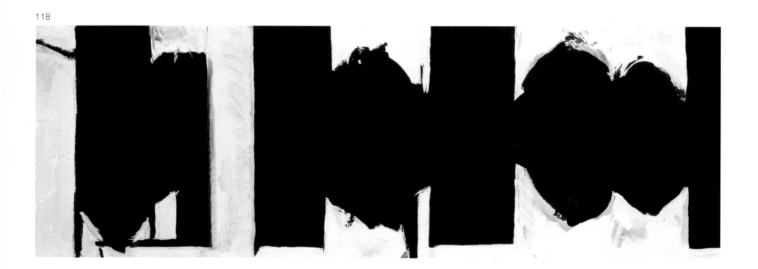

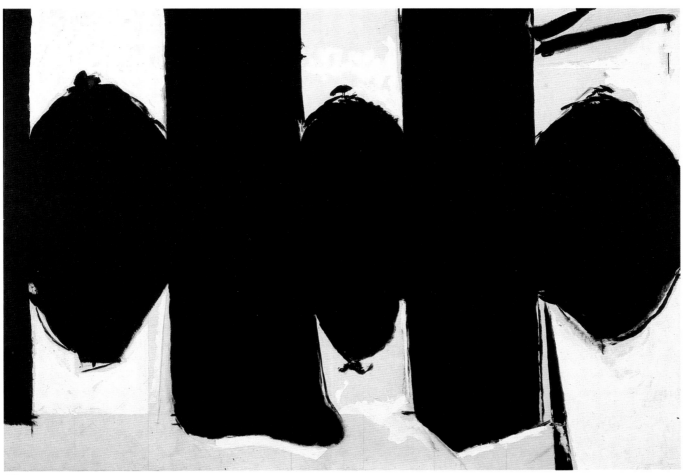

119

120

121

122. **Phoenician Red Studio.** 1977.
Acrylic on canvas, 86 × 192 in. (218.4 × 487.7 cm).
Photo: Steven Sloman.
Private Collection.

123. **Study for The Hollow Men.** 1977.
Pencil and gouache on mylar, 13½ × 23 in. (34.3 × 58.4 cm).
Photo: Ken Cohen.
Private Collection.

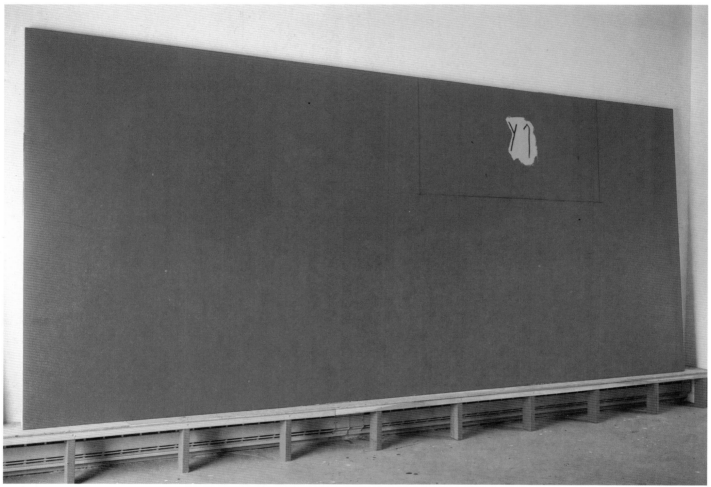

122

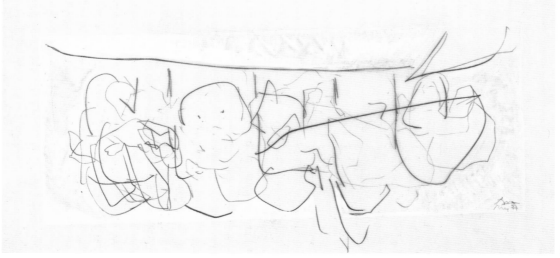

123

124. **Port de Boston II.** 1977.
Collage of acrylic and paper on canvasboard, 36×24 in.
(91.4×60.9 cm).
Photo: Steven Sloman.
Private Collection, Switzerland.

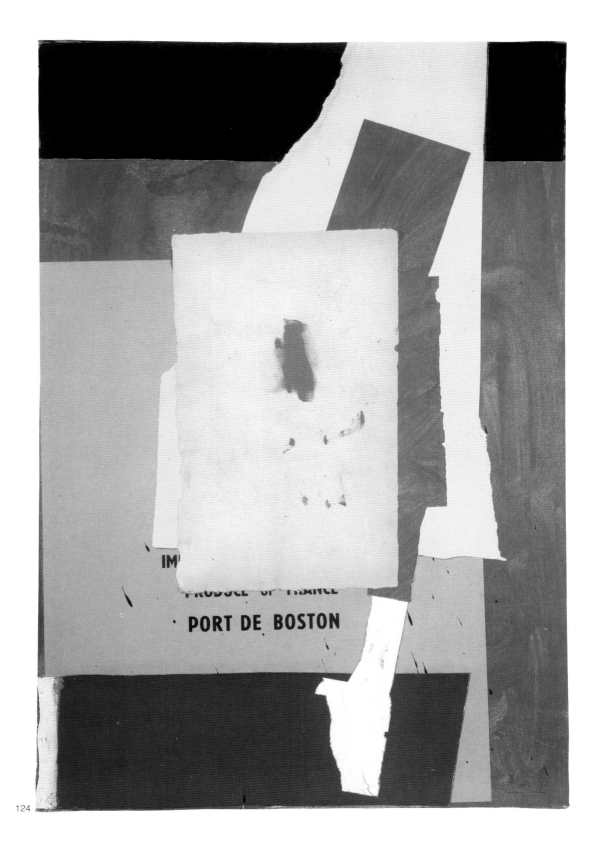

125. **Drunk with Turpentine No. 38.** 1979.
Oil on handmade paper, 16 × 20 in. (40.6 × 50.8 cm).
Photo: Steven Sloman.
Private Collection.

126. **Drunk with Turpentine No. 47.** 1979.
Oil on rag paper, 23 × 29 in. (58.4 × 73.7 cm).
Photo: Ken Cohen.
Private Collection.

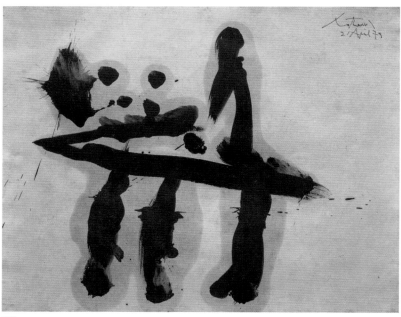

125

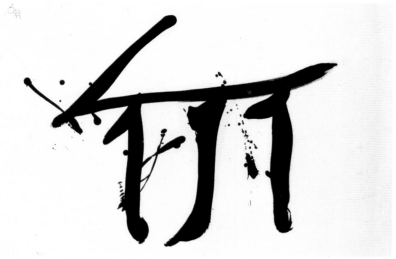

126

127. **Mexican Night.** 1979.
Oil on canvas, 48 × 48 in. (121.9 × 121.9 cm).
Photo: Steven Sloman.
Collection Douglas S. Cramer, Los Angeles, California.

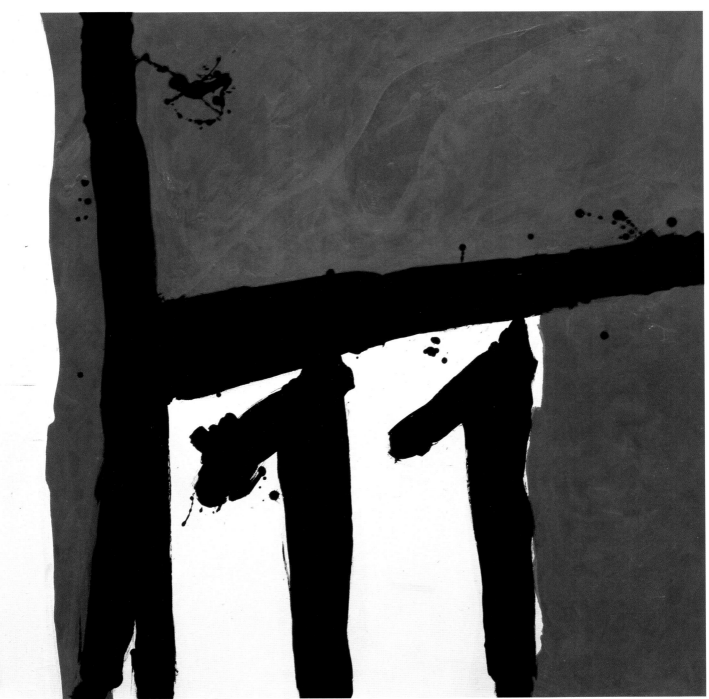

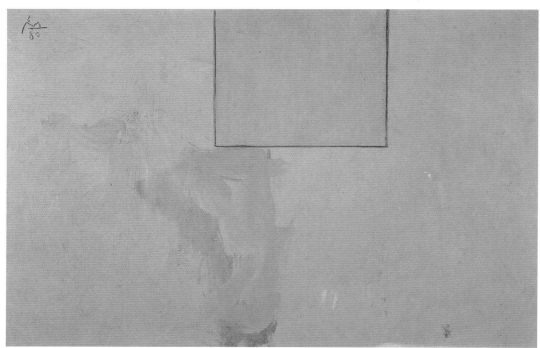

128

128. **Provincetown Blue.** 1980.
Acrylic and crayon on Tycore panel, 24 × 36 in. (60.9 × 91.4 cm).
Photo: Steven Sloman.
Private Collection.

129. **Gulfstream.** 1980.
Acrylic on canvas, 36 × 72 in. (91.4 × 182.9 cm).
Photo: Steven Sloman.
Private Collection.

130. **Cantata XIII.** 1980.
Acrylic and collage on gesso panel, 24 × 20 in. (60.9 × 50.8 cm).
Photo: Steven Sloman.
Private Collection.

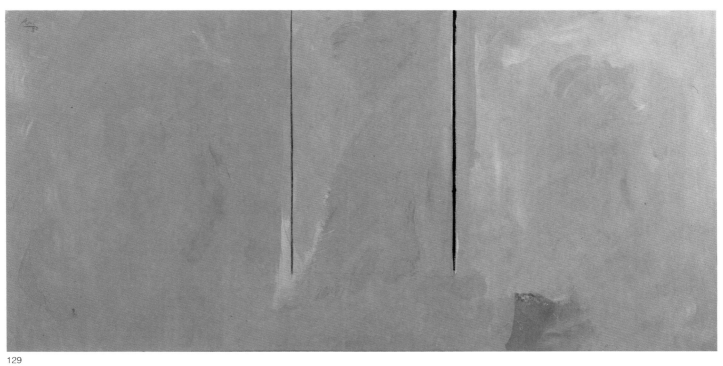

129

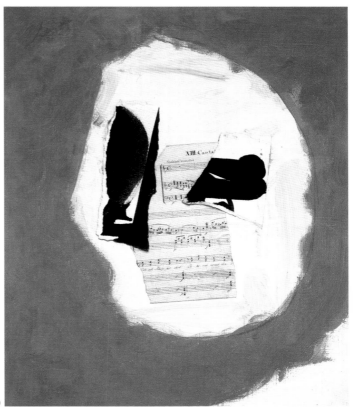

130

131. **Blue Elegy.** 1981.
Acrylic and charcoal on canvas, 69 × 99 in. (175.3 × 251.5 cm).
Photo: Steven Sloman.
Private Collection.

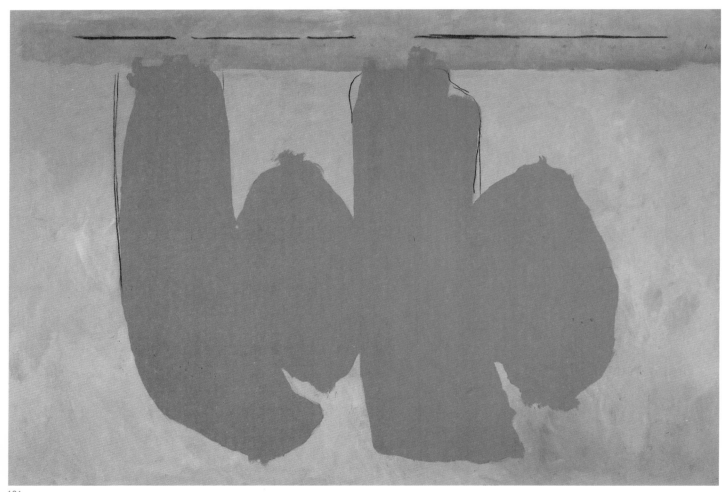

131

132. **Stephen's Iron Crown.** 1981.
Acrylic on canvas, 88 × 120 in. (223.5 × 304.8 cm).
Photo: Ken Cohen.
Private artist. On extended loan to The Fort Worth Art Museum.

133. **The Spanish King.** 1981.
Collage of acrylic and paper on board, 45 × 35 in. (114.3 × 88.9 cm).
Photo: Ken Cohen.
Collection Mr. and Mrs. Lawrence Rubin.

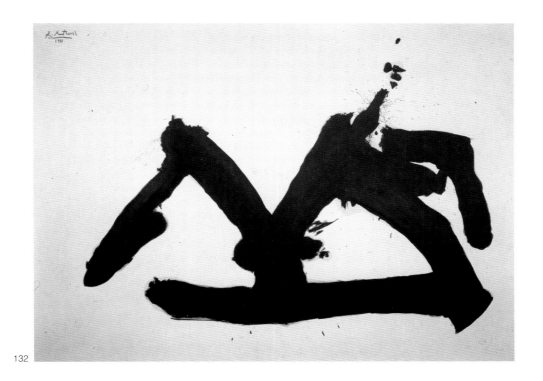

132

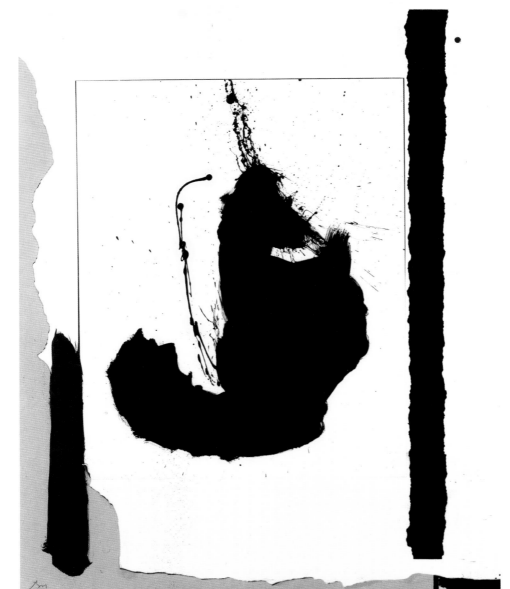

133

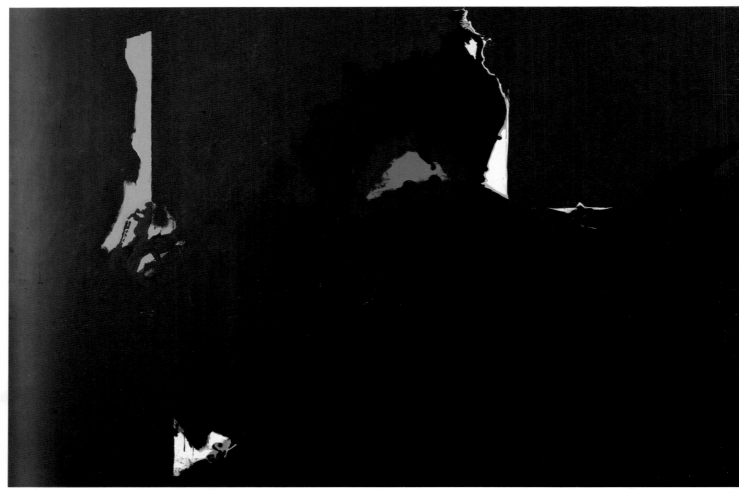

134

135

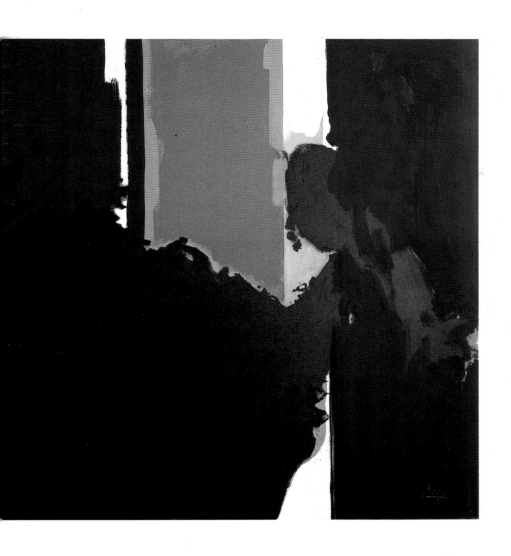

134. **Face of the Night (For Octavio Paz).** 1981.
Acrylic on canvas, 72 × 180 in. (182.9 × 457.2 cm).
Photo: Ken Cohen.
Private Collection.

135. **Broken Open.** 1981–87.
Acrylic on canvas, 72 × 84 in. (182.9 × 213.4 cm).
Photo: Ken Cohen.
Private Collection, California.

136. **The Hollow Men.** 1983.
Acrylic and charcoal on canvas, 88 × 176 in. (223.5 × 447 cm).
Photo: Steven Sloman.
Private Collection.

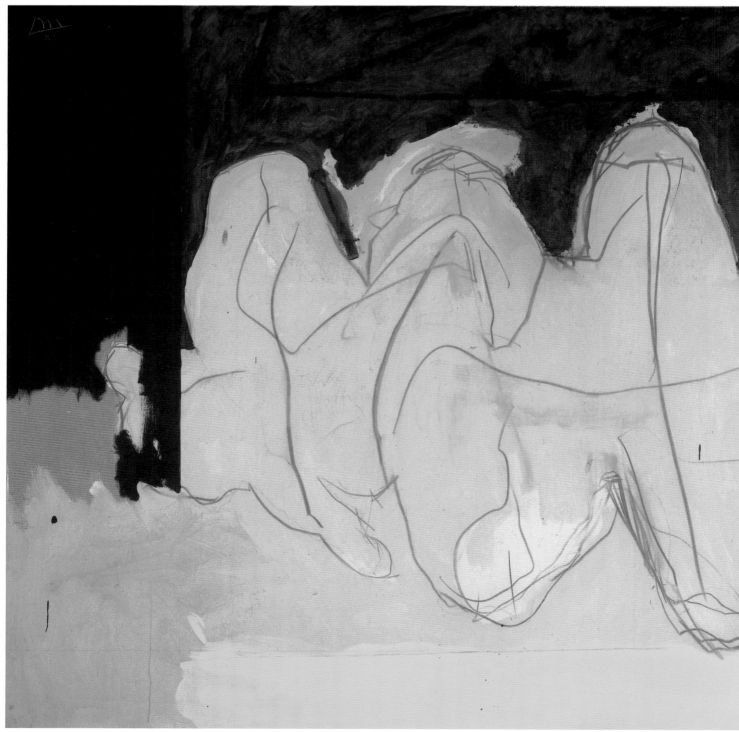

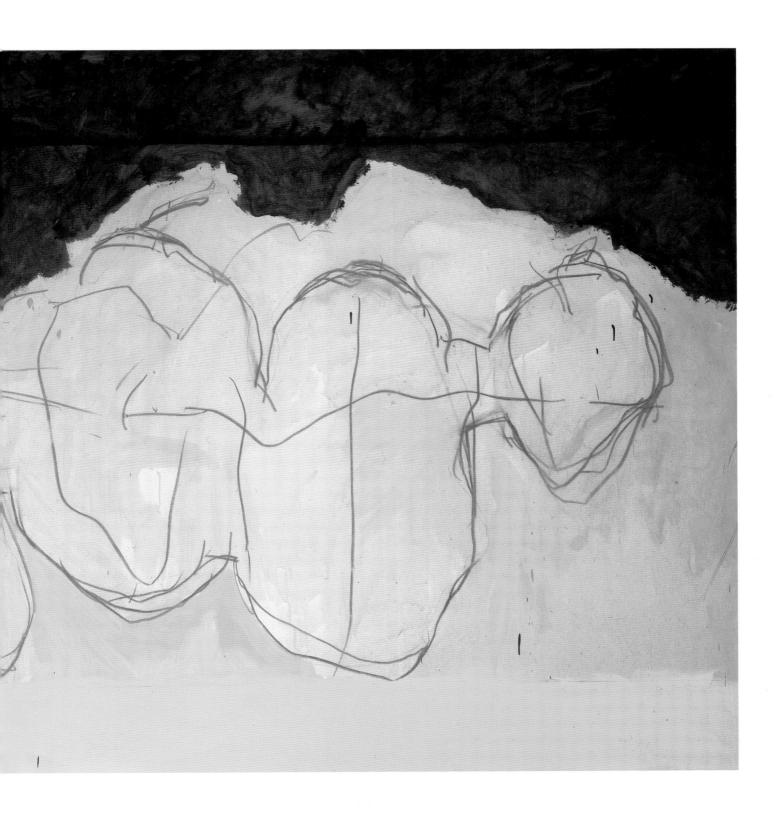

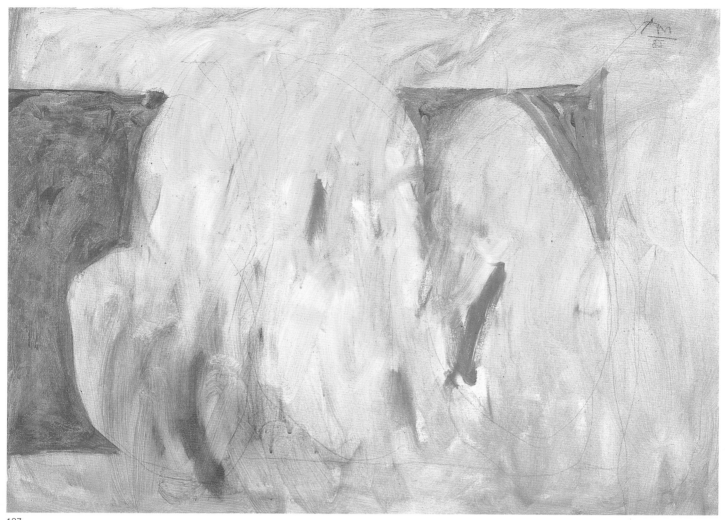

137

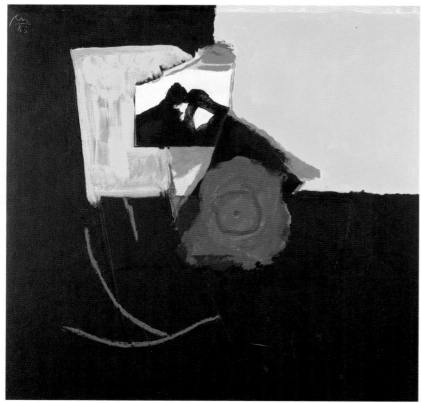

138

137. **Primavera Duet.** 1985.
Acrylic and pencil on canvas, 36 × 48 in. (91.4 × 121.9 cm).
Photo: Ken Cohen.
Private Collection.

138. **Goya's Dog.** 1985.
Collage and acrylic on canvas panel, 36 × 36 in.
(91.4 × 91.4 cm).
Photo: Ken Cohen.
Collection Michelle Rosenfeld, Upper Saddle River,
New Jersey.

139. **Quintet.** 1986.
Acrylic and charcoal on canvas, 36 × 72 in. (91.4 × 182.9 cm).
Photo: Ken Cohen.
Private Collection.

140. **The Green Studio.** 1986.
Etching and aquatint, 12 × 18 in. (30.5 × 45.7 cm).
Photo: Ken Cohen.
Published by Waddington Graphics.

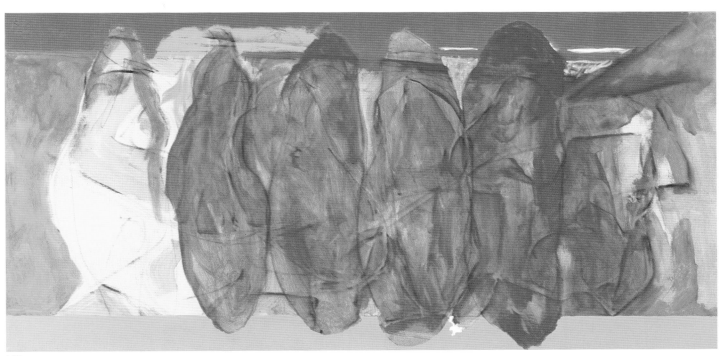

139

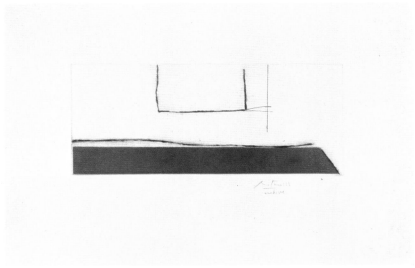

140

141. **The Big 4.** 1986.
Acrylic and chalk on canvas, 84 × 168 in. (213.4 × 426.7 cm).
Photo: Ken Cohen.
Private Collection.

141

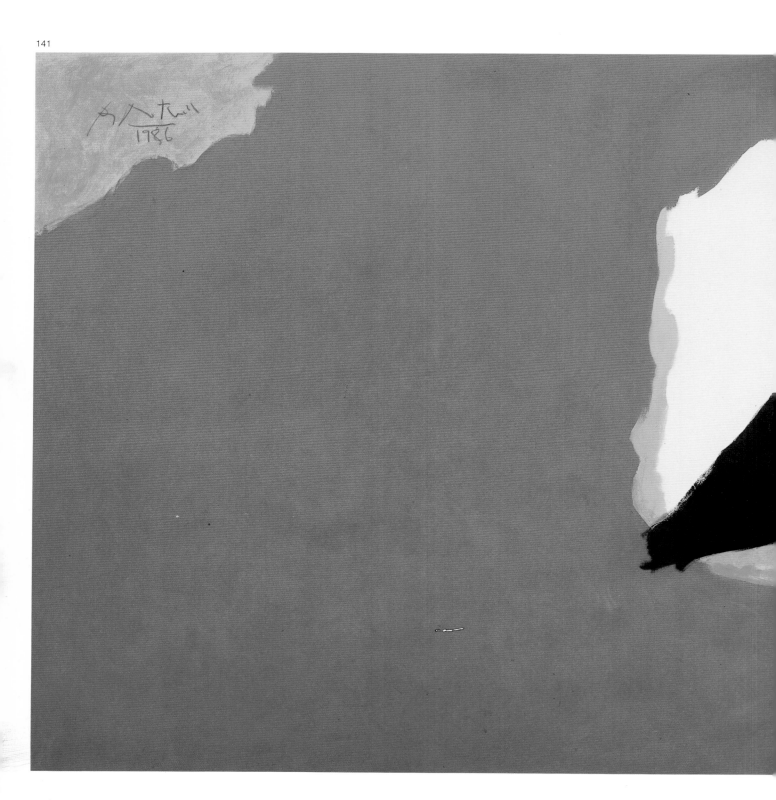

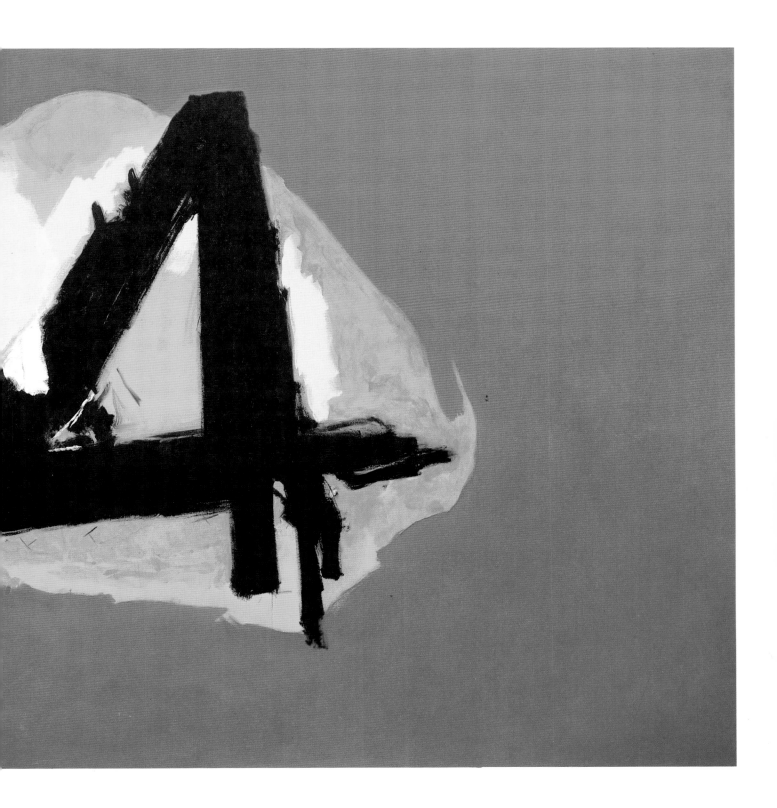

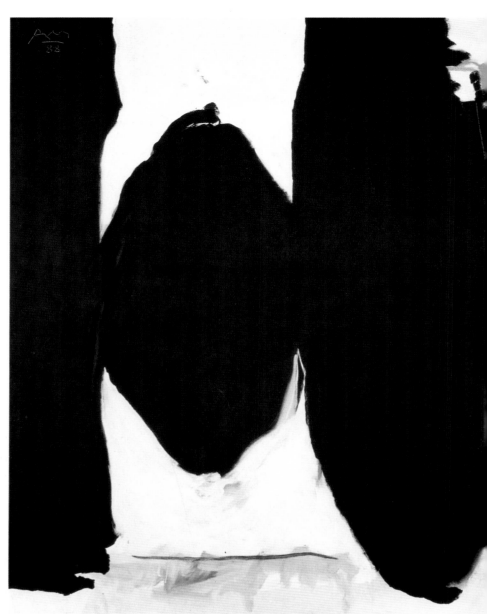

142

142. **Elegy to the Spanish Republic No. 171.** 1988–90.
Acrylic on canvas, 84 × 168 in. (213.4 × 426.7 cm).
Photo: Ken Cohen.
Private Collection.

143. **Elegy to the Spanish Republic No. 172 (with Blood).** 1989–90.
Acrylic on canvas, 84 × 120 in. (213.4 × 304.8 cm).
Photo: Ken Cohen.
Private Collection.

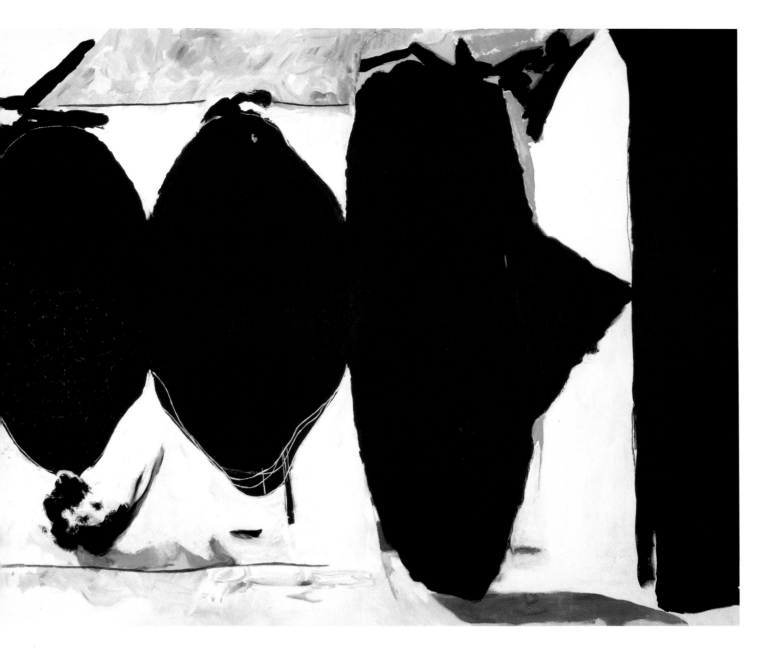

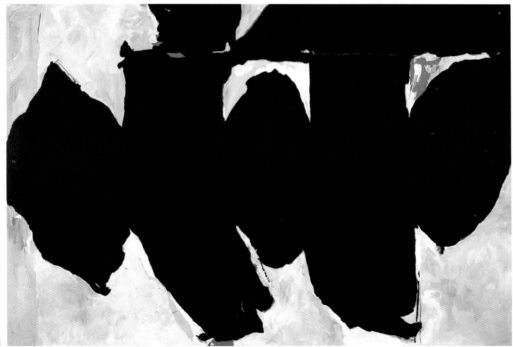

144. **The Grand Inquisitor.** 1989.
Acrylic on canvas, 84 × 168 in. (213.4 × 426.7 cm).
Photo: Ken Cohen.
Private Collection.

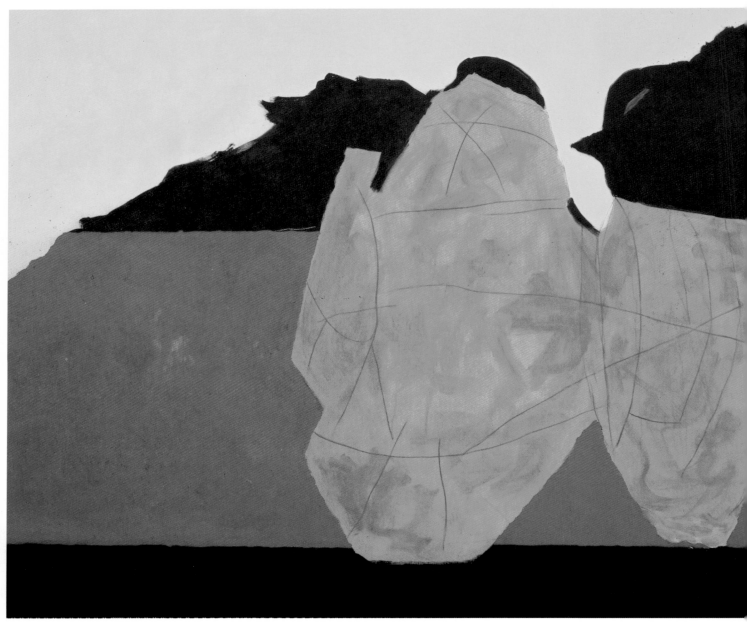

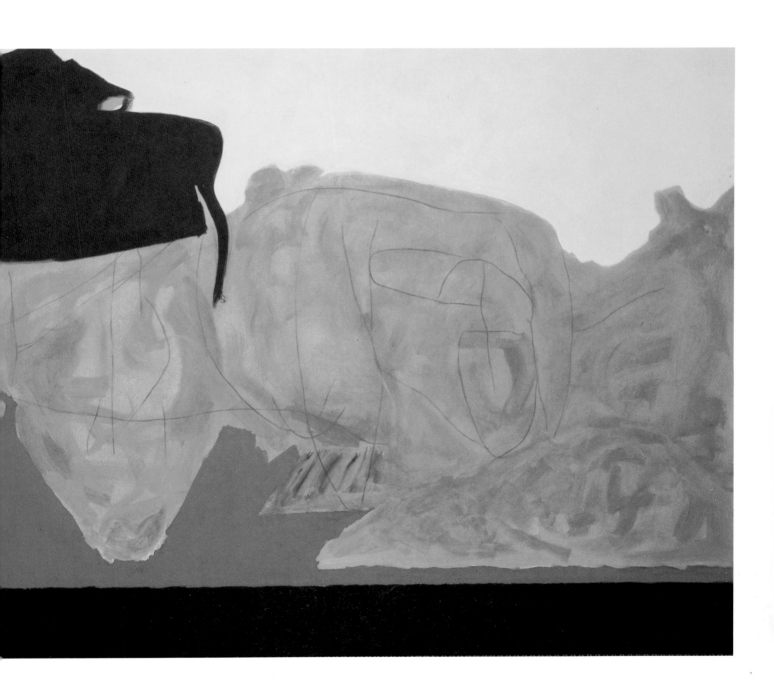

LIST OF ILLUSTRATIONS